Christine Bischoff, Francesca Falk, Sylvia Kafehsy (eds.)
Images of Illegalized Immigration

BBLACKBOXX BIBLIOTHEK

Image | Volume 9

CHRISTINE BISCHOFF, FRANCESCA FALK, SYLVIA KAFEHSY (EDS.)

Images of Illegalized Immigration
Towards a Critical Iconology of Politics

[transcript]

We would like to thank Matthias Müller for his proofreading and the Basel University, the Swiss National Science Foundation and the Freiwillige Akademische Gesellschaft for making the conference and publication possible.

Bibliographic information published by Die Deutsche Bibliothek
Die Deutsche Bibliothek lists this publication in the Deutsche Nationalbibliografie; detailed bibliographic data are available on the Internet at http://dnb.ddb.de

© 2010 transcript Verlag, Bielefeld

All rights reserved. No part of this book may be reprinted or reproduced or utilized in any form or by any electronic, mechanical, or other means, now known or hereafter invented, including photocopying and recording, or in any information storage or retrieval system, without permission in writing from the publisher.

Cover layout: Daniel Bisig, Sylvia Kafehsy
Proofread by Matthias Müller
Typeset by Justine Haida, Bielefeld
Printed by Majuskel Medienproduktion GmbH, Wetzlar
ISBN 978-3-8376-1537-1

Distributed in North America by

Transaction Publishers
New Brunswick (U.S.A.) and London (U.K.)

Transaction Publishers Tel.: (732) 445-2280
Rutgers University Fax: (732) 445-3138
35 Berrue Circle for orders (U.S. only):
Piscataway, NJ 08854 toll free 888-999-6778

Contents

Introduction
Christine Bischoff, Francesca Falk and Sylvia Kafehsy | 7

Migration, Law, and the Image: Beyond the Veil of Ignorance
W. J. T. Mitchell | 13

Milieus of Illegality
Representations of Guest Workers, Refugees, and Spaces of Migration in *Der Spiegel*, 1973-1980
Jan-Henrik Friedrichs | 31

The Making of "Illegality":
Strategies of Illegalizing Social Outsiders
Christine Bischoff | 47

Copying Camouflage
In/visibility of Illegalized Immigration in Julio Cesar Morales' Series *Undocumented Interventions*
Michael Andreas | 57

Images of Victims in Trafficking in Women
The Euro 08 Campaign Against Trafficking in Women in Switzerland
Sylvia Kafehsy | 71

Invasion, Infection, Invisibility:
An Iconology of Illegalized Immigration
Francesca Falk | 83

Voice-Over Image
Pamela C. Scorzin | 101

Masking, Blurring, Replacing:
Can the Undocumented Migrant Have a Face in Film?
Olaf Berg and Helen Schwenken | 111

Border: The Videographic Traces by Laura Waddington
as a Cinematographic Memorial
Eva Kuhn | 129

Politics, Representation, Visibility: Bruno Serralongue at the Cité Nationale de l'Histoire de l'Immigration
Lambert Dousson | 143

The Image versus the Map: the Ceuta Border
Marc Schoonderbeek | 155

Who is a Refugee—Strategies of Visibilization in the Neighbourhood of a Refugee Reception Camp and a Detention Centre
Almut Rembges | 167

Editors and Authors | 177

Introduction

CHRISTINE BISCHOFF, FRANCESCA FALK AND SYLVIA KAFEHSY

Illegalized immigration is a highly iconic topic. The public perception of the current regime for mobility is profoundly shaped by visual and verbal images, they play a crucial part in the creation of "imagined communities" (Benedict Anderson).

People without the legalized status of a residence permit and/or a working permit are today a part of the social reality—everywhere around the world. A state ignites processes of illegalization by its specific management and control of migration. It classifies people as "insiders" or "outsiders" in its "imagined communities". In this publication, we argue that those immigrants are *made* illegal by political and juridical strategies, they are *illegalized*. It is therefore our aim to trace the visual processes that produce these very categories.

As the issue of illegalized immigration is gaining increasing political momentum, we feel it is a well-warranted undertaking to analyze the role of images in the creation of illegalization. We therefore ask: Who has been creating these images? Under which conditions are they made? And where do they circulate? What is their relation to legal and political discourses? How are social movements appropriating these images, transforming them for their own ends? And under what circumstances can these images develop a momentum of their own? The representation of illegalization can only be properly analyzed in relation to the actual concrete form: This requires the analysis of the actual visual images, figures, symbols, narratives, metaphors—the material forms— in which symbolic meaning is circulated. Images and their production, transfer, and reception form a system of media practices that have a powerful impact on the perception and the everyday life of human beings. These visual practices don't merely reproduce points of view of different groups but actually produce them: Visuality not only signifies what might be referred to as a rising "flood of images", but a change in consciousness, which accords visual practices a much more substantial role in thought processes and in the acquisition of "knowledge".

The papers collected here aim to map out an iconography of illegalized immigration in relation to social, political, ethical and aesthetic discourses. They point out the "inaccessibility" of illegalized immigrants and the strategies, purposes, and dangers of giving persons without legal papers an individual face. Images can bring the violence inherent in illegalization out into the open and thereby shed a critical light on governmental policies of labour mobility. But showing what is hidden may sometimes lead to new forms of oppression.

In his contribution *"Migration, Law, and the Image: Beyond the Veil of Ignorance"* W. J. T. MITCHELL focuses on the twofold transformation of a native people into a diasporic population and a diasporic people into a nativist society. For Mitchell, the "problem" of migration is structurally and necessarily bound up with that of images: Images "precede" the immigrant in the sense that, before the immigrant arrives, his or her image arrives first. The critical situation in Israel/Palestine is defined by Mitchell within a broader survey of the overall question of immigration, taking up issues such as forced emigration and the spatial construction of displacement and confinement. Analyzing two recent documentary films, one Israeli, the other Palestinian, he discusses, among other things, how these scenes are in fact scenes of "illegalized" immigration. According to Mitchell, the Palestinians are treated as illegalized immigrants in their own land. The "veil of ignorance" allows liberal states to maintain their fictional status as liberal democracies. But it is precisely the image of the veil of ignorance that could be used to establish a normative order where the condition of illegalized immigrants is taken into account. Here, another role that the image can play becomes visible, namely to set out hypotheses, possibilities, and experimental scenarios for a world of open borders and universal human rights: The objective is not merely to change the way people see immigrants, Mitchell writes, but to change the way they see themselves.

The paper *"Milieus of Illegality, Representations of Guest Workers, Refugees, and Spaces of Migration in* Der Spiegel, *1973-1980"* by JAN-HENRIK FRIEDRICH explores the beginnings of a West German system of representation that made immigration appear a threat to the country by expressing it in terms of illegality and delinquency. Two historical events provide the focus for his paper: The recruitment ban for foreign workers in 1973 and the rising numbers of refugees in 1979/80. Articles and pictures in the German weekly *Der Spiegel* over several years are the author's sources. Remarkably, already in those days, pictures of deportation circulated in mass media. Furthermore, Friedrich highlights the imaginary component of the "ghetto". This image allowed transforming migration from a social into a spatial issue; urban space became one of the crucial categories in trying to *contain* this illegalized Other, and thereby rendered both the class character and the ethnic heterogeneity of the "ghetto" invisible.

Whereas the imagined ghetto of the former "guest workers" had clear boundaries, this is no longer the case with the "speed maniacs", as they seem to be everywhere and not confined to a particular place. In her paper

"*The Making of 'Illegality': Strategies of Illegalizing Social Outsiders*", CHRISTINE BISCHOFF asks how practices of social inclusion and exclusion are created or promoted by visual representations in the media. Analyzing a Swiss example, she is able to shed light on the processes by which migrants are turned into visual representatives of the blurred borders of nations. The discussion concentrates on the fact that stereotypes—such as the "speed maniacs with Balkan background"—are being given a "face" as part of a strategy to charge the topic with political impact in the vote about a bill that would have made naturalization easier for the second or third generation of immigrants living in Switzerland. Probably it is no coincidence that here the car became the leitmotif: Often the fathers and grandfathers of those depicted had stood at the assembly lines of the car factories of central and northern Europe, making their crucial contribution to automobile production. For the collective memory, the car is the symbol of the wealth of the rich north. And now, this symbol of wealth was reduced to metal scrap by the classical migrant workers' grandchildren.

In "*Copying Camouflage. In/visibility of Illegalized Immigration in Julio Cesar Morales' Series* Undocumented Interventions", MICHAEL ANDREAS explores mimetic and disruptive camouflage creating visual confusion. He states that at the border only detected, that is to say failed acts of illegal immigration become visible. He focuses on migrant acts of illegal border crossings on the US/Mexican border as forms of camouflage, and discusses the visualization of the invisible by both border agencies and in the work of the artist Julio Cesar Morales. Here again, the car becomes iconic.

SYLVIA KAFEHSY writes about "*Images of Victims in Trafficking in Women: The Euro 08 Campaign Against Trafficking in Women in Switzerland*". By taking as an example a video spot that was shown in Swiss stadiums during the 2008 European soccer championship with the aim of raising awareness about the trafficking of women in Switzerland, she points out the "paradox of victimization" as well as the power and the ambiguities inherent in such strategies of visualization. The essay concludes with an example of visual strategies in works of art that could be an inspiration for visual strategies that don't avoid complex contexts, but create nexuses where it is possible to interlace political and social contexts, or that show that victim narratives are indeed fictions and consequently can be experienced as such.

In her paper on "*Invasion, Infection, Invisibility: An Iconology of Illegalized Immigration*", FRANCESCA FALK contrasts in a paradigmatic way two photos of boat people: Either immigration is depicted as an invasion, or an individual refugee is portrayed as a victim, following the tradition of the Christian Iconography. Yet both discussed pictures share a common feature: the fear of infection. On the other hand, illegalized immigration inside Europe is often hidden from the public eye. The deportation camps are generally located at the geographical and social margins, and pictures of them hardly ever circulate in the Swiss media. Media consumers thus seldom come across the nationally approved compulsory measures for

which they are clearly politically accountable. To counteract such invisibilities, in some cities monuments are raised in order to make illegalized immigrants and the violence produced by their deportation visible. Furthermore, the European illegalization of immigration very often hurts people coming from former colonial regions. But also these historical connections linking the past with the present are very often invisible in today's discussion about immigration. Instead, in many anti-migration campaigns immigration is frequently depicted as a colonial invasion.

PAMELA SCORZIN in *"Voice-Over Image"* refers to a paradoxical use of images of illegalized immigration in the sense that people crossing borders illegally are shown in two ways: They are given high visibility as stereotyped clichés but simultaneously obscured into invisibility as humans and individuals. Showing images of boat people in various contexts, she argues that combining these representations in a multidimensional portrait might contribute to new perspectives that essentially are propelled by sound. Thus, the discussion of this paper revolves around the question if it is possible to "break" the power of images by considering their sonic context.

In their paper *"Masking, Blurring, Replacing: Can the Undocumented Migrant Have a Face in Film?"* OLAF BERG and HELEN SCHWENKEN explore methods by which undocumented migrants—who for obvious reasons do not want to be recognized—can be made to not only speak, but also to be visually present in films that are trying to create audio-visual representations of their protagonists. How can you *not* show their faces without criminalizing them? By exploring strategies of visual representation of undocumented migrants in documentary films—the use of masks or of special make-up, the substitution of images for their (illegalized) working activities, the visualization of these people's invisibility—Berg and Schwenken are able to illustrate the difficulties of creating images that are able to ensure the viewers' sympathies for undocumented migrants and at the same time respect the latters' need to stay anonymous. Visual techniques allowing for this kind of presence of undocumented migrants and their conditions thus contribute to the legitimate presence of migrant subjectivities that are usually portrayed as deviant and criminal. On the other hand, protecting the migrant's identity can easily produce a de-humanizing discriminatory effect on the migrant that strengthens the hostile perception of and policies against undocumented migrants. From this point of view, the aesthetic question *how* a film does or does not show the faces of undocumented migrants is a highly political issue.

EVA KUHN presents and discusses *"Border: The Videographic Traces by Laura Waddington as a Cinematographic Memorial"*. The setting is in northern France, in the area between the mouth of the Euro Tunnel and one of the infamous refugee camps whose inmates are constantly trying to cross the fencing construction at night. Waddington's video is an artistic approach to the "realities" of illegalized immigrants. Without showing faces she creates abstract images that present fragments of single actions

in a blurred videographic trace. The artist treats Sangatte both as the site of muffled fear and delectable hope as well as the site of bitter memory. But she thereby remains permanently the Other, an outsider, and she reflects herself as such in her images: *Border* deals with this experience of distance in a specific way.

LAMBERT DOUSSON writes about the work of *Bruno Serralongue at the Cité Nationale de l'Histoire de l'Immigration*, where—under the title of *"Manifestations du Collectif de sans-papiers de la Maison des Ensembles 2001- 2003"*—a series of 45 photos was presented. These photos show sans-papiers who demonstrate for papers and for the closing of the *Administrative Retention Centres*. Their photos could constitute, within a public state institution, a criticism of the present French illegal immigration policies. However, their specific *mise en scène* in the former Museum of Colonies has the effect of neutralizing their critical content. Indeed, the photos are transformed into illustrations, or even into decoration. Dousson thus contrasts the artistic work of the photographer against the mechanism of the exhibition that has tended to cancel out both the photos' political meaning and their emotional force by its exhibitive setting. He discusses why this exhibition de-politicizes the photos and whether, in a wider sense, historical documents are in danger of losing their critical message through circulation as works of art.

By developing critical investigations into the spatial practices within current societies, MARC SCHOONDERBEEK sees in *"The Image versus the Map: the Ceuta Border"* the architect as a visionary, engaged in the activity of producing an image of a possible future. Mapping unfolds, as he argues, its potential on the basis of its openness, its invitation to interpretation. With colleagues, he created a map of the border conditions in Ceuta that suggests an understanding of borders not as fixed lines or zones in the traditional sense but rather as zones of a sequence of divisions that are fluid both in space and time.

Finally, ALMUT REMBGES relates in *"Who is a Refugee—Strategies of Visibilization in the Neighbourhood of a Refugee Reception Camp and a Detention Centre"* her experiences in two projects she initiated. In an area outside the city of Basel, in-between the Swiss-German border and a camp of asylum seekers, the artists' collective *"Practical Theory & Company"* has established a picture service for the inmates. The asylum seekers are kept waiting for months, in arduous circumstances and under permanent examination, either for acceptance as a refugee or expulsion. *"Picture Service"* lends these refugees a camera for one day and the possibility to mail the photos home or to keep them as a memory. The pictures resulting from this project do not show "victims", but active individuals with hopes and plans, and therefore provide a vivid contrast to the photos of asylum seekers usually presented in the mainstream media. The second project *"AuQuarellclub sans frontiers"* is a kind of enduring flashmob which gathers every second week on the pavement in front of the detention centre. The participants sit down and paint pictures of the building. Sometimes

the security calls the police. Then, the police ask questions about art and escape plans, checking bags and names. "No, it's not prohibited to sit here and paint", they say, "but we have to make sure that everything is okay."

In our publication, scholars of literature and visual studies, art historians, artists, architects, historians, sociologists, cultural anthropologists, political scientists and philosophers outline their particular field of research on "*Images of Illegalized Immigration*". But the boundary between who is illegal and legal can shift: people whose residence status is not "illegal" can become illegalized on account of certain (none-)behaviour and (none-)action. Furthermore, the illegalization of immigration and the illegalization of emigration are in a complex and historically changing way related to each other. In this publication we focus on the former.

A considerable amount of literature has been published on the topic of illegalized immigration. However, the question how images "generate" such conceptions of illegalization as a social production and a practice, has, to our knowledge, not been systematically approached until now. One central question is, then, how a notion like "illegal immigration" can come to be taken for granted: Illegalization is produced by law, but naturalized through the everyday use of images. The production of law, on the other hand, is also driven by both mental and materialized images. A critical iconology may help us to see such mechanisms.

With this publication, we hope to open up space for new perceptions and perspectives on illegalized immigration. The reader, however, has to keep in mind the circumstance that the participants of this Call-for-Paper-Conference and therefore also the contributors to the publication all have an American or European background. Belonging to the "global North", they can move freely and legally around most of the world, whereas others can be detained at every stage of their travel. If there is something like the "freedom of movement", it seems to be a human right for some, but not for others.[1]

1 | This publication is based on the proceedings of a two-day conference in summer 2009. We would like to thank Matthias Müller for his proofreading and the Basel University, the Swiss Science Foundation and the Freiwillige Akademische Gesellschaft for making the conference and publication possible.

Migration, Law, and the Image: Beyond the Veil of Ignorance

W. J. T. MITCHELL

Our topic, "Images of Illegalized Immigration", demands a convergence of three fields—1) law, with its entire edifice of judicial practice and political philosophy; 2) migration, as the movement and settlement of living things, especially humans, across the boundaries between distinct habitats; 3) iconology, the theory of images across the media, including verbal and visual images, metaphors and figures of speech as well as visual representations. Law and migration engage the realm of images as the location of both the sensuous and the fantasmatic: concrete, realistic representation of actuality, on the one hand, and idealized, or demonized fantasies of migrants as heroic pioneers or invading hordes, on the other.

One peculiarity must immediately strike an image theorist in contemplating this array of problems. Images are "imitations of life", and they turn out to be, in a number of important senses, very much like living things themselves.[1] It makes sense, therefore, to speak of a "migration of images" of images themselves as moving from one environment to another, sometimes taking root, sometimes infecting an entire population, sometimes moving onward like rootless nomads.[2] The animated, life-like character of images has been recognized since ancient times, and that is why the first law concerning images is a prohibition on their creation, accompanied by a mandate to destroy them. If the relation of the law to migration is mainly negative, a mandate to block the movement of living things, the relation of the law to images is exactly analogous. The prohibition on images is grounded in an attempt to sequester a political and religious community from contamination by images, and to extirpate those alien forms of imagery commonly known as idols. The image is thus always involved with the other—with alien tribes, foreigners, invaders, or conversely, with

1 | See Mitchell 2005 for an extended discussion of this point.
2 | See Mitchell 2004.

native inhabitants who must be expelled. Since other people, both kinfolk and strangers, can only be apprehended by way of images—stereotypes of gender, race, ethnicity, etc.—the problem of migration is structurally and necessarily bound up with that of images. Migration is not a mere content to be represented in images, but is a constitutive feature of their life, central to the ontology of images as such.

But there is an important limit to this analogy that we should note at the outset. The prohibition on images, especially the dangerous images of other, is rarely successful. In contrast to real human bodies, images cross borders and flash around the planet at lightning speed in our time, and they were always "quick", in every sense of the word. Unlike real living bodies, images are very difficult, if not impossible to kill, and the effort to stamp them out often has the effect of making them even more virulent. The idea of a "plague of images" has become a commonplace since Baudrillard, and the difficulty of containing or censoring the migration of images is a well-established fact. The laws that govern the migration of real bodies and borders are without question much better enforced than those against images. Images "go before" the immigrant in the sense that, before the immigrant arrives, his or her image comes first, in the form of stereotypes, search templates, tables of classification, and patterns of recognition. At the moment of first encounter, the immigrant arrives as an image-text, whose documents go before him or her at the moment of crossing the border. This simple gesture of presentation is repeated millions of times every day throughout the world and might be regarded as the "primal scene" of law and immigration in the face to face encounter.

Insofar as our topic is "illegalized" immigration, it engages the whole domain of law, and the underlying foundations of political philosophy, a highly abstract and general field. In Western jurisprudence, the law is grounded in political philosophies, principally in liberalism, that insist on some form of primacy for the law in its most abstract sense, as applying to equally abstract subjects or persons. The "legal subject" has to be an abstraction, or the law is not the law, at least in liberalism. Notions of the equality of subjects before the law, the moral equality of persons quite apart from accidents of birth, race, or culture; the individual as a subject of rights and responsibilities, sovereign in its value—all these features of the liberal notions of law and politics remain very difficult to imagine or represent concretely. That is part of the point of liberalism: as a political and legal philosophy, it is deliberately abstract and schematic, employing an ascesis of images, most visibly represented in the image of "Blind Justice" with her scales.[3] One might even see it as an instance of the aniconism and iconophobia of Judeo-Christian and Muslim religious law and its grounding in an invisible, hidden personification of divine justice.

3 | Martin Jay's question, "Must Justice Be Blind? The Challenge of Images to the Law," archived at the Slovenian Institute of Philosophy, may be taken as exemplary here. See web page at http://fi.zrc-sazu.si/?q=en/node/334.

"The principles of justice," as philosopher John Rawls put it, "are chosen behind a veil of ignorance" that eliminates all concrete contingencies and particularities—in other words, all sensuous images.[4]

Of course there are other notions of the law that are more concretely embodied and visible: the body and buildings associated with sovereignty; notions of cultural custom and communal authority that may clash markedly with liberal notions of individual freedom and equality. When the realm of images and the imaginary collides with the law, in other words, the abstract tends to become concrete, and liberalism's picture of a rational, legal, politically just framework for immigration begins to expose its contradictions. As Phillip Cole notes in his book, *Philosophies of Exclusion: Liberal Political Theory and Immigration*, "liberal political philosophy [...] comes to an end at the national border"[5]. Rawls' "veil of ignorance" is rent by a revelation of flesh and blood human beings who are *not* members of a political community, and are outside the contractual protection of a nation-state. The abstract legal subject takes on a human face, and the abstract notion of borders becomes a concrete site. Cole, in fact, opens his book with a meditation on the proper image for the cover of a book about liberal political theory and immigration, and immediately notes a reversal of expectation. He had been imagining "something dramatic signifying exclusion—a painting of city walls with massive gates closed against besieging hordes, or a black and white photograph of barbed-wire fences and people with guns keeping out bedraggled travelers. I was searching for something spectacular or stark, which would signify one or other of the poles around which discussions of immigration gather—that liberal democratic states are justified in erecting firm barriers against teeming masses that would drain them dry, or that they are jealously guarding their privileges against the weak and helpless"[6]. But the image that Cole finally adopted was quite at odds with this imaginary scene, turning out to be a quite banal photograph of a man painting a white line down the middle of a street.

4 | Rawls 1971. It is important to note that, from another standpoint, the veil of ignorance is an *invitation* to imagination, because it encourages the speculative possibility that when the veil is lifted, one might be poor, powerless, ill, enslaved, or otherwise abject. Rawls's veil is a device for preventing abstract notions of justice from being grounded in a comfortable, bourgeois position of autonomy and freedom. I am grateful to Rob Kaufmann, Professor of English at University of California, Berkeley, for extensive correspondence on this point.
5 | Cole 2000.
6 | Ibid, p. ix.

Figure 1: "Border." Reproduction of the Hulton Getty Picture Collection

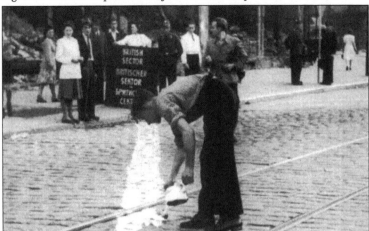

This 1947 photograph of a British official marking the boundary between the Soviet and British sectors of Berlin reveals to my eye two quite contradictory readings: on the one hand, it signifies (as Cole notes) the arbitrary, even imaginary and ephemeral character of a border, like a child's drawing a line in the sand to claim a momentary territory; on the other hand, as we now know, it was a premonition of a global dividing line that was central to the Cold War for half a century. It became the frontier of clashing political philosophies, and the site of numerous "legalized" murders and tragic separations that still linger, and not only in the consciousness of the German people, but across the world. The banality of this image of "illegalized" migration was matched by its fatefulness for the world order from 1945 to 1989.

Immigration at the level of the image, then, has to be seen as perhaps the most radically *dialectical* image available to us in the present moment. I'm using dialectical here in Walter Benjamin's sense of the image that captures "history at a standstill"; but I'm also interested in the vernacular sense of the dialectical image as a site of visible, audible, palpable contradiction, where the real and the imaginary suddenly crystallize in a symbolic form, epitomized by the merely imaginal character of the white line and its fateful realization. Migration as a topic engages all the inherent dialectics of the image, and exacerbates them. Figure and ground (the migrant's body and the physical border); immigration as an affair of bodies and spaces; of living things and environments; the push and pull of movement and stasis, exile and return, expulsion and invasion. We might schematize the dialectics of migration with the following diagram:

```
┌─────────────────────────────────────────────────────────┐
│                      MIGRATION                          │
│                                                         │
│         EMIGRATION              IMMIGRATION             │
│                                                         │
│         Exit                    Entrance                │
│         Departure               Return                  │
│         Exile, Nomad            Settler, Colonist       │
│         Expulsion               Invasion                │
│         Refugee                 Detainee                │
│                     Borders                             │
│                     Frontiers                           │
│                     Checkpoints                         │
│                     Internment camps                    │
│                     Ghettoes                            │
└─────────────────────────────────────────────────────────┘
```

In calling this a "dialectical" diagram I want to insist that its elements do not have the status of binary oppositions that remain in fixed positions. They are, rather, dynamic opposites that are manifested in times and places, events, narratives and dramatic scenes, and above all, in points of view. Every emigration is at least in principle an immigration somewhere (and to someone) else. Every departure implies an arrival, and perhaps a return. Every exile longs for a home, and even the most radically rootless nomad requires an oasis as a temporary home. Invasions are almost invariably accompanied by expulsions such as ethnic cleansing and the production of masses of refugees. And at every turn, the law is invoked to justify expulsion or confinement, exile or colonization. Every legalization is at the same time an illegalization, as the law of Manifest Destiny showed when it justified driving Native Americans from their ancestral homelands to make room for European settlers.

The dialectical image of "history at a standstill" is most often revealed when the image captures a figure or space of arrested motion, or (what may come to the same thing) of endless repetition. The most salient fact about migration in our time is the way it has become, not a transitional passage from one place to another, but a permanent condition in which people may live out their lives in a limbo of illegalized immigration, perpetual confinement in a refugee camp, or a perpetual motion and rootlessness, driven from place to place.[7] We might call this, inverting Heidegger, immigration as *dasein*. This paradoxical condition is nicely captured in the Dustbowl ballad, "How Can You Keep on Moving", collected and performed by Ry Cooder: "How can you keep on moving, unless you migrate too? / They tell you to keep on moving, but migrate you must not do. /

7 | One of the enduring scandals of the U.S. immigrant detention system is the number of detainees who die in custody, often without being counted, and without any account of the manner of their deaths. See Bernstein 2009.

The only reason for moving, and the reason why I roam / Is to move to a new location, and find myself a home." The balladeer wants to insist on the logical connection between moving and migrating, only to be told by the law that they are opposites: moving is mandated and migrating is forbidden. And this law was being applied, it should be noted, not to aliens arriving from another country, but to citizens of the U.S., refugees from the Dustbowl in Oklahoma during the Great Depression. America is not only a "nation of immigrants", as is often said, with the Statue of Liberty welcoming "your poor, your tired, your huddled masses" of immigrants from abroad, but a nation of *internal* migration in which whole populations surge across the borders between states and regions, sometimes voluntarily, as in the case of the 19th century pioneers heading westward, or involuntarily, as in the removal and ethnic cleansing of the Cherokee nation on the notorious "Trail of Tears". The Great Migration that brought African Americans from the rural south to the industrial north was, at the level of the imaginary, a utopian reversal of the obscene parody of immigration that had been forced upon them with their forced migration as slaves. The law showed its teeth at both ends of the African American migration, legalizing slavery as a Biblically sanctioned institution, supported further by the laws of property in the notorious Dred Scott decision of the U.S. Supreme Court, and enforced spatially in the long border between the slave-owning states of the South, and the free states of the North. The Dred Scott decision (1857) had the effect of rendering African Americans *and their descendants* "resident aliens", ineligible for the rights of U.S. citizenship: "persons of African descent cannot be, nor were ever intended to be, citizens under the U.S. Constitution. Plaintiff is without standing to file a suit."[8]

Migration in search of freedom, or as a compulsion to slavery might be taken, then, as the absolute dialectical poles of the law of human movement. God tells Abraham: "Get thee out of thy country, and from thy kindred, and from thy father's house, unto a land that I will shew thee: And I will make of thee a great nation." He later tells Moses to lead the Israelites out of captivity into their promised land. What is not generally noted is that these mandated, "legalized" immigrations are accompanied by conquest, colonization, and expulsion of the native inhabitants, as well as (not incidentally) their images and idols. "When you cross the Jordan into Canaan, drive out all the inhabitants of the land before you. Destroy all their carved images and their cast idols, and demolish all their high places. Take possession of the land and settle in it, for I have given you the land to

8 | Cp. The notorious Article 1 Section 9 of the U.S. Constitution: "The migration or importation of such persons as any of the states now existing shall think proper to admit, shall not be prohibited by the Congress prior to the year one thousand eight hundred and eight, but a tax or duty may be imposed on such importation, not exceeding ten dollars for each person." Congress prohibited the international slave trade in 1808, but treated it as taxable immigration prior to that.

possess." (*Numbers* 33:52-53) If our goal is to make visible and to ponder "images of illegalized immigration", we need to focus, not only on images of the immigrant body—faces, genders, skin color, clothing, the data gathered on identification documents—but also on images such as "the Jordan" to be crossed over and the "promised lands" to be conquered. Images of immigration crucially involve the places, spaces, and landscapes of immigration, the borders, frontiers, crossings, bridges, de-militarized zones, and occupied territories that constitute the material and visible manifestations of immigration law in both its static and dynamic forms.[9] Above all, we should consider the emergence of the detention camp as a new form of legal limbo where persons may be detained indefinitely, in a situation that is de jure "temporary" but de facto "permanent." Illegalization of immigrants, and the spaces set aside for them, may be regarded as a more moderate version of the most militant form of illegalization in our time, the concept of the "unlawful combatant." What the illegalized immigrant and unlawful combatant share is a peculiar, paradoxical status in relation to the law—at one and the same time they are subject to the law and excluded from it. Illegalization places them outside legal resources such as due process, habeas corpus, and elementary human rights, at the same time that it does so *in the name of the law* or "under the color of legality." The reliance of the Bush administration's extra-legal detention camps (Guantanamo the principal example) on elaborate legalistic justifications perfectly exemplifies the paradoxical lawful/lawless character of these institutions, and their peculiar status as both temporary and permanent, visible and invisible.

As a mnemonic device, we might exemplify these two manifestations of the law in the phenomena of the immoveable wall, on the one hand, and the flying checkpoint, on the other. These two forms of interdictory legal space have been made famous, of course, by their emergence as fundamental structures of everyday life in the occupied territories of Palestine, but they instantiate a much more general dialectic that governs social space globally, from Tibet to the U.S.-Mexican border, to the boundaries of Russia and Georgia, to the barrier that once divided Catholic and Protestant Belfast along the Falls Road. At one pole of this dialectic is the relatively permanent structure that may divide peoples and prevent *any* movement, much less immigration or emigration—for generations. At the other is the flying checkpoint, a regular feature of military occupations, in which a population is subjected to unpredictable and arbitrary blockages of movements. A routine practice in failed states with insurgencies is the phenomenon of the paramilitary group establishing an ad

9 | See Derrida 2000, p. 51: "The frontier turns out to be caught in a juridico-political turbulence, in the process of destructuration-restructuration, challenging existing law and established norms." All this as a result of the "mutation" (as deconstruction) brought on by new technologies of communication and "social media" such as e-mail.

hoc checkpoint to extract tribute, intimidate populations, and exterminate enemies defined along racial, religious, or tribal lines. In countries like this, everyone is a potential immigrant whenever they try to move anywhere, even within their own homeland. The immigrant is close cousin to the refugee.

And the opposite of the refugee is, of course, the visitor, the guest who comes perhaps with the objective of settling among us, or conquering us. It may be helpful then to come at the question of immigration from the perspective of the *absolute immigrant*, the arrival of an alien from outer space. Especially useful here are the kinds of science fiction stories that postulate the viewpoint of the aliens rather than the earthlings, as is the case in the wonderful novels of Octavia Butler. Butler (an African American novelist who died in 2006) developed an entire series of novels (the *Xenogenesis* series, also known as *Lilith's Brood*) based on the premise of genetic aliens known the *ooloi*, who travel the universe in search of interesting life forms with which they can mate.[10] The objective of this travel and cross-pollination is the enhancement of the diversity of life, the acceleration of evolutionary processes of hybridization and mutation. Needless to say, Butler's aliens have to encounter terrestrial human beings in order to get the story moving, and these encounters are invariably filled with ambivalence—fascination, horror, disgust—and thus almost inevitably lead to violence, but (much more interestingly) to sexual encounters and even marriage and reproduction of hybrid offspring. The *ooloi* in particular are erect bipeds whose bodies are completely enveloped in a "skin" consisting of thousands of tentacles (imagine a full-body Medusa) that are constantly in motion, expressing the mood of the alien, each containing a tiny stinger that is capable of injecting death-dealing and painful poison or intensely pleasurable and ecstatic elixirs of sexual enjoyment into the body of anyone whom they embrace. One never gets over an *ooloi* hug.

From the standpoint of Butler's aliens, then, the universe is a vast field of life-forms in constant motion, awaiting visitation by other life-forms. Even fixed, static forms such as vegetative life are involved in micro-movements and growth, and they often spring into more dramatic forms of migration aided by animals (such as bees carrying pollen) or simply by the wind carrying their seeds abroad. The *ooloi* regard all life forms, from the simplest microorganism to the virus, the fungus, the cactus, all the way up the ladder of creation to higher mammals and intelligent beings capable of complex symbolic behavior, as potential partners in the evolutionary saga.

10 | More precisely, the *ooloi* are the "third gender" of a race of extraterrestrials known as the Oankali. It is the ooloi who conduct genetic experimentation.

A salient contrast with Butler's utopia of limitless migration is the recently released science fiction film, *District 9*.[11] Set in Johannesburg, South Africa, against the backdrop of the history of apartheid with its Bantustans and racial pass laws, this film concerns the arrival of an advanced species of bipedal crustaceans who have made a forced landing on earth and whose only wish is to return to their homeland. The damage to their ship, however, requires an extended stay, and they quickly achieve the status of undesirable and illegalized aliens, referred to contemptuously as "prawns". They are compelled to live in the shanty-town of District 9, a place that is ruled by paramilitary gangs and government operatives with a license to kill, and that strongly resembles the contemporary shantytown of Kai alecha ("beautiful place") outside Capetown, and numerous other *favelas* and slums from Brazil to India. The film centers on a hapless, well-intentioned mid-level bureaucrat who is saddled with the impossible task of removing the aliens to another detention camp, going from one shanty to the next with a clipboard and legal documents that the aliens are required to sign in order to certify the legalization of their removal, and the illegalization of their continued stay in District 9. But the law quickly breaks down and violence breaks out. The bureaucrat becomes infected with the bodily fluids of the aliens, and his body begins a gradual metamorphosis into the form of the aliens, a transformation reminiscent of Kafka's Gregor Samsa, and the mutation of the human body rendered immortal in *The Fly*. Rumors spread that the bureaucrat has been having sex with the aliens, and he becomes the object of a ferocious manhunt with the secondary objective of using him as an experimental animal to analyze the biological character of the aliens.

It is hard to imagine a more vivid dramatization of the collision of liberal notions of legality with the visceral reality of migration. *District 9* is destined, I suspect, to become for this decade what *The Matrix* was for the 1990s, an allegory of collective global anxieties about a rising flood of migrations spurred by the economic displacements of globalization and the literal disappearance of human habitats caused by global warming. It also makes explicit the contradiction built into liberal notions of immigration law, namely that the law is inherently lawless, ad hoc, and permeated by ideological prejudices that make it exactly the opposite of an instrument of justice. It is well known that American immigration law, from the "Chinese Exclusion Act" of 1882 right down to the present day is a travesty of justice that is merely a systematic, institutional form of racism. What *District 9* helps us to see is that, in practice, these forms of racism devolve quickly into a complete denial of the humanity of the alien, the treatment of immigrants as cattle to be herded from one pen to another. Immigrants in the state of Texas, for instance, are confined in remote camps where it is difficult for lawyers to communicate with them. They have fewer rights

11 | Directed by Neil Blonkamp who also wrote the screenplay. Ranked #2 on movie meter out of 10,000 slots in the final week of August 2009.

than criminals, and are generally despised by the judges who decide their fate.[12] Add to this the whole range of sexual anxieties focused on aliens, that they are reproducing too rapidly, and that they are mating with the "native" population and polluting their racial purity, and one sees all the ingredients for a form of liberal jurisprudence that throws a veil of ignorance over de facto fascism.

What happens when the space of illegalized migration is not merely a camp, a detention center, or a shanty-town, but an entire country? The answer is to be found in a country that I am going to refer to by a hyphenated name, Israel-Palestine, a place that concentrates all the contradictory images we have been contemplating into a small region that, by all accounts, is at the center of the most important global political conflict in our time, (as Berlin was throughout the Cold War), the struggle between the West and the Middle East, European Judeo-Christian civilization, and the Arab and Islamic world.[13] Space forbids a detailed consideration of this complex and deeply fraught region, so a few snapshots will have to suffice. Israel "proper" (which is in itself a deeply contested phrase) contains a sizeable minority of Palestinians who are denied many of the rights of Jewish citizens. In fact, as Saree Makdisi points out, "Israel lacks a written constitution that guarantees the right to equality and prohibits discrimination among citizens"[14] at the same time that it trumpets its status as "the only liberal democracy in the Middle East". Insofar as it is a "Jewish state", a polity defined by religion and ethnicity rather than by a secular or race-neutral concept of citizenship, it "is not the state of its citizens, but rather [...] the state of a people"[15], many of whom do not actually live in Israel, but are invited, even encouraged to immigrate there. The legalized, even mandated migration of Jews to the homeland is enforced by a "law of return" that is exclusively for Jews, no matter where they come from. Palestinians who were forced into exile since 1948, who have titles to land and property inside Israel, have no right of return, and no legal means of seeking compensation for their losses. The Palestinian diaspora lives, by definition, in a state of permanent illegalized immigration with respect to its homeland.

The Palestinians who live in Israel proper, then, at least enjoy some of the minimal rights of citizenship while being denied the rights of nationality (though Avigdor Lieberman, the current Defence Minister, would like to compel all non-Jewish citizens of Israel to sign a loyalty oath or be subject to expulsion). Palestinians in the occupied territories of the West

12 | I am grateful to Anne Pinchak, ex-immigration lawyer, for sharing her practical experience on these matters with me.

13 | For a familiar argument that immigration from the Middle East to Europe is threatening a "Moorish return" that will destroy Western civilization, see Caldwell 2009.

14 | Makdisi 2008, p. 146.

15 | Ibid, p. 144.

Bank and Gaza, by contrast, enjoy none of those rights, and are subject to military rather than civil law. It is virtually impossible to describe the complexity of the occupation from a legal standpoint: the multitude of permits, licenses, passes, and identity papers required of Palestinians surpasses the ingenuity of the South African apartheid regime, to which it is often compared. Gaza has been described as the world's largest open-air detention camp, a densely populated strip of land whose inhabitants are mainly refugees living in appalling conditions, a state of permanent humanitarian crisis, most of them prevented from leaving, or threatened with no possibility of return should they manage to escape. This tiny territory is regularly subjected to ferocious military assaults that make only token attempts to discriminate between civilians and non-combatants. In the recent (2009) Israeli invasion of Gaza, about a third of the casualties were civilians. Gaza is thus the epitome of the most extreme contemporary condition of the refugee internment camp, at the same time that it is treated by Israel as if it were a sovereign nation ruled by a rogue terrorist regime with whom no negotiation is possible. The news blackout and general censorship of all images coming out of Gaza constitute a Rawlsian "veil of ignorance" that allows Israel to maintain its own fictional status as a liberal democracy.

But it is in the West Bank that this veil is most dramatically torn away. The notorious "security wall" (known as the "apartheid wall" by Palestinians) is the most visible manifestation, a 30 foot high wall of concrete slabs that snakes its way through the West Bank, often plunging deep into the occupied territories to protect the illegal Israeli settlements, or to surround Palestinian villages such as Qalqilya and cut them off from the agricultural lands on which their economic life depends. I have discussed elsewhere some of the Israeli attempts to mend the veil by painting over the security wall with murals that make it seem to disappear in favor of depopulated Arabian pastoral landscapes, but these efforts seem only to make the veil more egregiously visible, exposing the fantastic contradiction between the imaginary peace the Israelis talk about, and the actual state of permanent war in which they have chosen to live.[16]

16 | For further discussion, see Mitchell 2006.

Figure 2: Miki Kratsman, *Photo of Security Wall at Abu Dis*

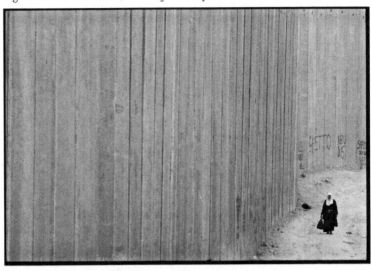

Figure 3: Miki Kratsman, *Wall at Gilo*

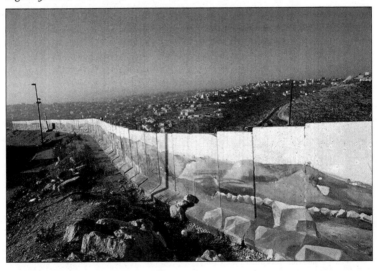

Two recent documentary films, one Israeli, the other Palestinian, expose the nature of illegalized immigration when it is concentrated into a relatively tiny space and imposed on an indigeneous population. The Israeli film is entitled *Checkpoint*, by Yaav Shamir (2003), a "fly on the wall" documentary surveying some of the more than 500 fixed and flying checkpoints that are sprinkled profusely over the West Bank. The film opens with a scene at a flying checkpoint that introduces the viewer to the petty details of daily life under military occupation. It is set in a scene of what might be called "uglified" landscape: a pond in the foreground that is obviously not natural, a "borrow-pit" created by moving earth to create a roadway, leaving behind marshy, infertile marshland that is marked by human footprints. Perhaps the most obvious is the banality of the ensuing action, the sense that this is a boring ritual, one that is repeated so often that it is regarded as a routine performance by the Israelis and a numbing, daily humiliation to be endured with silent resentment by the Palestinians. It has all the signs of a border crossing, with the inspection of belongings and the emptying of suitcases, but it is important to note that this is *not* taking place at any border between Palestine and Israel, but is internal to the West Bank, on the road between Nablus (the second oldest city in Palestine) and Jericho (the oldest).

The second thing that may strike us is the attitude of the soldiers, a mixture of cynical detachment, arrogance, and insolence, as they smile and smirk self-consciously for the camera and strut their authority over older people. They issue contradictory commands, one soldier telling the Palestinians to line up by the side of the road, then ordering them to remove their suitcases from the van (which requires them to return to the van), and then the other impatiently ordering them to line up again by the roadside. The Palestinians register their sense of being caught in a wedge between two arbitrary authorities by pointing out that "he told us to get our bags", and the driver trying to claim an exception for himself, both from the line-up and the removal of his belongings.

This is a scene of "illegalized immigration" in two senses of the phrase. On the one hand, it imposes upon the lawful, native inhabitants of a country a ritual that reduces them to the status of immigrants in their own land, immigrants that are greeted under a cloud of suspicion as potential criminals or terrorists. On the other hand, the soldiers themselves, as representatives of an unlawful military occupation, are performing a kind of arbitrary and capricious authority that amounts to the lawlessness of mere force, embodied in the automatic weapons that they carry so ostentatiously. The real illegal immigrants in this scene are the soldiers themselves, and the over quarter million settlers that Israel has illegally planted in the West Bank. Having traveled in the West Bank with Palestinians myself, subjected to periodic stops at flying checkpoints, I can testify that this scene is absolutely typical and true to my own experience. On one stop the teen-aged soldier who inspected my passport expressed surprise to find an American citizen in the West Bank. "What are you doing here?" he asked. My answer was, "I was about to ask you the same question." Of course my

Palestinian comrades immediately put their fingers to their lips and urged me to shut up. Later they told me that if it had not been for my presence, they would probably all have been beaten up by the soldiers.

If the soldiers at the flying checkpoint were acting out all the tell-tale signs of a fascist mentality, this mindset is made verbally explicit at the main permanent checkpoint between Ramallah and Jerusalem. An otherwise nice young soldier who is clearly bored with his job has completely gone over to the dark side. He refers to the Palestinian town of Ramallah as a "zoo", and calls the Palestinians animals, himself as their "zookeeper". And he is defiant and proud to be telling the truth to the film-makers about an attitude he knows that he shares with many of his countrymen. We are human beings; they are not. Racism resolves into a bio-racial picture. Ethnocide, ethnic cleansing, and extermination are the next logical step. Israeli General Rafael Eitan put it in the clearest terms in 1983 when he predicted a time when "all the Arabs will be able to do […] is to scurry around like drugged cockroaches in a bottle"[17].

The horrific irony of these scenes cannot be lost on anyone who has (as I do) a deep sympathy for and connection with Israel and the Jewish people. These soldiers are only a couple of generations away from the victims of the Holocaust, and the whole fascist resolution of the "Jewish Question" in terms that are intelligible in terms of illegalized immigration. Jews were "illegalized" in Nazi Germany, treated as racial foreigners in the midst of the German "Volk", subject to dispossession, expropriation of their property, deportation, and of course, a Final Solution of industrialized genocide, in which they were treated as animals, or more precisely as vermin to be exterminated. All this was supported by a process of *legalization* justified by a state of emergency, what Nazi legal philosopher Karl Schmitt called a "state of exception". Small wonder that, right alongside the legalized immigration encouraged by the Law of Return there is a significant tendency toward *emigration* of middle class Israeli Jews who cannot bear watching their children transformed into fascists by the occupation. As one Israeli father put it in another documentary film about this issue, "I would be willing to send my children to risk their lives in defense of this country. But to see them becoming morally corrupted as agents of this occupation is more than I can bear."[18]

Israelis with a sense of history and justice understand quite clearly that the security wall and the occupation and the checkpoints and the settlements have little to do with security. They are, as Israeli scholar Ilan Pappe has shown, instruments of a long process of ethnic cleansing that began in 1948 and continues to the present day, always hidden under the veil of legality on the one hand, and the exceptional demands of security on the other.[19] Key to this process is a double system of legalized immigration for Jews, and

17 | See the obituary of the "earthy" General Eitan in *The Independent*, November 26, 2004, http://www.independent.co.uk/news/obituaries/rafael-eitan-534569.html.
18 | *For My Children*, dir. Michal Ariad (2006).
19 | Pappe 2006.

the reduction of Palestinians to the status of illegal immigrants. The aim is finally to encourage all the Palestinians to emigrate, not by direct violence, but by a war of legal attrition that makes ordinary life and civil society impossible. But Palestinians constitute about 50% of the population of Israel-Palestine (or "Greater Israel" as the Right likes to call it). A disproportionate share of this population is under 25 years old, unemployed, and living in a state of constant rage and emotional mobilization. The wonder is that there is not more violence. If Israeli fanatics manage to set off a bomb in the Dome of the Rock in Jerusalem, or Hamas and Hezbollah obtain rockets that can reach Tel Aviv, a fuse will be lit that could set off a chain reaction of weapons of mass destruction throughout the Middle East and beyond.

A recent Palestinian film that shows the other perspective on this situation is *Journey 110*, made in the spring of 2009 by Khaled Jarrar. It contrasts strikingly with the Israeli film *Checkpoint* in its strict economy of means (a single camera as opposed to many) and its restriction to one scene, an underpass filled with sewage that passes underneath one of the restricted highways, accessible only to Israelis, that connects Ramallah to Jerusalem. (Most Palestinians are forbidden from going to Jerusalem; the attempt to do so makes them illegal immigrants). Much of the film, therefore, is shot in darkness, with only the faint outlines of the tunnel and the silhouettes of Palestinians—men, women, and children—slogging through the stagnant, boulder-strewn water. Some make the passage with plastic bags tied around their shoes; others are attempting the dark passage barefoot. The scenes are generally back-lit by the distant "light at the end of the tunnel", which turns out to be obstructed by large boulders and the occasional appearance (off camera) of Israeli soldiers, who send the Palestinians fleeing toward the other end of the tunnel.

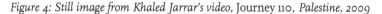
Figure 4: Still image from Khaled Jarrar's video, Journey 110, *Palestine, 2009*

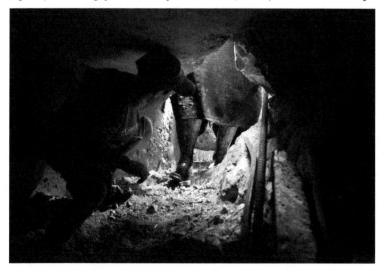

This deceptively simple film captures in 12 excruciatingly long minutes one of the most fundamental experiences of everyday life in Palestine. Like Tania Bruguera's checkpoint installation at *Documenta 11*, it subjects the viewer to the ordeal that it represents, turning the darkened space of the theater into an analogue of the underpass. Its insistence on remaining confined to this space enacts the sense that Palestinians live in a "no exit" situation, with no outsides to their underground existence. Movement and obstruction, migration and internment, have become for them a way of life rather than a temporary passage. In this regard, the film reminds us of the structuralist films of Michael Snow in the sixties with their obsessive exploration of single, confined spaces (especially corridors). But now the perceptual exploration has been given a specific human and political content. The details of the film—the plastic bags, the bare feet, the voices, including occasional laughter—puncture the darkness and make it clear why the Palestinian people are so difficult for the Israelis to control, why every barrier they erect will be surmounted or undermined.

We could descend endlessly into the vortex of images, law, and immigration that constitutes the political culture of Israel-Palestine. I want to conclude, however, by returning to a more general and global view of this issue, by way of a brief meditation on the work of Cuban artist Tania Bruguera, who has made the question of immigration a central topic of her work. At *Documenta 11* she installed a recreation of an immigration checkpoint that could have been anywhere in the world. The spectator passed through a gauntlet of loud noises, shouting, and dazzling search-lights that induced an intense affect of anxiety, panic, and disorientation that almost invariably accompanies, in some degree, every passage through a border security checkpoint. I have to say that I found the work deeply unpleasant, and resented it at the time as overly literal. But I have not forgotten it, and it is perhaps a useful work as a kind of shock treatment that provides some glimpse of the experience of illegalized immigration.

More interesting and successful is Bruguera's current long-term performance art project in Europe, which aims to create an "immigrant's party", a political organization based, not on ethnicity, national origin, or identity, but on the shared experience of immigration. Her work is centered in Paris, for centuries one of the centers of immigration from all corners of the globe, and the capital of both secular, enlightened liberalism, on the one hand, and the development of some of the most despicable racial theories in Western pseudo-science, on the other. The same culture produces Rousseau and the Comte de Gobineau, Jean-Paul Sartre and Jean-Marie Le Pen. Bruguera's staging of this project as an artistic performance is what has allowed it to attain funding from the French government; a non-artistic, directly political proposal of this sort would have had nowhere to go for support except the fragmented non-community of immigrants who are as suspicious of each other as they are of the government.

It is impossible to predict at this point what will become of Bruguera's project. As a work of conceptual performance art it may simply pass into the archives of contemporary art as an interesting idea whose time is, as Jacques Derrida liked to put it, "to come". Whatever the result, the process will centrally engage the question of the image, and especially the deconstruction of the racist and racializing images that are endemic to the representation of immigrants. The objective will be not merely to change the way people see immigrants, but to change the way they see themselves, enabling the production of new, self-generated images and words to articulate the common interests of immigrants, both legal and illegal. And to do so, not just in order to create new icons, but to generate new situations and performances, from the immediacy of the mass assembly to the staging of events for the mass media.

As the fastest-growing population on the planet earth, the Immigrant's Party will have to create its own slogans and identity as an emergent public sphere, building on the blank space or "place of negativity" that has been such a critical component of recent critiques of democracy.[20] It may even have to re-invent a new form of Rawls's "veil of ignorance" in order to suspend the divisive forces of identity politics, racial, ethnic, and religious schisms typified by that other veil, the one worn by women that has been so toxic within French political culture.

I'm aware that this will all sound impossibly utopian and imaginary, but that is surely another role that the image has to play in relation to illegalized immigration, namely to set out hypotheses, possibilities, and experimental scenarios for a world of open borders and universal human rights. The road of militarization and racist schemes of national security is a one-way street to global fascism and anarchy. And there is one contemporary phenomenon at the level of the image that offers some hope. As you may know, the most powerful man in the world, the current President of the United States, has been declared by the "birthers" movement, with the assent of the leadership of the Republican Party, to be an illegal immigrant. Obama's image has now gone through the entire cycle of demonization and idealization, merged with the visages of Jesus, Mao, Lenin, Bin Laden, and Hitler, he is now revealed at last as an undocumented alien. When an African American man, embodying all the characteristics of a multi-racial, multi-ethnic identity that both fulfills and defies racial categories becomes the leader of the so-called "Free World," is declared to be an illegal immigrant, perhaps an Immigrant's Party is not so very far behind. Obama's image, as distinct from his actual policies, has had the effect of rending the veil of liberalism, or (more precisely) of turning it into a

20 | I'm thinking particularly here of Ernest LaClau and Slavoj Žižek's debate over the role of negativity in contemporary democratic politics. Certainly immigrants in the U.S. occupy precisely the position of the negative in contemporary political polemics. Among the many lies that were circulated about Obama's health plan was the claim that it would provide insurance for illegal immigrants.

screen for the projection of the most extremely antithetical fantasies. We will continue to need the veil of ignorance in order to secure any notion of legality with respect to migration; we will need to rend that veil, and project new images on it in order to have any hope of justice.

LIST OF FIGURES

Figure 1: "Border." Reproduction of the Hulton Getty Picture Collection.
Figure 2: Miki Kratsman, Photo of Security Wall at Abu Dis.
Figure 3: Miki Kratsman, Wall at Gilo.
Figure 4: Still image from Khaled Jarrar's video, *Journey 110*, Palestine, 2009.

BIBLIOGRAPHY

Bernstein, Nina. 2009. "Officials Say Fatalities Of Detainees Were Missed." *New York Times*, August 18.
Caldwell, Christopher. 2009. *Reflections on the Revolution in Europe: Immigration, Islam, and the West*. New York: Doubleday.
Cole, Philip. 2000. Philosophies of Exclusion: Liberal Political Theory and Immigration. Edinburgh: Edinburgh University Press.
Derrida, Jacques. 2000. *Of Hospitality*. Stanford: Stanford UP.
Makdisi, Saree. 2008. *Palestine Inside Out: An Everyday Occupation*. New York: W. W. Norton.
Mitchell, W. J. T. 2004. "Migrating Images: Totemism, Fetishism, Idolatry." In *Migrating Images*, ed. Petra Stegmann and Peter C. Seel, p. 14-24. Berlin: Haus der Kulturen der Welt.
Mitchell, W. J. T. 2005. *What Do Pictures Want?* Chicago: University of Chicago Press.
Mitchell, W. J. T. 2006. "Christo's Gates and Gilo's Wall." *Critical Inquiry* 32 (Summer).
Pappe, Ilan. 2006. *The Ethnic Cleansing of Palestine*. Oxford: Oxford University Press.
Rawls, John. 1971. *A Theory of Justice*. Cambridge: Harvard University Press.

Milieus of Illegality

Representations of Guest Workers, Refugees, and Spaces of Migration in *Der Spiegel*, 1973-1980

JAN-HENRIK FRIEDRICHS

"The containment of the Other seems to become socially necessary when the frontiers of one's own community and the legitimacy to categorically deny other groups access to it become problematical."[1]

Torn between a need for migrant workers and the self-conceptualisation as a non-immigrant society, the relation between Germans and those who were considered foreigners was never an easy one. Often legal and economic requirements stood in contrast to images of the national Self and the alien Other. Nevertheless, these images reacted to migration policies and provided the necessary knowledge for further governmental practices.[2]

Two events were of major importance for the knowledge production on illegalised migration and will therefore form the chronological framework of this article: the recruitment ban for foreign workers of 1973 and the rising numbers of refugees in 1979/80. Articles from the weekly *Der Spiegel* surrounding these events and the accompanying photographs provide the empirical basis of this case study, as migration to Germany, including illegalised migration, was and is being perceived primarily through the media.[3] In this article I will trace the beginnings of a "regime of representation"[4] that constructed migration to West Germany in terms of illegality and delinquency.

1 | Eder/Rauer/Schmidtke 2004, p. 14.
2 | Cf. Foucault 1972; Foucault 1990; Foucault 1991.
3 | Cf. Heck 2008, p. 35. This case study is based on a sample of 27 articles, only a few of which are explicitly mentioned in the text.
4 | Hall 1997, p. 232.

I understand *images* in a double sense: as metaphors on a textual level; and as photographical pictures that served to illustrate the written text.[5] These images depicted migrants and migration primarily in terms of a threat and an object of regulating policies—especially when it came to illegalised forms of migration—and shaped the contemporary perception of immigration in several ways. Firstly, the primary metaphorical concepts to understand migration changed from one of an ongoing (cultural) war to that of a catastrophic flood of illegal immigrants. Secondly, the trope of "illegality" that successively covered all aspects of migrant life called for subjugation under strict state policies of potentially all migrants, regardless of their individual juridical status. Finally, the image of the "ghetto" allowed transforming migration from a social into a spatial issue; urban space became one of the crucial categories in trying to *contain* this illegalised Other and to keep up the notion of Germany as a non-immigration society. The discourse on migration can thus be understood in the context of an encompassing transformation towards a society of control and a revaluation of the concept of nationhood.

1973-75: THE END OF LABOUR MIGRATION— FROM "GUEST WORKERS" TO IMMIGRANTS

Following the Second World War and the economic miracle of the 1950s, the German labour market reached full employment in 1960.[6] To further fuel the economic growth, recruitment agreements were signed with several Mediterranean countries: from Italy (1955) to Turkey (1961) and Yugoslavia (1968). Due to these agreements the number of foreign workers rose steadily until it reached its peak in 1973 with almost 2.6 million migrant employees. Perceived as "guest workers" (*Gastarbeiter*) who would eventually return to their sending countries, reality proved these assumptions wrong. By 1973 it had become quite clear that there was a growing number of immigrants who were not part of the workforce, mainly due to family reunifications, "a clear indication of a trend toward long-term stay in the Federal Republic, or even permanent settlement, by a mounting number of foreign nationals"[7]. The number of immigrants rose to almost 4 million, making up for 6.4% of the population (compared to 1.2% in 1961). In the same year—due to the beginning economic crisis—a recruitment halt was initiated by the German government.[8]

In this situation *Der Spiegel* published a cover story on the Turkish community in the Federal Republic.[9]

5 | Lakoff/Johnson 1980; Hall 1997; Barthes 1981; Barthes 1999.
6 | The following according to Herbert 1990, p. 197-210.
7 | Ibid, p. 231.
8 | Cf. Rist 1978, p. 60-88.
9 | "Die Türken kommen" 1973.

Figure 1

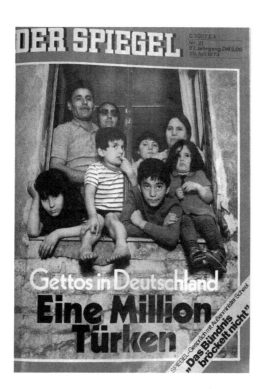

Two main topics were dealt with in the article: the vast number of Turkish migrants and their housing conditions. The article drew a threatening image of one million Turks already living in Germany and more of them only waiting for an opportunity to come. Adding to these "official" immigrants were "cohorts of illegal" migrants and the growing number of Turkish children. One of the captions summarized: "A Turk doesn't stay alone for long."[10]

By far the most common metaphorical concept was that of war. Turkish immigration appeared as an "invasion"; the families waiting in Turkey for a chance to reunite with their husbands and fathers were described as the "reserve" that, in combination with an "army of non-registered [workers]", threatened the integrity of the German state.

The connection between the metaphor of war and the concern for urban space was most explicit in the description of a bar as a "Turkish stronghold" (*Türkenfestung*) with bullet holes in the ceiling. In conjunction with the term "colony" for neighbourhoods with a high proportion of immigrants, migration to West Germany appeared not as a necessary means for economic growth but as an attempt to colonize the country.[11] The role

10 | Ibid, p. 26.
11 | Ibid, p. 24.

of Germany as a former colonial power was thus neglected and turned into the opposite.

Yet space and migration were also linked by biologistic metaphors. As the immigrants were "swarming in", their neighbourhoods developed a dynamic of their own, the "ghetto growth" (*Eigendynamik des Getto-Wuchses*). This organic notion linked easily with metaphors of diseases: "A fringe group town [*Randgruppenstadt*] that, *suffering* from racial conflict, crime, and decaying houses, seems to be condemned to the apathy of a *lingering illness*, is still rather a nightmare in this country. Yet first Harlem *symptoms* are already visible. At the sites of erosion of German cities 'a new subproletariat is *growing*, the *seeds* of new sources of *social epidemics* are *sprouting*.'"[12] Whether the term *ghetto* in connection with biologistic metaphors also implies a historical reference to national socialist conceptions is not clear. Frequent comparisons with the United States, however, especially with the New York neighbourhood of Harlem, rather seem to indicate a re-import of the term from a US-American context.

Still, the use of terms like "illness," "symptoms," and "epidemics" needs further attention. Martina Löw has shown how concepts of the human body have changed with the end of Fordism in the 1970s from one of a disciplined body, clearly defined and shaped by industrial labour, to that of an immune system.[13] It seems that these new conceptualizations of the body were corresponding to a new understanding of the urban, in which migrants played the role of a hostile virus. Urban spaces with a high proportion of foreigners thus appeared as centers of a disease that has to be understood in both a literal—as unhygienic living conditions—and a figurative sense—as a sickness of the German body politic.

Housing conditions of migrant workers had always been more or less disastrous. Those who tried to escape the dormitories provided by the employing companies often experienced racist discrimination on the housing market. They "were living in areas in which, according to contemporary dictums of city planning, there shouldn't be any apartments at all, in zones of extreme pollution, or in neighbourhoods needing redevelopment"; often excessive rents had to be accepted due to a lack of alternatives.[14] Migrants were thus used by landlords to maximize profits until a building could eventually be torn down. Still, the term "ghetto of foreigners" (*Ausländergetto*) is misleading. Spatial segregation was a common structure characteristic of German cities and the so-called "ghettos" were places of the urban poor which always included a vast majority of German citizens.[15] Even in the symbolically laden neighbourhood of Berlin Kreuzberg only every fifth person did not have German citizenship. Yet

12 | Ibid, p. 26, my emphases.
13 | Löw 2001, p. 128.
14 | Karakayali 2000.
15 | Von Saldern 1995, p. 366-369.

the portrayal as "migrant ghettos" rendered both their class character and their ethnic heterogeneity invisible.

THE ACCOMPANYING PICTURES

The majority of photos illustrating the article focused on urban spaces of Turkish life in Germany, thus supporting the image of ethnically defined segregated neighbourhoods. A couple of street settings were supplemented by scenes in cafés, shops, markets, and living rooms. Almost all of the captions identified these spaces as exclusively defined by ethnicity (e.g. *Türkenkneipe*), enforcing the notion of a colonizing invader and creating a "fundamental dichotomy of ethnic differentiation"[16].
A series of pictures from a 1975 article connected the topics of urban space, immigration, and illegality in a most powerful way.[17]

Figure 2

It depicted the milieu of "illegal" migrants in Germany and consisted of three images that were labelled as "place of residence Berlin-Kreuzberg", showing an apartment block; "meeting place train station", with groups of men in a station hall; and as "workplace fish factory", showing two workers with boxes of fish.[18]
Although these images seem to mark very specific places, they subsumed in fact every space of migrant life under the term of a milieu of illegality: the private, the public, and the work sphere. Whether a colleague

16 | Eder/Rauer/Schmidtke 2004, p. 20.
17 | "'Ich hier Bruder besuchen.'" 1975.
18 | Ibid, p. 42.

in the factory, a neighbour from next door, or just a passer-by—they could all be suspected of being "illegal". This was probably most explicit in the picture of the two factory workers: black bars cover their eyes, strengthening the impression that something felonious is happening. At the same time, readers were not being told what exactly it was that identified these places and people as "illegal", thus leaving it up to their imagination.

In contrast to earlier articles, even the production sphere was now included in a network of deviant spaces. Here, the changing understanding of "illegality" becomes apparent: unlike current conceptions of illegal immigrants as people who are crossing borders without permission, after 1973 being an illegal alien meant first and foremost to work without an official permit.

Apparently, the recruitment ban made it possible to perceive at least some of the "guest workers" as "illegal" aliens who would try to make it into the country to pursue goals of their own. One of the reasons for an overall sense of lack of control was the inability to stop migrants at the nation's borders. Whoever had a tourist visa could easily enter the country and stay until after the visa had expired. A cartoon in the same *Spiegel* issue emblematized this idea: a vast crowd of men, recognizable as Turkish workers by their stylized clothes and moustaches, is waiting at the German border. A mafia-style leader (in the context of its publication recognizable as a facilitator or *Schlepper*) claims in bad German that they are a tourist party.

The article put this facilitator into the context of an "Underground" (English original), or a "Pizzeria-Mafia".[19] This Mafia was not only an import from abroad; it appeared to be an international conglomerate of criminals and "illegal" workers: "The journalist Milan Ilinić [...] sees a dubious International of illegal migratory workers on the road—'quite clever, the nation is nothing to them'. Such economic migrants, who are looking for their fatherland wherever they're able to indulge themselves, discover it mostly in the Federal Republic, without much effort."[20]

Yet even without a valid visa was it possible to enter the country. The first picture that illustrated the 1975 article on "illegal" migration showed a family of migrants besides a van, close to the Berlin wall.[21] West German authorities never accepted the frontier to the German Democratic Republic as an official border and dispensed with carrying out passport controls. This enabled migration via the Schönefeld airport in East Berlin to the West. By marking a random migrant family near the border to the GDR as "illegal" though, every migrant was put under the suspicion of having entered the Federal Republic illegally.

19 | Ibid, p. 45; Ibid, p. 43.
20 | Ibid, p. 42.
21 | Ibid, p. 38.

1979-80: A NEW PATTERN OF IMMIGRATION— ASYLUM SEEKERS, CAMPS, AND DEPORTATION

The recruitment ban of 1973 did not show the expected results and the concept of migration as an easily controllable phenomenon became much more difficult to sustain. These difficulties would further increase with the rise of a new pattern of immigration: asylum seekers.[22] As a consequence of the experiences with National Socialism, the right to asylum due to political persecution had become part of the German constitution. The numbers of asylum seekers had always ranged from around 2,000 to 5,600 petitioners per year, most of them coming from the Warsaw Pact states. This changed drastically at the end of the 1970s. The figures rose to 107,818 petitions in 1980. The origin of those seeking refuge had also shifted to countries from the so called Third World, mainly Asia and the Middle East. More than 50% of the petitioners though, came from Turkey, fleeing political violence and the military coup d'état of the same year. In fact, the recruitment ban itself caused the numbers to rise: seeking asylum was one of the last possibilities to enter Germany in a legal way.

It doesn't come as a big surprise that the metaphorical concepts employed to talk about immigration underwent a significant change as well. Military vocabulary was almost never used. Instead, the metaphorical concept of the wave or flood had come to the fore. A "swelling inflow of asylum seekers" caused a rising "flood of petitions";[23] West Germany was "flooded by a wave of aliens", asylum seekers, or refugees respectively.[24] The rising number of asylum seekers was perceived as a chaotic "catastrophe" which stood in contrast to the colonizing "invasion" by Turkish guest workers in the 1970s. It seems that the military metaphor was closely linked to work migration, whereas it must have appeared inappropriate for the *Völkerwanderung*[25] of 1979/80. This is probably due to the well-regulated character that was associated with the ordered immigration of the 1960s and early 1970s. The necessary physical examinations of guest workers in their home countries might have evoked images of the draft of recruits to an army.[26] Another possible explanation might be the perception of guest workers as part of the "industrial reserve army" of the German industry which might have triggered the use of other military metaphors. None of these characteristics could be applied to the new "wave" of asylum seekers. The image of the wave then demanded a purely technical treatment of immigration; one that aimed to counteract this danger by building a dam against it.[27]

22 | The following according to Bade/Oltmer 2010; Bundesamt für politische Bildung 2010; Pieper 2008, p. 48; Bundesamt für Migration und Flüchtlinge 2010.
23 | "Auf Biegen oder Brechen" 1979, p. 37.
24 | "'Finished, aus'" 1980.
25 | "Auf Biegen oder Brechen" 1979, p. 37.
26 | Most explicit in "Saisonarbeiter" 1956.
27 | Heck 2008, p. 38.

Other discursive elements were taken up and altered slightly. Despite the perception of this new form of immigration as overall chaotic, facilitators and subcontractors were again singled out as playing a major role in the process. "Illegal placement officers", "organized circles of facilitators," and "black middlemen" appeared as the regulating "authorities" behind migration who had replaced the state as a determining agent.

What was new, was the portrayal of refugees as victims—not of the situation in their home countries but of the professional facilitators who "exploit [them] in a bestial and brutal way".[28] This distinction is important, as it allowed a representation of refugees as victims and impostors at the same time, lured into Germany by facilitators in search of a better life, but with no right to political asylum. This tendency to victimize and criminalize migrants could also be found in the images accompanying the articles.

THE ACCOMPANYING PICTURES

One of the images—and places—that came to symbolise the new pattern of immigration was the *Lager*, the camp.

Figure 3

Ausländer in Abschiebehaft: Mit Schleppern aus dem Fernen Osten

Figure 3 shows a group of men in a small fenced yard, identified as detained foreigners waiting for their deportation.[29] No faces are visible, they are either hidden or turned away from the camera; one person in the foreground covers his face as if he was crying. The whole scene is supervised by a German police officer, the only person who is gazing directly at the camera.

28 | "Auf Biegen oder Brechen" 1979, p. 37.
29 | Ibid; cf. also "'Finished, aus'" 1980, p. 39.

It is remarkable to note how in contrast to the textual statements, the state was again reintroduced here as a powerful and adequate agent.[30] The picture can therefore be identified as the wish for a strong state that takes up the fight against the Mafia of facilitators. The migrants themselves were turned into a silent mass, the simple object of state policies. At the same time, the police appeared as the proper institution when it came to dealing with migration.

A new law on the procedure for granting the right of asylum (*Asylverfahrensgesetz*) in 1982 further tightened the spatial control of refugees. Asylum seekers were compulsorily distributed among the German *Länder* and had to stay within the range of their respective aliens department; communal accommodation and allowances in kind rather than cash became the rule.[31]

Not only the *Lager* became one of the new spaces of migration.[32] Images of public authorities, mainly aliens departments, figured prominently.[33] These pictures fit into the discourse of a run on Germany that was simply too big to handle, for instance when they showed the sign of a closed office responsible for aliens with the caption of an "overstrained authority".[34] More common though, was the image of a large crowd of people, beleaguering an authority.

Figure 4

30 | Cf. Heck 2008, p. 39.
31 | Thimmel 1994, p. 18; Heck 2008, p. 75.
32 | Images of camps with a similar composition can also be found in "'Da sammelt sich'" 1980; "'Menschliches Frachtgut'" 1980; "'Raus mit dem Volk'" 1980. A similar place is the residential accomodation: "Augen zu" 1980; "So drastisch" 1980.
33 | E.g. "'Da sammelt sich'" 1980; "'Finished, aus'" 1980.
34 | "'Finished, aus'" 1980, p. 34.

In one case, the depicted crowd was supervised by German police officers, thus deploying similar means as the photo of detained refugees described above. The effect of all these images was a double one: they added to the notion of an invasion of foreigners; and they addressed the state as the primary agent to deal with this problem, something that was no predominant discursive element when it came to work migration of the 1970s.

Another space continued to play an important role in the representation of migration: the *ghetto*. Considering the new pattern of immigration, the depiction of camps and public authorities as places of asylum seekers was plausible. Yet the ghetto was far from being such a place, as the term referred to neighbourhoods with a high percentage of guest workers-turned-immigrants, whereas refugees would be accommodated either in camps or in decentralised housings such as hostels.

The images used in representing refugees show striking similarities to those of the mid-1970s, as in the case of Turkish-owned grocery stores and cafés.[35] In linking the rising numbers of refugees with the already established migrant communities, both appear as merely two sides of the same coin. Two *Spiegel* articles quoted the mayor of Stuttgart, Manfred Rommel: "Without a prompt change, slum-like ghettos of foreigners will inevitably form, with all social, hygienic, and criminal consequences. First symptoms are already recognizable. Just about half of all asylum seekers in Stuttgart are still able to find accommodation on their own… over-occupancy and lack of hygiene are the results."[36]

It is striking how metaphorical concepts of hygiene and disease have been carried over from the mid 1970s.[37] Both groups, labour migrants and refugees, were now being amalgamated in the category of the "foreigner". This also meant that institutions like the police and measures like deportation came to appear as appropriate options for a policy dealing with all migrants, no matter what their status or how long they had been in Germany.

The image of the ghetto itself also changed its character. Although it was still a place of exoticism,[38] its boundaries seem to have become more consolidated. A new motif was introduced: the frontier of the ghetto.

One image showed a wall with a racist slogan in the foreground and apartment blocks in the background.[39] Although it is not clear if the apartment buildings were mainly inhabited by migrants, if they were part of a "ghetto", the composition evoked the notion of a besieged place, clearly defined by surrounding walls. This new image can be understood as an attempt to transform immigration from a "problem" that could be encoun-

35 | For example: "Die Türken kommen" 1973; "'Raus mit dem Volk'" 1980.
36 | "Augen zu" 1980, p. 51; "'Finished, aus'" 1980, p. 34. On the Turkish perception of "over-occupancy" cf. Mandel 2008, p. 148-151.
37 | Cf. footnote 12.
38 | Cf. "Die Türken kommen" 1973, p. 28; "Türken in Berlin" 1980.
39 | "'Finished, aus'" 1980, p. 33.

tered everywhere and that affected society as a whole into a purely spatial phenomenon, with clearly defined borders, that could be addressed by appropriate policies.

Figure 5

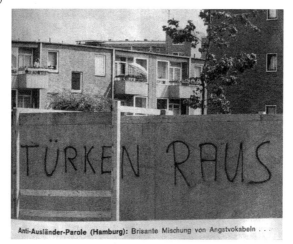

Anti-Ausländer-Parole (Hamburg): Brisante Mischung von Angstvokabeln . . .

Conclusion

Scholars have recently argued that despite the rising number of illegalized immigrants it wasn't until the 1990s that illegal immigration became a significant topic in the media. Only then had the discourse on exclusion been supplemented by one on the control of borders, and new discursive borderlines had been established, with police and facilitators at the fringes of a territory of crime and illegality.[40] This is only partly true, as the foundation for these concepts was already laid in 1973 and developed significantly throughout the 1970s and early 1980s.

The category of space is crucial for an understanding of the successive illegalisation of migration during that period, as one became an illegal immigrant not necessarily by illegally crossing the German border. Illegality was as much defined by belonging to certain deviant spaces within Germany. Already in the 1970s these had been imagined as an Underground of crime and illegality. Every aspect of migrant life—private, public, and work sphere—came under scrutiny. Around 1980 this underground was populated by masses of innocent yet nonetheless illegalized asylum seekers, its discursive borders marked by police and facilitators.

Especially the image of the ghetto underwent a drastic change: from that of a bridgehead in an ongoing colonization and a herd of a possibly spreading illness to a container of the Other with successively consoli-

40 | Heck 2008, p. 239; Ibid, p. 37.

dated frontiers. In a time when efficient border controls became more difficult, the border of the ghetto supplemented the nation's frontiers. The imagined border of the ghetto thus merged with the border of the nation, separating the imagined communities of "Germans" and "foreigners".

As much as the ghetto always was the imaginary product of German anxieties rather than an adequate description of socio-cultural realities, the newly instituted camps for refugees since the 1980s added an all too real spatial confinement for many migrants. Accompanied by laws that limited asylum seekers' freedom of movement, the camps aimed at gaining a political and spatial control over migrants that had been lost in regard to the former "guest workers". At the same time, images of overcrowded camps seemed to verify metaphors of a flood of foreigners that had to be stopped at the German borders.[41]

So although images of border crossings did not play a major role until the 1990s, concepts of illegality, space, frontiers, and the state were constantly revaluated. The inefficiency of the 1973 recruitment ban had shown that the nation was no longer congruent with the territory of the nation-state. The *exclusion* of the Other at the borders of the state had thus to be complemented with its *inclusion* within these borders.

But illegalized migration also marks a bigger shift from a society of discipline to one of control. According to Gilles Deleuze, the environments of enclosure described by Foucault as disciplinary institutions—school, barracks, factory, prison—are giving way to free-floating forms of permanent and infinite control: the corporation with its competitive principle of "salary according to merit" substitutes the factory of the mass worker; perpetual training replaces the school; continuous control the examination.[42] Urban space changes accordingly: it is no longer just a spatial arrangement of separate disciplinary institutions; it becomes itself a site of permanent control of the individual. Spatial confinement of refugees in camps and the attempt to control entire neighbourhoods of migrants complement each other. "The repressive exclusion of the illegalized can successfully be legitimized under the pretence of saving spatial control and the socio-cultural hegemony of the collective of 'legals', of the orderly registered."[43] Consequentially the spatial distribution of migrants came under scrutiny—often in an attempt to establish links between migrants and crime.[44]

The trope of the illegal immigrant was thus an attempt to redefine the concept of nationhood in terms of norms, deviance, and delinquency. At the same time, it was part of an ongoing debate about the governance of

41 | Cf. Heck 2008, p. 38.
42 | Deleuze 1992, p. 5.
43 | Heck 2008, p. 242.
44 | Cf. Franzen 1978; Selke 1977; Hottes /Pötke 1977; Borris 1973, Hoffmeyer-Zlotnik 1977; Schildmeier 1975. Weinhauer 2007, p. 89 sees a general rise of criminological geography at this time.

the state's territory. It is in this sense that discourses on sites which are "at once central to society's periphery and peripheral to society's center"[45] can be understood as a complex renegotiation of the very foundation of this society.

List of Figures

Figure 1: *Der Spiegel*, July 30, 1973, front page.
Figure 2: *Der Spiegel*, June 02, 1975, p. 42.
Figure 3: *Der Spiegel*, December 10, 1979, p. 37.
Figure 4: *Der Spiegel*, July 28, 1980, p. 30.
Figure 5: *Der Spiegel*, June 16,1980, p. 33.

Bibliography

"Auf Biegen oder Brechen zu den Deutschen." 1979. *Der Spiegel* 50, December 10: p. 37-46.
"Augen zu." 1980. *Der Spiegel* 49, December 01: p. 46-53.
Bade, Klaus J./Oltmer, Jochen. 2005. "Flucht und Asyl 1950-1989." *Bundeszentrale für politische Bildung*, March 15, http://www.bpb.de/themen/ACNRV4,0,0,Flucht_und_Asyl_19501989.html (accessed April 21, 2010).
Barthes, Roland. 1981. *Camera Lucida. Reflections on Photography*. New York: Hill and Wang.
Barthes, Roland. 1999. "Rhetoric of the Image." In *Visual Culture. The Reader*, ed. Jessica Evans and Stuart Hall, p. 33-40. London, Thousand Oaks, New Delhi: Sage.
Borris, Maria. 1973. *Ausländische Arbeiter in der Großstadt. Eine empirische Untersuchung am Beispiel Frankfurt*. Frankfurt/Main: EVA.
Bundesamt für Migration und Flüchtlinge, ed. 2010. "Geschichte des Bundesamtes." http://www.bamf.de/cln_180/nn_443360/DE/DasBAMF/Chronik/Bundesamt/bundesamt-node.html?__nnn=true (accessed April 21, 2010).
Bundesamt für politische Bildung, ed. 2010. "Entwicklung der Asylantragszahlen seit 1953." http://www.bpb.de/files/UTIHUH.pdf (accessed April 21, 2010).
"'Da sammelt sich ein ungeheurer Sprengstoff.'" 1980. *Der Spiegel* 23, June 02: p. 17-18.
Deleuze, Gilles. 1992. "Postscript on the Societies of Control." *October* 59/1: p. 3-7.
"Die Türken kommen – rette sich, wer kann." 1973. *Der Spiegel* 31, July 30: p. 24-34.

45 | Mandel 2008, p. 141.

Eder, Klaus/Rauer, Valentin/Schmidtke, Oliver, eds. 2004. *Die Einhegung des Anderen. Türkische, polnische und russlanddeutsche Einwanderer in Deutschland*. Wiesbaden: Verlag für Sozialwissenschaften.

"'Finished, aus, you go, hau ab.'" 1980. *Der Spiegel* 25, June 16: p. 32-42.

Foucault, Michel. 1972. *The Archaeology of Knowledge; and The Discourse on Language*. New York: Pantheon Books.

Foucault, Michel. 1990. *The History of Sexuality. An Introduction*. New York: Vintage Books.

Foucault, Michel. 1991. "Governmentality." In *The Foucault Effect. Studies in Governmentality*, ed. Graham Burchell, Colin Gordon, and Peter Miller. London: Harvester Wheatsheaf.

Franzen, Jürgen. 1978. *Gastarbeiter – Raumrelevante Verhaltensweisen. Migrationsmodell und empirische Studie am Beispiel jugoslawischer Arbeitskräfte in Hannover*. Hannover: Geographische Gesellschaft.

Hall, Stuart. 1997. "The Spectacle of the 'Other'." In *Representation. Cultural Representations and Signifying Practices*, ed. Stuart Hall, p. 223-279. London, Thousand Oaks, New Delhi: Sage.

Heck, Gerda. 2008. *'Illegale Einwanderung.' Eine umkämpfte Konstruktion in Deutschland und den USA*. Münster: Unrast.

Herbert, Ulrich. 1990. *A History of Foreign Labor in Germany, 1880-1980*. Ann Arbor: University of Michigan Press.

Hoffmeyer-Zlotnik, Jürgen. 1977. *Gastarbeiter im Sanierungsgebiet. Das Beispiel Berlin-Kreuzberg*. Hamburg: Christians Verlag.

Hottes, Karlheinz/Pötke, P. Michael. 1977. *Ausländische Arbeitnehmer im Ruhrgebiet und im Bergisch-Märkischen Land. Eine bevölkerungsgeographische Studie*. Paderborn: Schöningh.

"'Ich hier Bruder besuchen.'" 1975. *Der Spiegel* 23, June 02: p. 38-47.

Karakayali, Serhat. 2000. "Across Bockenheimer Landstraße." *Diskus* 2 (August), http://copyriot.com/diskus/2_00/a.htm (accessed April 21, 2010).

Lakoff, George/Johnson, Mark. 1980. *Metaphors We Live By*. Chicago: University of Chicago Press.

Löw, Martina. 2001. *Raumsoziologie*. Frankfurt/Main: Suhrkamp.

Mandel, Ruth Ellen. 2008. *Cosmopolitan Anxieties: Turkish Challenges to Citizenship and Belonging in Germany*. Durham, NC: Duke University Press.

"'Menschliches Frachtgut.'" 1980. *Der Spiegel* 29, July 14, 1980: p. 23-27.

Pieper, Tobias. 2008. *Das Lager als Struktur bundesdeutscher Flüchtlingspolitik*. Berlin (Dissertation).

"'Raus mit dem Volk.'" 1980. *Der Spiegel* 38, September 15: p. 19-26.

Rist, Ray C. 1978. *Guestworkers in Germany. The Prospects for Pluralism*. New York: Praeger.

"Saisonarbeiter. Musterung in Mailand." 1956. *Der Spiegel* 14, April 04: p. 34-36.

Saldern, Adelheid von. 1995. *Häuserleben. Zur Geschichte städtischen Arbeiterwohnens vom Kaiserreich bis heute*. Bonn: J.H.W. Dietz Nachfolger.

Schildmeier, Angelika. 1975. *Integration und Wohnen. Analyse der Wohnsituation und Empfehlungen zu einer integrationsgerechten Wohnungspolitik für ausländische Arbeitnehmer und ihre Familien.* Hamburg: Hammonia.

Selke, Welf. 1977. *Die Ausländerwanderung als Problem der Raumordnungspolitik in der Bundesrepublik Deutschland. Eine politisch-geographische Studie.* Bonn: Dümmler.

"So drastisch." 1980. *Der Spiegel* 8, February 18: p. 24-25.

Thimmel, Stefan. 1994. *Ausgegrenzte Räume – Ausgegrenzte Menschen. Zur Unterbringung von Flüchtlingen und AsylbewerberInnen am Beispiel Berlin.* Frankfurt/Main: Verlag für Interkulturelle Kommunikation.

"Türken in Berlin—'die Heimat hast du hier'." 1980. *Der Spiegel* 5, January 28: p. 38-44.

Weinhauer, Klaus. 2007. "Polizei und Jugendliche in der Geschichte der Bundesrepublik." In *Jugend, Delinquenz und gesellschaftlicher Wandel. Bundesrepublik Deutschland und USA nach dem Zweiten Weltkrieg*, ed. Detlef Briesen and Klaus Weinhauer, p. 71-93. Essen: Klartext.

The Making of "Illegality":
Strategies of Illegalizing Social Outsiders

CHRISTINE BISCHOFF

Figure 1

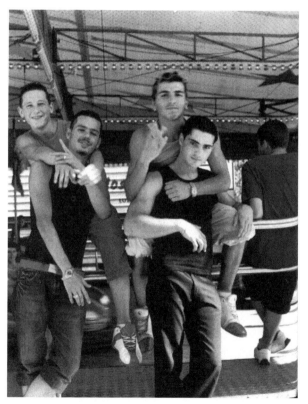

INTRODUCTION

Iler, Mentor, Albert and Lon. They are posing for the photographer at a Swiss fairground, affecting a "cool" attitude and presenting themselves as a close-knit community—in the typical way young men like to do who are not quite adults or have not been adults for a long time (Figure 1)[1]. These young men are no "illegals"—at least not according to their legal status. They do not only have the permanent right of residence in Switzerland but have spent most of their lives in Switzerland and were even born here. Neither do they conform to our collective image of illegalized migrants which is primarily characterized by exhausted boat people from Africa or by people who, due to their unclear right of residence, live a shadow existence as employed slaves, particularly in the catering or building industries. No, these four men we see in the picture and who were the subject of an extensive photo report in the magazine of the Swiss newspaper *Tages-Anzeiger*, published in the summer of 2004, do not lead such a life. Nevertheless: On account of their behaviour, their habits, their language, their existence is, in the perception of many Swiss citizens, closely associated with illegality.

Every society has its outsiders—and due to their social and family origins, Iler, Mentor, Albert, and Lon belong to that group in Switzerland which in the eyes of many is prototypical for being not really accepted: the Kosovo Albanians. The media mostly present them as good-for-nothings, neither fluent in Albanian nor German, growing up in between all cultures and being at home in none. Accordingly, the photo report from which the pictures shown here are taken carries the headline: "We, the Cursed". This form of ironic, and at the same time resigned self-description shows that the image conferred from the outside can be integrated as part of one's own identity and, when required, summoned in a kind of self-fulfilling prophecy: Give to a group a bad image and it will correspond to it.

The first significant migration movement from Kosovo to Switzerland occurred in the 1960s and 1970s. These people were classical migrant workers, who intended to work in Switzerland, save money and return home after a short time. The "cursed" are the children of those migrants who came to Switzerland already with the second major migration wave at the end of the 1980s: At that time, repression by the Serbian government became increasingly brutal, and when at the beginning of the 1990s political violence escalated in Yugoslavia, returning home had become impossible, and in Switzerland a process called "family reunification" got under way.[2] And those children who today are called "cursed" were confronted with the fact that their admired fathers, who had always been bringing money and presents home, actually had badly paid jobs in Switzerland,

1 | Leuthold 2004, p. 22-33.
2 | For further information about the history of migration of these specific ethnic group in Switzerland see for example: Kämpf 2008.

were hardly understood by the authorities, and had a bad reputation with the locals. At school, the children were expected to adjust to Swiss society as swiftly as possible. At home, on the other hand, the parents feared they might be alienated from their own culture. There was pressure from all sides, and in order to survive, these Kosovians quickly had to produce an identity of their own which made it possible for them to react to the most diverse situations.

However, public presentation and perception only rarely interpret this generating of flexible identities as an achievement of these "secondos". On the contrary: they are guilty. Guilty because by the way they are presented—above all visually—in the public media, "boys" such as Iler, Mentor, Albert and Lon succeed in making Swiss citizens livid with rage, triggering political crises and becoming the topic of campaigns which are discussed all over Switzerland. In the year 2004, this media discourse, which turned young men of the second and third generations of immigrants from the regions of former Yugoslavia into the prototype of delinquents, reached its peak. What had happened?

THE SPEED MANIACS FROM THE BALKANS AND THE REJECTED NATURALIZATION BILLS OF 2004

In September, 2004, Switzerland voted on the so called "naturalization bills". Swiss voters were called on to decide whether naturalization should be made easier for the second and third generations of immigrants living in Switzerland by reducing bureaucratic and other obstacles, and whether the Swiss passport should therefore be made more accessible to people of foreign origin born in this country. Apart from making them Swiss nationals, conferring "Swiss citizenship"[3] would also enable these people to be granted civic rights and obligations as well as political participation. The bills were finally rejected by the popular vote. The remarkable thing is that not only many Swiss citizens but also other migrant groups in Switzerland put the blame for the failure of the bills first and foremost on nationals from the "Balkan region", the so-called "Yugos",—that is, people such as Iler, Mentor, Albert and Lon. This was due to the fact that in the summer of 2004 there was not only a controversial debate in the media over the political vote on the possibility of facilitating naturalization, but the media also created and staged a new "enemy image" and used it as a backdrop against which fundamental integration problems of young migrants in Switzerland were discussed: "The speed maniacs from the Balkans" were born as the mass media's children.[4]

3 | Information about history and specific definitions of "Swiss citizenship" in: Argast 2007.
4 | Bischoff 2006, p. 10-15.

Particularly the print media mixed reports on the political vote on the possibility of facilitating naturalization with a number of other reports on so-called speed maniacs: reports about young men organizing illegal races on public roads with their tuned cars and causing serious accidents, some of them with fatal casualties. The readers were led to assume that speed maniacs are young, male, automobile-crazy—and that they come from Southeast Europe. The image of the young, male migrant from Southeast Europe's former war regions, giving free rein to his aggressions behind the wheel of a powerful vehicle, was established among the readers by way of this media fabrication of threat. The reports were accompanied by always the same, constantly repeated pictures of wrecked automobiles.

These pictures are characterized by "visual trivialities": at first sight, they do not seem to be very meaningful. However, these apparent picture trivialities prove to be hints, as they allow for the interpretation of meanings which cannot be recognized by help of the "mere" text of the report. In the context of the media debate on naturalization and speed maniacs, these pictures became markers, a "visual allegory" of "reduced willingness to adjust"[5], something particularly migrants of the second and third generations with Southeast European origin were accused of. The car was presented as the weapon in the hands of unintegratable migrants from Southeast Europe, who in this way became a threat to the entire Swiss society. By way of the visually prestigious object of the car, their apparent dangerousness was made visible. For this strategy of representation, in the course of which what cannot really be shown is made visible, Stuart Hall uses the term "fetishism": "Fetishism takes us to the realm where imagination intervenes in representation; to the level where what is shown or seen by representation can be understood only in relation to that what cannot be seen or shown. Fetishism includes replacing a dangerous and powerful but forbidden power by an 'object'. [...] It permits keeping up the double focus—watching and not watching at the same time."[6] In numerous letters to the editor Swiss people expressed their fear of being killed by these "speed maniacs from the Balkans". If this was to be, at least the maniacs should not be allowed to do this with Swiss passports in their pockets.[7] Admittedly, this is quite a simplified depiction. But we should not be surprised that media users drew such conclusions.

For weeks and months, the media, particularly the print media, dealt with the question from where these dangerous drivers originated. The media published a number of pictures, preferably pictures of road accidents, maps and most of all infographics to investigate the origins of speed maniacs. For many, the danger came from the East or the Southeast, as is so often the case with xenophobic discourses about foreigners in the European context. A danger, however, for which no statistic or any other evidence

[5] | Schär 2004, p. 12.
[6] | Hall 2004, p. 154-157.
[7] | *Tages-Anzeiger* September 21, 2004, p. 27.

could be presented, since Swiss statistics on road accidents do not record categories such as nationalities or ethnic origins. Nevertheless, the media negotiated a whole catalogue of steps that might lend themselves to dealing effectively with the problem of speed maniacs: suggestions made by all Swiss print media were numerous and "loud". Some called for revoking driver's licences in advance[8] and for confiscating the cars as the "weapons used in the crime"[9]. In letters to the editor the suggestion was discussed to pillory speed maniacs by publicizing the names of legally sentenced speed maniacs.[10] Others advocated a "forced therapy" for speed maniacs.[11] A Swiss ex-member of the National Council made the suggestion to send speed maniacs to a "rehab to clean the floors there, or to a hospital where people with severe brain injuries are nursed".[12] It was also suggested to require people coming from the "Balkans"[13] to take an additional driving test for Swiss traffic. And finally the media drew the conclusion that it was high time to explain to the "Machos from the Balkans" what Swiss laws were about.[14]

AMIR B.—THE ICON OF EVIL:
CRIMINALIZATION AS A KIND OF ILLEGALIZATION

But media debates also always need new faces. The debate on speed maniacs was given its face with Amir B. All the media portrayed the then 22 year-old who was living in the greater area of Zurich and had come from Kosovo to Switzerland as a child, as the prototype of the speed maniac. In interviews—such as one from the *Sonntagsblick*—he was quoted with sentences such as this one: "I'm a psycho, after all. I'd rather kill myself than lose a race" (see Figure 2).[15]

In front of the camera of Swiss TV Channel SF 1 he raced against an unidentified competitor in a built-up area. For him, closed-track street races were not an option: "It's much more fun when it's illegal." And his friend, Ahmed, had no inhibitions about stating that he had been riding at a speed of 120 km/h in a 50 km/h zone.

8 | *Tages-Anzeiger* September 9, 2004, p. 17.
9 | *Neue Zürcher Zeitung* October 1, 2004, p. 51.
10 | *Tages-Anzeiger* September 9, 2004, p. 11.
11 | Ibid, p. 27.
12 | *Tages-Anzeiger* September 20, 2004, p. 11.
13 | *20 Minuten* October 6, 2004, p. 3.
14 | *Tages-Anzeiger* September 20, 2004, p. 11.
15 | *Sonntagsblick* September 19, 2004, p. 3.

Figure 2

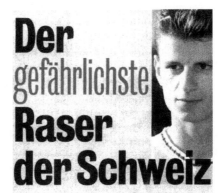

Amir B. became the incarnation of the dangerous speed maniac, who was raised "from the cool tuner to become the nation-wide figure of shame", as it said in one of the original texts of the *Neue Zürcher Zeitung*.[16] In Amir, all the elements of an absolutely negative status came together—as is typical for stigmatization and exclusion processes: the migrant status, the lower class status, the criminal status.[17] The media made this unstable outsider, living at the fringes of society, the focus of societal interest—at least for some time. And he was shown as being representative for everyone with origins in the region of former Yugoslavia. Suddenly, everyone from that region came under suspicion of perhaps being a criminal. And this form of criminalization made it possible to question the legitimacy of their residence status in Switzerland, not necessarily on a juridical, but on a social level. In the public discussion it was now possible to voice the opinion that they were not entitled or no longer entitled to stay in Switzerland.

The topic "speed maniac from the Balkans" was staged by the media as an interaction between a existent social practice in a small group of young people and a discriminating name which was politically instrumentalized and generalized. And it is probably no coincidence that for the migration discourses of the past decades the car is, more than anything else, the *leitmotif*: often the fathers and grandfathers of those depicted had stood at the assembly lines of the car factories of central and northern Europe, making their crucial contribution to automobile production. In the collective memory, the car is the symbol of the wealth of the rich north.[18] And now, this symbol of wealth was reduced to scrap metal by the classical migrant workers' grandchildren.

16 | *Neue Zürcher Zeitung* September 26, 2004, p. 27.
17 | Bude 2004, p. 5; Elias/Scotson 1993, p. 14; Hohmeier 1975, p. 5-24.
18 | Osten 2005, p. 28; Sachs 1990, p. 129-133.

For the viewer, these kind of images of male car fanatics evoke scenarios that threaten with violence. Such pictures demonstrate the absurdity of emphasizing the male body. For post-industrial society, the excessively presented male body of the foreign migrant, as we still know it from the 1950s, 1960s and 1970s, loses economic significance. In modern Western European societies, which like to refer to themselves as knowledge societies, the body, which is a particularly important item especially for men without a good school education, loses its meaning. The strong, healthy body no longer guarantees a place in the labour market of modern migration societies. Indeed, the visual representation the body remains the most important feature of these men (Figure 1). At the same time however, the representation shows them as migrants without a task. These are—to use a term coined by Michel Foucault—"undisciplined bodies", because they cannot be utilized, controlled and disciplined any more by technologies of rationalization and strict economization.[19] Represented the way they are, the men in fact appear to the viewer as freely moving forces of threat.

The Ethnicization of Everyday Conflicts

In the debate on speed maniacs in 2004 there was particular emphasis on what was called "belonging to an ethnicity". Previously, speed maniacs, a problem which is almost as old as car traffic itself, had been dealt with in public debates primarily as a problem of young, male drivers. Now, there was an increasing ethnicization of a phenomenon which before had been discussed chiefly as a generation- and gender-specific topic. This was due to the numerous reports in which Amirs, Ahmeds, and Igors from the Kosovo, from Serbia-Montenegro and Macedonia played the main role. Belonging to an ethnicity became the essential pattern of interpretation and the omnipresent frame of orientation within the debate on this everyday issue.[20] Such processes of ethnicization are social systems of organization which help to create demarcations between actors and groups on the basis of self-ascribed and other-ascribed identities and images. In this manner, cultural differences are socially organized and these constructed differences model the perception of members as well as of non-members of ethnic groups. By means of pictures and texts, social conflicts were stylized as undeniable "facts" of ethnic characteristics. Whether the "facts" were true or not becomes trivial, what is important is solely whether the stories are believed to be true.

By mixing the debate on speed maniacs and that on the naturalization bills, it was possible to depict people of Southeast European origin as deficient regarding their contribution to society and as representing a hazard for Switzerland. By way of exclusion and closing off, the "spatial construct

19 | Foucault 1979.
20 | Garhammer 2003, p. 179-201; Bukow 1996, p. 6-7.

of Switzerland" and the "Swiss national mentality" was reproduced, and the so called "Balkans region" and the people from there were presented as a spatial, political, social and cultural counter-image. The reasons for this must be seen in the 1990s and in the resurrection of the negative image of this region, which was in particular communicated by the mass media. The violent struggles in Southeast Europe established and reinforced the stubbornly maintained collective external perception of the "Balkans" as Europe's "problematic region"—the "Balkans region" as a spatial counter-image to Western and Central Europe, so to speak the "Balkans region" as a kind of "anti-Europe".

Concluding Remarks

Images play an important role in this discursive construction of stereotyped ideas. In the context of the media debate, authors, those depicted as well as recipients mutually refer to visually set symbols and the images connected to imagination. It is only the power of the discourse, and here above all of the visual discourse, which creates that what it names. In this sense, the creation of stereotypes must be considered a performative act—as does Judith Butler—which through constant repetition and presentation creates ever more manifestations of the stereotype.[21]

Thus, the debate on the "speed maniacs from the Balkans"—and here I will conclude my remarks—is an example of how certain social or ethnic groups are turned into a topic, above all a visual topic, because in a given political situation they are considered a current issue. As regards depiction and perception, they experience particular reserve or attention by the receiving society—and often both at the same time. The discourse, in particular the visual discourse, has the power to depict them as normal or different, as integratable or unintegratable, to construct them as an ethnicity and pass judgment on them with the aid of cultural or even biological arguments and thus to create the basis for the way in which they are dealt with.

This means that the discursive communication of certain "images of people", for example the type of the "speed maniacs from the Balkans", has not only consequences at the abstract-cultural level but also explicit effects on the everyday and practical living environment of individual groups. The media debate on speed maniacs, for example, resulted in various Swiss insurance companies deciding to demand an insurance premium which was up to thirty per cent higher for new customers of Southeast European origin. Some insurance companies even refused to accept such new customers at all. Whether the political vote on the "naturalization bills" would have had a different result, is a matter of speculation. However, it is an example of how by means of media images and

21 | Butler 2001, p. 35-36.

texts strategies of belonging and closing-off are made to work. This debate was used to create a confrontation between an imagined "we-group" and some constructed "others". The others in this case were the "speed maniacs from the Balkans". Young men from Southeast Europe who through other media debates on unemployment, crime and macho behaviour had already been and still are, deeply rooted in the perception of many recipients as a "problematic collective".

LIST OF FIGURES

Figure 1: Photo report: Ruedi Leuthold. 2004. "Wir Verfluchten." Das Tagesanzeiger-Magazin 39: p. 22-33.
Figure 2: Photo report: Daniel Jaggi and Yvonne Kummer. 2004. "Der gefährlichste Raser der Schweiz." SonntagsBlick 38: p. 2-3.

BIBLIOGRAPHY

Argast, Regula. 2007. *Staatsbürgerschaft und Nation. Ausschliessung und Integration in der Schweiz 1848-1933*. Göttingen: Vandenhoeck & Ruprecht.
Bischoff, Christine. 2006. "Die Raser vom Balkan – Bemerkungen zur Inszenierung eines Medienspektakels." *Kuckuck. Notizen zur Alltagskultur* 21: p. 10-15.
Bude, Heinz. 2004. "Das Phänomen der Exklusion. Der Widerstreit zwischen gesellschaftlicher Erfahrung und soziologischer Rekonstruktion." *Mittelweg 36* 4: p. 3-15.
Bukow, Wolf-Dietrich. 1996. *Feindbild Minderheit. Zur Funktion von Ethnisierung*. Opladen: Leske and Budrich.
Butler, Judith. 2001. *Körper von Gewicht: die diskursiven Grenzen des Geschlechts*. Frankfurt/M.: Suhrkamp.
Elias, Norbert/Scotson, John. L. 1993. *Etablierte und Aussenseiter*. Frankfurt/M.: Suhrkamp.
Foucault, Michel. 1979. *Überwachen und Strafen*. Frankfurt/M.: Suhrkamp.
Garhammer, Manfred. 2003. "Der Fall Ahmet und die Ethnisierung von Jugendgewalt." In *Die Ethnisierung von Alltagskonflikten*, ed. Axel Groenemeyer and Jürgen Mansel, p. 179-201. Opladen: Leske and Budrich.
Hall, Stuart. 2004. "Das Spektakel des 'Anderen'." In: *Ideologie, Idenität, Repräsentation. Ausgewählte Schriften 4*, ed. Stuart Hall, p. 108-166. Hamburg: Argument Verlag.
Hohmeier, Jürgen. 1975. "Stigmatisierung als sozialer Definitionsprozess." In *Stigmatisierung: Zur Produktion gesellschaftlicher Randgruppen, Band 1*, ed. Manfred Brusten and Jürgen Hohmeier, p. 5-24. Neuwied: Luchterhand.

Kämpf, Philipp. 2008. *Die Jugo-Schweiz: Klischees, Provokationen, Visionen.* Zürich: Rüegger.

Leuthold, Ruedi. 2004. "Wir Verfluchten." *Das Tagesanzeiger-Magazin* 39: p. 22-33.

Osten, Marion von. 2005. "Die Fahrbahn ist ein graues Band. Überlegungen zu einigen privaten Fotos mit Automobilen." *31 – Das Magazin des Instituts für Theorie der Gestaltung und Kunst, Zürich* 6/7: p. 25-33.

Sachs, Wolfgang. 1990. *Die Liebe zum Automobil. Ein Rückblick in die Geschichte unserer Wünsche.* Reinbek bei Hamburg: Rowohlt.

Schär, Markus. 2004. "Kosovo-Albaner: Gebremster Wille zur Anpassung." *Die Weltwoche* 40: p. 12.

Copying Camouflage
In/visibility of Illegalized Immigration in Julio Cesar Morales' Series *Undocumented Interventions*

MICHAEL ANDREAS

MIGRATION AND VISIBILITY

Since the earliest days of the nation state, immigration (and sometimes emigration) has been conceived as a phenomenon threatening the nation state and consequently has to be governed and controlled. In the 19th century, newly developed media techniques such as statistics and photography operated within discourses of population guidance to depict what belongs to the state and what has to be excluded—be it abnormal, pathological or foreign. Since then, national borders have been in a state of constant ideological and technological proliferation, with security issues emerging after 9/11 as a preliminary meridian.

In migrant societies, visual structures operate to observe and normalise immigration. *Illegal* immigration is not an entity: it emerges as such, by a disturbance in the visual order of controlled border crossings. Michel Foucault's works on the visual have emphasised that a certain power is inherent in the visual—not only in modes of representation[1], but also in the anticipation of the watching by the watched.[2] Clandestine immigration is a phenomenon which is planned outside the regimes of visibility and outside the supervision of government agencies. Only detected, i.e. failed acts of clandestine immigration come into view—they are illegalized.

I will describe this paradoxon in the visualisation of clandestine immigration with two concepts derived from the field of biology, which have been discussed prominently within Postcolonial Studies. In his essay "Of mimicry and man: The ambivalence of colonial discourse", Homi Bhabha describes which forms of invisibility, of non-identity and indistinguish-

1 | See Foucault 1970.
2 | See Foucault 1975.

ability have developed in colonial societies. Using the biological principle of mimicry as a metaphor for the colonised adapting to an "environment" of colonisers, Bhabha describes how forms of invisibility produce similarities and not equalities between the colonisers and the colonised, the latter thus being recognised "as a subject of a difference that is almost the same, but not quite"[3]. Michael Taussig, also drawing on Darwinian biology, uses the term mimesis to describe cultural contacts, the production of meaning on the side of the colonisers and the resulting Othering of the colonised. Introducing the complex term mimesis instead of the mere biological definition of mimicry, Taussig focuses on the field of aesthetics by emphasising the Aristotelian tradition of the word and, more specifically, the reproducibility of art and images, their aesthetics and anaesthetics as first described by Walter Benjamin.[4]

Using the concepts of mimesis and mimicry outside the field of natural science thus does not mean advocating biological concepts, such as a *survival of the fittest* or instinct-driven acting. What functions as a metaphor in Bhabhas text to describe which kind of adaptations and imitations take place in colonial societies then becomes a strong impetus to describe the margins of colonial history, which is directly linked to art history and the limitations of perception. With the concepts of mimicry and mimesis, the visual order of the border and, with it, its notion of national identity is disrupted.

In the following text, I will focus on a particular series of art and with it on a phenomenon limited to the few legal ports of entry from Mexico to the US. This is itself, of course, a limited perception. From a political or historiographical point of view, it is indeed highly debatable in how far the US/Mexican border can be interpreted as a product of colonialism or postcolonialism in the first place. I will thus use "postcolonial" neither as a term regarding a fact-based history of the US/Mexican border, nor as a term describing actual postcolonial (political, economical) interdependencies between these countries, but render postcoloniality at this very border within the field of aesthetics; as (limited) perception, of visibility and invisibility, which do exist outside the hard facts of politics or historiography. Nevertheless, what I will outline is neither limited to the field of aesthetics, thus being a solely philosophical question, nor will I try to isolate a piece of art from its political surroundings; but scrutinise which forms of visibility and invisibility the public discourse of the US/Mexican border produces.

Drawing on mimetic and disruptive camouflage, creating visual confusion and thus aesthetic phenomena, I will describe which specific political aesthetics of in/visibility the different forms of border crossings produce.[5] Focusing on migrant acts of illegalized border crossings on the US/Mexican border as forms of camouflage, and discussing the visualisation of the invisible by both border agencies and in the work of visual artist Julio Cesar

3 | Bhabha 1994, p. 86.
4 | Benjamin 1977, see further Buck-Morss 1992.
5 | For different figures of border crossers see Horn/Kaufmann/Bröckling 2002.

Morales, I will try to challenge the notion of illegalized immigration as a mere product of political suppression and point out which specific political aesthetics and evidences such border crossings produce instead.

MIGRATION, *POWER* AND *BECOMING*

The US have had a long history of border security based on ethnic profiling. Starting with *Operation Wetback*, a project launched by the former US Immigration and Naturalization Service in the 1950s and using the racial slur *wetback* explicitly in its name, where "Mexican looking", i.e. migrants of Hispanic or Native appearance, were systematically picked up in the US hinterland and deported to Mexico.[6] Security issues emerging after 9/11 caused the founding of the US Department of Homeland Security. With the Operations *Frontline, Return to Sender* and *Scheduled Departure* the newly founded department launched at least three projects resulting in the departure of at least 500,000 migrants considered illegal.

The homepage of the US Customs and Border Protection (CBP), a division of the US Department of Homeland Security, excessively documents acts of failed migration.[7] As a governmental website, it offers various profiles of officers or departments, news on traffic volumes, law enforcement activities intermingled with different self-produced press-releases highlighting spectacular attempts of smuggling and/or illegal immigration, "Three Arrested with Counterfeit Certificates of Naturalization by Lukeville CBP Officers", "Disguised Delivery Van Fails to Deceive Border Patrol", "Chocolate-Covered Cocaine Discovered by CBP at JFK", and so on. The site not only serves as a platform for public relations, but also as an information and picture source for journalists covering news about the border, and thus as a starting point for news coverage about the border, aiming at people living in the US hinterland. In this public American discourse, illegal immigration is reduced to only two types of entrants: lawbreaking migrants on the one side and criminal smugglers on the other. The predominant anti-trafficking discourse is thus bound to a conception of border politics which individualises border crossing and displays migrants either as culprits or as victims of a people smuggling mafia.

Focusing on news coverage of attempted people smuggling on the land border between the US and Mexico, two major narratives can be isolated: *faking* or *aching*, the notions of deception or despair; this is either highlighting smugglers who failed to deceive the government authorities and were caught smuggling cocaine under chocolate icing or people in fake branded vans, or putting an emphasis on the individual migrants themselves, concealed in various car parts. The CBP has a particular inter-

6 | For the historic influence of the "Operation Wetback" on arts and popular culture see Denning 1996 and Pease 2001.
7 | CBP.gov.

est in exposing these migrant bodies, unbelievably concealed in speaker boxes, glove compartments or seats, and presents them as vulnerable individuals, hiding in trunks or under hoods, encapsulated by dashboards or even sewn into seats.[8]

Figure 1: Enrique Aquilar Canchola, crossing at San Ysidro in July 2001. Photograph taken by the U.S. Immigration and Naturalization Service

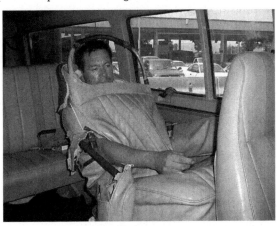

The photographs produced by the border agency establish, willingly or not, a public discourse of "the migrant" who is forced to travel hundreds of miles in a car seat to escape his/her allotted destiny. So which ways other than labelling border directives racist and pitying the poor migrant who gets trapped in the control mechanisms of a repressive nation state can be found? Foucault's notion of *power* can provide useful insights here, since in his terms power does not solely mean plain repression. As he states in *Discipline and Punish*: "We must cease once and for all to describe the effects of power in negative terms: it 'excludes', it 'represses', it 'censors', it 'abstracts', it 'masks', it 'conceals'. In fact, power produces; it produces reality."[9] Gilles Deleuze, in his rereading of Foucault, adds to the notion of power that of *Becoming*: "[P]ower is in the state of infinite becoming; there is a becoming of power, which accompanies and surrounds history."[10] Power does not only produce visibility, simultaneously power produces invisibility by "masking" or "concealing", by the precise arrangement of visibility as described by Foucault. But power not only conceals actively: The individuals trying to undermine a visually controlled border do so by *becoming* invisible.

8 | Credits are due to Nanna Heidenreich and Uli Ziemons, who pointed me to this very example of border crossings.
9 | Foucault 1975, p. 194.
10 | Deleuze 1992, p. 119, my translation from the German translation.

Camouflage and *Becoming-Animal*

Hsuan Hsu has called camouflage one of the most remarkable aesthetic phenomena of postmodern life. "[B]oth stealth bombers and suicide bombers blend in with their surroundings; antennae and radio towers are designed to simulate trees; along the borders between Gilo and neighboring Palestinian settlements, barrier walls are painted to resemble the landscapes they block out; fashion and advertising continually manipulate the fine line between standing out and blending in; and biologists have begun studying the phenomenon of 'urban speciation', in which insects and birds mimic and adapt to various aspects of urban environments."[11]

When analysed in the field of perception, camouflage can be subsumed as an opposition to some kind of visibility. The heterogeneity of military, economic, and biological contexts listed by Hsu can easily be adapted to phenomena of globalised societies, since immigrants, refugees and minorities of all kinds are supposed to assimilate to new cultural contexts. The works of scholars like Homi Bhabha and Michael Taussig demonstrate how hegemonic ideals of Westerness or Whiteness depend upon the unsettling dynamics of "colonial mimicry" or "racial performativity". Camouflage can thus emerge as a key concept when analysing perception, dispositives of control, and an/aesthetics on any kind of border, not only by immigrants hiding in car seats, but also by concealing precarious borderlands such as in Israel and neighbouring Palestinian settlements.

On many borders, and in multiple variations, visibility is thus contrasted by *becoming* invisible. The concept of *Becoming* as achieved by Deleuze with Félix Guattari in *A Thousand Plateaus* seeks to articulate a political practice in which social actors escape their normalised representations and reconstitute themselves as participating individuals.[12] In a variety of Becomings specified by Deleuze and Guattari—Becoming-Intense, Becoming-Animal, Becoming-Woman, among others—Becoming-Imperceptible is the intrinsic end of Becoming, it is a process of Becoming everybody and everything, eliminating constructions, attributes and names, and describing what exceeds normalisation. The end of all Becoming is not proliferation; it is the disappearance of differences of any kind. Becoming-Imperceptible, hence invisible, "is Deleuze and Guattari's universal political project because one has suppressed in oneself everything that prevents us from slipping between things and growing in the midst of things"[13].

As a starting point from where identity and subjectivity emerge as questionable, Becoming-Animal is a major concept in the variety of Becomings. Within the different border discourses, the animals are, to begin with, a name: British sailors called helpers of stowaway passengers *sharks*, human trafficking is called *koyun ticareti*, sheep trade, in Turkish, and in Chinese

11 | Hsu 2006, p. 169.
12 | See Deleuze/Guattari 1987.
13 | Papadopoulos/Tsianos 2008.

people smugglers are called *shetou,* snakeheads. On the borderline of the US and Mexico, *coyote* does not only denote the prairie wolf, it also designates the commercial guides who organise undocumented migrational movements in the borderland. The contemporary public American discourse of il/legal immigration is framed by metaphors, be it controlled immigration as a phenomenon that can be "spurred" or "curbed", and illegal immigrants as pack animals, packs that can be "lured" or have to be "ferreted out".[14]

The political potential of *Becoming-Animal* exceeds, as a matter of course, the different names of smugglers or migrants. The various political implications of the concept will guide me through an aesthetical analysis of the images of detected migrants concealed in cars. I will describe this paradox in the visualisation of illegaliszed immigration with two concepts derived from the field of biology, which have gained a certain popularity within Postcolonial Studies. Using the biological principles of mimesis and mimicry, Taussig and Bhabha have described which forms of invisibility, of non-identity and indistinguishability have developed in colonial societies. Mimicry has, however, never been a mere biological concept: When first discovered and denominated by Charles Darwin's contemporary and colleague Henry Walter Bates, mimicry was indeed a phenomenon of the flora and fauna. On his trip to South America in the middle of the 19th century, Bates spotted visual similarities among different species of plants and animals. As mimicry, it soon became a key concept in natural sciences, because it perfectly fitted the theories of his influential colleague. However, Bates did not restrict the newly discovered effect to plants and animals: for Bates, and in the colonial Amazon region, mimesis, mimicry, adaption, intermingling seem the best terms to describe the rituals of the natives as well: "All the Roman Catholic holidays are kept up with great spirit, rude Indian sports being mingled with the ceremonies introduced by the Portuguese."[15]

In 20th century philosophy, mimicry became more than a mere challenging of biological identity construction via taxonomies. In the middle of the 20th century, French surrealist Roger Caillois analysed the adaptive coloration of animals as a deeply visual phenomenon. In *Meduse & Cie,* Caillois refers to studies of adaptation from the field of 19th century biology, but transfers them to a modernist aesthetics. Mimicry, he states, cannot solely be reduced to a phenomenon of flora and fauna, be it as *camouflage* (blending with the surroundings), but also as *travesty* (pretending to be someone else) or *intimidation* (the illusion of a dangerous other). In case of the not concealing, but highlighting colouring of certain butterflies and moths, anticipating the observer by the observed becomes the main principle. In the case of the tigers' disruptive camouflage, adaptive coloration challenges the camera eye with the ability of a human, knowing eye.[16] Especially the world of insects, but ver-

14 | For the numerous and diverse animals of migration see Santa Ana 1999 and Florian Schneider's essay in Horn/Kaufmann/Bröckling 2002, p. 41 et sqq. For *Becoming-Animal* of migration see Papadopoulos/Tsianos 2008.
15 | Bates 1910, p. 283.
16 | See Caillois 2007, p. 101 et sq.

tebrates as well, and their profoundly organised social structures provides a connection to analyse human culture: "[T]he inexplicable mimetism of insects immediately affords an extraordinary parallel to man's penchant of disguising himself, wearing a mask, or playing a part—except that in the insect's case the mask or guise becomes part of the body instead of a contrived accessory."[17]

In his book *Mimesis and Alterity* Michael Taussig uses the phenomenon of mimicry to describe adaptation as relations of power and knowledge existing in colonial societies. Taussig draws on the Cuna, a South American Native ethnicity, to describe White colonisers' obsession with the Cuna's excessive use of Western pop culture, including distorted reflections of a popular iconic image from the early 20th century. Later on, in two chapters of *The Location of Culture*, Homi Bhabha uses the concept of mimicry to explain how colonial power produces more than a mere repression of the colonised by the coloniser. Hence, the re-enactment of the coloniser can never equal the colonising "original", and within the process of translation, the colonial discourse becomes fragile—colonialism thus fragmenting the identity as well as the presumed authority of the colonisers. With mimicry, similarities, and not equalities are produced, the colonised becoming "a subject of a difference that is almost the same, but not quite"[18].

In his series *Undocumented Interventions*, visual artist Julio Cesar Morales takes on the precise difference described by Bhabha. By reproducing actual acts of failed border crossings, i.e. detected illegal migration on the US/Mexican border, Morales comments on the visibility of what was intended;

Figure 2: Julio Cesar Morales, Undocumented Interventions, *# 5, 2005*

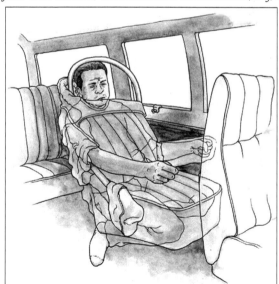

17 | Caillois 1961, p. 20.
18 | Bhabha 1994, p. 122.

to stay invisible; migrants who tried to disguise themselves as objects thus making themselves invisible are made visible not only by the act of detection, but also by being exposed on the Customs and Border Protection's Website.

Morales' ongoing series *Undocumented Interventions* consists of numerous paintings and was part of a travelling exhibition of so-called Chicano artists which migrated through museums in Los Angeles, Mexico City, New York, Houston and Phoenix in 2008 and 2009. With the series, the artist explores the cultural phenomena of human trafficking through a failure of attempted smuggling. Morales' key concept is a documentary approach. The series consists of imaginations of failed attempts to smuggle people to the US, documented by the border patrol. But Morales does not imagine those well-documented cases of people smuggling, illegalized border crossings that are documented, but reproduces the very pictures taken by officers of the US Customs and Border Protection while on duty. He does so by reproducing, or mimicking, every single detail of the picture, the colours, the framing, the perspective, and only adding transparency to the material which was intended to conceal.

What is most striking in the criticism of Morales' work is that most critics comment on the documentary approach of *Undocumented Interventions*, thus ignoring the fact that Morales is doing much more than just copying, reproducing or mimicking what was made visible by the CBP before. With Morales' work, critics tend to argue, the pitiful migrant gets his/her place in museums.

I am arguing that Morales makes perfectly visible what theorists have recently named the *Autonomy of Migration*. Yann Moulier-Boutang and others have observed that the illegalization of migration produces migrant objects rather than migrant subjectivity and instead claimed that migration itself produces and establishes specific practices, new geographies and specific aesthetics, thus being an agent of attribution and changing hegemonic border discourses and not merely being an object of attribution.[19] What can be discovered in and with the help of Morales' work is more than a simple addendum to *Becoming-Invisible* in actual border-crossings. Since invisibility is made impossible by an omnipresent gaze of the US border agency, and even more, also made public by flaunting the photographic document of this very gaze on the internet, Morales' work is also a critique on the directive of absolute visibility not only at the US-Mexican border. If we follow Taussig and Bhabha, Morales also produces what can be called a *postcolonial mirror*: doubling the agency's fascination with illegal migrants' inventiveness, subjects who perfectly know the illegalization of their border crossing, but nevertheless, in acts of slick and "sly civility"[20], diffuse, undermine and refuse to accept a national identity.

19 | See Moulier-Boutang 2002; Mezzadra/Neillson 2003.
20 | Bhabha 1994, p. 132 et sqq.

Copying

The *Autonomy* which Morales' work hints at becomes even more obvious when tracing the pictorial sources of *Undocumented Interventions*. In 2004, the *San Diego Union-Tribune* published an article with a photograph[21], which is considered to be the inspiration for Morales' ongoing series *Undocumented Interventions*.[22] The Tribune mentioned a case of a failed attempt by a Mexican family to cross the border, the youngest child sewn into a *piñata*, a common element of Mexican popular culture and also a popular souvenir, a figurine of some kind, believed to have originated among the native peoples of Mexico. After the family had been detected—the mother hidden in the trunk, the older child tucked away under the back seat—the officers of the US Customs and Border Protection took a photograph of what they considered a spectacular act of disguise; the youngest child hiding in the piñata. That photograph was also used in the *Tribune* article. In the same way as in *Undocumented Interventions #5*, Morales copies the photo, the camera angle and distance, the colours, and every single detail of the portrayed, from the frayed skirting of the figurine to the distinguished colouring of the toeholds on the child's socks, adding only transparency to what was meant to conceal the migrant body.

Figure 3: *Unnamed girl of 4 or 5 years in piñata crossing at Tecate in November 2004*

What becomes obvious here is an idiosyncrasy within the sense of vision, between the visible and the invisible, between gaze and object, between visual control and *Becoming-Invisible*. The desired picture of legal, controlled immigration on the side of police and policies is first contrasted by the desired invisibility of the migrants. This gaze is re-established by uncovering, identifying, documenting and publishing, which is, again, contrasted by artistic hyper-transparency, pastiche and parody. Adding curatorial practice (exhibitions in Los Angeles, Mexico City, New York, among others), what was artistic becomes activist. Migratory aesthetics—if that is what we want to call it—can thus be subsumed "as something that is realised as an event—a collective enunciation—within a given exhibition"[23].

21 | See Berestein 2004.
22 | See Marquez 2008.
23 | Bennett 2007, p. 459.

Figure 4: Julio Cesar Morales, Powerpuff *(detail), 2005, from the series* Undocumented Interventions

Following Jacques Rancière, the *Autonomy* is brought up by a double redistribution of the sensible.: Politics, in the words of Rancière, develop from dissensus as opposed to police consensus, which is disturbed by a political redistribution of the visible. Art propounds politics, in Rancières terms, by establishing a dissensus between what is seen and what is made visible. Adding curatorial practice to the artistic act establishes a political momentum.

"The politics of works of art plays itself out to a larger extent—in a global and diffuse manner—in the reconfiguration of worlds of experience based on which police consensus or political dissensus are defined. It plays itself out in the way in which modes of narration or new forms of visibility established by artistic practices enter into politics' own field of aesthetic possibilities. [...] It is up to the various forms of politics to appropriate, for their own proper use, the modes of presentation or the means of establishing explanatory sequences produced by artistic practices rather than the other way around."[24]

The idiosyncrasy between consensus and dissensus, between visibility and invisibility taking place at the US/Mexican border also recalls Walter Benjamin's metaphor of the vision's tactility, which "opens" and "penetrates" the body.[25] While Benjamin is writing about photographic vision,

24 | Rancière/Rockhill 2004.
25 | Benjamin 1977, p. 31 et sqq.

Morales reverts what Benjamin proved is the reproducibility of the piece of art. Reproduction, photography's singularity, is itself reproduced by a piece of art. Morales' ongoing series thus not only challenges the practices of the border patrol, *or* solely questions omnipresent photographic visibility, but hints at the global distribution of pictures. By law, as defined in the US copyright law in Title 17 of the US Code, any picture taken by an employee of governmental agencies cannot be copyright protected. "Copyright protection [...] is not available for any work of the United States Government [...]. A 'work of the United States Government' is a work prepared by an officer or employee of the United States Government as part of that person's official duties."[26] This law makes the pictures of illegalized migrants part of the public domain, thus a welcome source for illustrations of border-related news in the media. For the making, distribution and economic success of works of art, possible copyright infringements can become crucial. With the decision to limit his series to copying picture material documented by border officials, Morales also enables himself to fully engage in a documentary approach that is completely liberated from economic constraints or repressions by the police—he does not actually have to be at a certain scene at a certain time.

The bypassing of possible copyright infringements is even more obvious when looking at the precise origin of the *Powerpuff* figurine:

Figure 5: Buttercup *from the TV Series* Powerpuff Girls

26 | US Code 2002.

The piñata used in the case of the Mexican family is based on a character of the Cartoon Network's series *Powerpuff Girls*, a television series targeting a US pre-school age audience. In a world of free floating pictures, of satellite television and globally acting media corporations, the iconic image of *Buttercup*, some way or other, made its way over the border and became a pattern for a supposedly "pure" element of Mexican folklore. What Benjamin hoped for in 1935 was the rededication of reproducibility; the perceptibility of what was, was made, or has become invisible; the possibilities of an apparatus to illuminate[27] has clearly become a global advertising and distribution instrument as well as a mechanism for multiple forms of border restrictions. The picture of the girl in the piñata is therefore extremely visible. It is a document of migrational despair, an act of control and its critique, simultaneously an end point and a starting point for the global distribution of reproducible pictures.

LIST OF FIGURES

Figure 1: Enrique Aquilar Canchola, crossing at San Ysidro, July 2001. Photograph taken by the former U.S. Immigration and Naturalization Service.
Figure 2: Julio Cesar Morales, *Undocumented Interventions*, # 5, 2005, from the ongoing series.
Figure 3: Unnamed girl of 4 or 5 years in piñata crossing at Tecate in November 2004. Photograph taken by the U.S. Customs and Border Protection.
Figure 4: Julio Cesar Morales, *Powerpuff* (detail), 2005, from the ongoing series *Undocumented Interventions*.
Figure 5: *Buttercup* from the TV Series *Powerpuff Girls*. Craig McCracken/Hanna-Barbera/Cartoon Network. Drawing by Flickr user Rakka, licensed Creative Commons, http://www.flickr.com/photos/rakka/4424824333/sizes/l/#cc_license (accessed May 25, 2010).

BIBLIOGRAPHY

Bates, Henry Walter. 1910 [1863]. *The Naturalist on the River Amazons*. London: J. M. Dent & Sons.
Benjamin, Walter. 1977 [1934/35]. *Das Kunstwerk im Zeitalter seiner technischen Reproduzierbarkeit*. Frankfurt/Main: Suhrkamp.
Bennett, Jill. 2007. "Migratory Aesthetics: art and politics beyond identity". *Proceedings of the Ecuentro II: Migratory Aesthetics conference*, http://home.medewerker.uva.nl/m.g.bal/bestanden/Reader%20Encountro%20Mieke%20Bal%20FINAL%2030%20augustus.pdf (accessed May 17, 2010).

27 | See Buck-Morss 1991, p. 144

Berestein, Leslie. 2003. "Girl found in piñata during border check." *San Diego Union-Tribune*, November 12, http://legacy.signonsandiego.com/news/metro/20041112-9999-7m12pinata.html (accessed May 17, 2010).

Bhabha, Homi K. 1994. "Of mimicry and man: The ambivalence of colonial discourse." In *The Location of Culture*, Homi K. Bhabha, p. 85-92. London, New York: Routledge.

Buck-Morss, Susan. 1991. *The Dialectics of Seeing: Walter Benjamin and the Arcades Project*. Boston: MIT Press.

Buck-Morss, Susan. 1992. "Aesthetics and Anaesthetics. Walter Benjamin's Artwork Essay Reconsidered." *October* 62 (Autumn): p. 3-41.

Caillois, Roger. 2007 [1960]. *Méduse & Cie. mit Die Gottesanbeterin und Mimese und legendäre Psychastenie*. Berlin: Brinkmann & Bose.

Caillois, Roger. 1961. *Man, play and games*. New York: The Free Press of Glencoe.

Deleuze, Gilles. 1992. *Foucault*. Frankfurt/Main: Suhrkamp.

Deleuze, Gilles/Guattari, Félix. 1987. "1730: Becoming-Intense, Becoming-Animal, Becoming-Imperceptible…" In *A Thousand Plateaus. Capitalism and Schizophrenia*, Gilles Deleuze and Félix Guattari, p. 232-309. Minneapolis, London: The Univ. of Minnesota Press.

Denning, Michael. 1996. *The Cultural Front: The Laboring of American Culture in the 20th century*. London, New York: Verso.

Foucault, Michel. 1970. "Las Meninas." In *The Order of Things: An Archaeology of the Human Sciences*, p. 3-16. New York: Vintage.

Foucault, Michel. 1975. *Discipline and Punish: the Birth of the Prison*. New York: Vintage.

Horn, Eva/Kaufmann, Stefan/Bröckling, Ulrich, eds. 2002. *Grenzverletzer. Von Schmugglern, Spionen und anderen subversiven Gestalten*. Berlin: Kadmos.

Hsu, Hsuan L. 2006. "Who Wears the Mask?" *The Minessota Review* 67 (Fall): p. 169-175.

Marquez, Letisia. 2008. "Life in Colors: the Chicano Canvas." *UCLA Magazine* 46 (Spring), http://www.magazine.ucla.edu/features/chon-noriega/ (accessed May 27, 2010).

Mezzadra, Sandro/Neillson, Brian. 2003. "Né qui, né altrove – Migration, Detention, Desertion: A Dialogue." *Borderlands* 2/1, http://www.borderlands.net.au/vol2no1_2003/mezzadra_neilson.html (accessed July 5, 2010).

Moulier-Boutang, Yann. 2002. "Nicht länger Reservearmee. Thesen zur Autonomie der Migration und zum notwendigen Ende des Regimes der Arbeitsmigration." *Subtropen* 12 (April): p. 1-3.

Papadopoulos, Dimitris/Tsianos, Vassilis. 2008. "The Autonomy of Migration. The Animals of Undocumented Migration." *translate/eipcp*, September 15, http://translate.eipcp.net/strands/02/papadopoulostsianosstrands01en, (accessed May 25, 2010).

Pease, Donald. 2001. "Borderline Justice/States of Emergency: Orson Welles' Touch of Evil." *The New Centennial Review* 1: p. 75-105.

Rancière, Jacques. 1999. *Disagreement: Politics and Philosophy*. Minneapolis: University of Minnesota Press.

Rancière, Jacques/Rockhill, Gabriel. 2004. "The Janus-Face of Politicized Art. Interview for the English Edition of The Politics of Aesthetics." In *The Politics of Aesthetics*, Jacques Rancière and Gabriel Rockhill. p. 49-66. London: Continuum.

Santa Ana, Otto. 1999. "'Like an animal I was treated': Anti-immigrant metaphor in US public discourse." *Discourse and Society* 10: p. 191-224.

Taussig, Michael. 1993. *Mimesis and Alterity: A Particular History of the Senses*. London, New York: Routledge.

U.S. Code, Title 17, Copyright, as of 2002, 2000 Edition and Suppl., §101: Definitions and §105: Subject matter of copyright: United States Government work. http://uscode.house.gov/search/usco2.shtml (accessed May 27, 2010).

Images of Victims in Trafficking in Women
The Euro 08 Campaign Against Trafficking in Women in Switzerland

Sylvia Kafehsy

How can you use a large-scale event such as the Euro 08 to raise the awareness of trafficking in women in Switzerland? How do you inform the target group, soccer fans, in an appropriate manner that does justice to the "complexity of the facts and circumstances in women trafficking"[1]? Not an easy task, even more so if you follow the advice of a PR agency that has recommended to show a video spot on the large public screens in the designated fan areas and to show this spot between live broadcasts on TV.[2]

The *Euro 08 Campaign Against Trafficking in Women* was an initiative launched by more than 25 organisations. It was started by women's groups in collaboration with the Federal Police Office. This essay focuses on the video spot that informed spectators during the European soccer championship on women trafficking in Switzerland.[3] It is 50 seconds longs and shows women trafficking in a stereotypical manner. Women are offered for sale in a basement. It mainly focuses on one woman who at the end of the video spot works as a prostitute in a shop-window. In the last shot, the camera zooms in on her starkly made-up face. We are familiar with these images from campaigns on social issues as well as from regular commercials. Rhetorical devices such as narrative condensation, irritating sequences of images, staged catastrophes, concepts of extremes and borderline situations are deployed to effectively arouse compassion and to stimulate the readiness to make donations.

1 | Final Report, http://www.stopp-frauenhandel.ch/ (accessed October 2008).
2 | Agentur walker, www.walker.ag (accessed October 2008).
3 | http://www.stopp-frauenhandel.ch/spot/ (accessed October 2008).

From a critical feminist perspective, this type of representation stylizes women as naive, helpless, innocent victims without any agency. In the first part of my paper, I will focus on the effects of these visual strategies and will then turn to the question why women's groups, who basically want to support migrants, choose these visual strategies.

I am rather surprised that these images are imprinted on my memory, although I did not consider the effects in this video particularly impressive. Yet I can surmise the emotional potential of these images, such as compassion, shock, voyeurism, sensationalism, or sexual stimulation. The second part of my paper will deal with these attractions of the victimizing gaze.

I further assume that images of victims are generally very effective because of their emotional potential. Otherwise, they would not keep recurring so insistently. In the conclusion of my paper, I will plead that we should learn to better understand the effects of these images, since pointing out their falsehood will not eliminate them from the public sphere. However, this does not mean that we have to stick with these images. Particularly for a campaign that wants to do justice to the complexity of the subject matter, it would be interesting to examine uses of images that go beyond the paradoxical victim-perpetrator model. Consequently, this essay concludes with examples of visual strategies and new approaches in recent research on affects and emotions that transcend the concept of the victim and provide new perspectives on the subject matter.

PART 1: A CRITICAL ANALYSIS OF THE VISUAL STRATEGIES OF THE VIDEO SPOT

The campaign's background

In 2006, there was already talk in Germany of around 40,000 *forced prostitutes* during the World Soccer Championship. This rumor was denied after officials confirmed a mere five cases during the *FIFA 2006 World Cup*. This astonishing difference not only underlines the dubious credibility of figures purveyed by both sides, but also that our ideas about women trafficking and how to fight it are in no way commensurate with reality. The Federal Police Office was alarmed by this situation and publicly pointed out the difference of these figures. Nevertheless, they recommended a two-pronged strategy against women trafficking during the *Euro 2008* similar to the German approach: prevention and consciousness raising by NGOs, repression and control by the police. Women's groups in Switzerland actively supported this approach. The initiators of this campaigns thus entered the distribution networks of those who routinely peddle images of criminal foreigners, associatively linked to fantasies of highly professional criminal organizations that are supposed to dominate the sex business by means of corruption, blackmail and intimidation. Empirical

studies prove, however, that this is not the case with migrant prostitution.[4] And as Andrijasevic Rutvica points out, anti-trafficking campaigns also fail to consider that it is the tightening of immigration control as well as restrictive labour laws that create such conditions of trafficking and labour exploitation.[5]

Groups of sex workers like *Dona Carmen*[6] in Germany have frequently emphasized the negative effects of such image campaigns. The images reinforce the morally coded negative public image of the profession and consequently contribute to a broad acceptance for repressive measures. In this context, it is worth noting that since 2001 prostitution is no longer considered indecent in Germany, thus prostitutes are regular workers with rights and duties. I am not aware of any critical responses to the campaign in Switzerland. The legal situation of prostitution in Switzerland is still more complex and heterogenous. Since 1942 voluntary prostitution has been legal in Switzerland. Since 1973, prostitution has been a constitutionally protected trade and for many decades prostitutes have been liable and eligible for social security benefits. However, contracts of a prostitute with a client or an employer are considered immoral and lewd behavior by Swiss law.

Affects as Information

The board of the campaign was very well aware of the potential for conflict outlined above as can be surmised from their final report on the campaign. However, it lists only one actual countermeasure against the stigmatization of prostitutes with its very real effects on their working situation and their everyday life, namely that they refrained from using the term "forced prostitution" since it suggests an equation of prostitution and forced labor.[7] It also becomes evident in the final report that the images chosen by the PR agency walker have caused discussions amongst the initiators of the campaign. In the end, however, they apparently decided to rely on the know-how of a professional PR agency that would use sensationalism and the dramatization of images, based on the infotainment approach of contemporary campaigns and the input logics of mass media, to gain the attention of the large audience of the *Euro 08*. In the final report, they write that the spot should provide information on the "complex subject matter of trafficking in women" without degrading women by portraying them as mere merchandise.[8] The initiators consider the unequivocal representations of women being sold—just like at a "cattle auction" with pushing

4 | http://www.maiz.at/fileadmin/maiz/pdf_uploads/SIC_Migrantinnen_im_globalen_Sexmarkt_maiz.pdf (accessed July 2009); http://www.donacarmen.de/wp-content/uploads/Rostock.pdf (accessed July 2009).
5 | Andrijasevic 2007.
6 | www.donacarmen.de (accessed March 2009).
7 | http://www.stopp-frauenhandel.ch/files/dokumente/schlussbericht.pdf, p. 4.
8 | Ibid, p. 5.

and taxing—as a mere allusion to violence because of the editing of the spot.[9] The final zoom on the face of a woman displayed for prostitution in a store window is not considered an image of a victim, but "[...] an image of woman who cannot fathom what happens to her and to others"[10]!

These images turn the so-called *information* provided by the video spot into merely emotional appeals that leave the viewer with a threatening scenario and unanswered questions. Effects are ascertained, yet no causes are established. At times, the video spot seems to suggest that you only have to win the occasional duel with a women trafficking syndicate to eradicate the problem of women trafficking. The underlying ethical concept of good and evil casts women traffickers as barbarians and women as victims in order to denounce injustices, to arouse pity without asking for the causes. The position of main character of the plot merely points to the precariousness of a traumatic situation. The viewer is reduced to playing the role of the angry witness. Close-ups, like the one in the final zoom, heighten this effect. The face offers an ideal possibility of affective identification. The zoom makes the viewer aware of his passive position, while it simultaneously compels him to empathize with the other person. The close-up leaves no possibility for distance.

Moreover, the visual elements and sequences of the video, in particular when edited at a fast pace, heighten the impact of violent scenes in a manner that could very well turn out to be counterproductive. I will return to these unintended effects and the general unpredictability of an image's impact in the second part of the essay. First, however, I want to examine why a campaign intended to raise awareness of women trafficking produces a video spot that employs these visual strategies.

Why did women's groups choose this visual strategy for the video spot?

Pornography and prostitution have always been highly divisive issues for women's groups. In the 1980s and 1990s, Catherine McKinnon and Andrea Dworkin, the famous leaders of the *Women against Pornography* movement in the USA, and Alice Schwarzer in Germany have supported the prohibition and illegalization of prostitution and pornography. In the current debates, it strikes me that Alice Schwarzer, who is once again all over the place with her *PorNo* campaign, never talks about critical feminist issues like the critique of repressive ideas of moral behavior or of bourgeois institutions and value systems such as marriage. Also has the *PorNo* debate always resorted to the style of the yellow press that embellishes the sleazy public image of the sex industry with matching imagery.

In this, campaign women's groups and organizations with a critical feminist background, who are counseling and supporting migrant sex workers,

9 | Ibid, p. 5.
10 | Ibid, p. 5.

have chosen to use visual clichés. *FIZ MAKASI* since 2003 a sub-group of *FIZ*[11] in Zurich, as the main initiator of the campaign, is an interesting example for the development in recent years. Although *FIZ MAKASI* continues to counsel migrants, shifts in terms of issues, visual strategies, and general procedures point to a change of direction. Decisive for the project is the collaboration with the police. In the 1990s, FIZ frequently highlighted the economic situation of the women in their countries of origin and thus decisively shaped the political discourse on prostitutes from Eastern and Latin American countries. Today, however, they focus on preventive information in their countries of origin, designed to deter women from coming to Switzerland, and on cooperating with the police, consequently, it has become easier for them to create a consensus with groups that have never supported demands for the emancipation of women. The images in this campaign illustrate these developments and the conflicts of women's groups that want to support migrants, yet are opposed to prostitution. It is self-evident that seeking a consensus with these groups has never contributed to improving the discriminated situation of illegal prostitutes. Hence, these images continue a tradition of victimizing imagery for charitable purposes dating back to abolitionist visual propaganda. In almost every European country, prostitution functions in accordance with the abolitionist system that resulted from a movement in England at the end of the 19th century. In 1875, Josephine Butler, who supported the self-determination of women in this profession, founded the *International Abolitionist Federation* to protect prostitutes from coercion by the state. Its goal was legalization and information. Later women's groups only partially accepted these demands and morally condemned the sex business. The result is that prostitution is not forbidden in most West European countries, yet subject to state control.

PART 2: THE LURE AND ATTRACTION OF IMAGES OF VICTIMS

We associate images of victims with a strong expressive potential, since the suffering that these images stage comes close to our own physical suffering. Besides helplessness and horror, the video spot evokes other characteristics of this gaze. The staged scene that intends to visualize suffering simultaneously stimulates desire as both lust and disgust. Just like porn uses the humiliating ritualized interplay of lust and disgust, such as in scenes of female slave trading. An ad for the *Gonzo porn series*, for instance, lures potential customers with a plot in which perverted sex gangsters keep

11 | FIZ Fachstelle Frauenhandel und Frauenmigration, Zurich, http://www.fiz-info.ch/(accessed April 2010). FIZ MAKASI offers counseling for illegal female prostitutes in Switzerland and provide legal and (psycho-)social support for victims of women trafficking. FIZ MAKASI has become an important contact point for sex workers and a decisive force in the political discourse on prostitution by women from Eastern and Latin American countries.

women in cages like cattle. The image of the woman as passive victim is a classic topic of the porn industry that effectively stimulates sexual desires.

The plot of the video spot also illustrates the moral and ethical judgments inherent to the condemnation of prostitution. Among others, we encounter the despotic gaze on the Eastern prostitute and the idea that sex work is singularly dangerous. Since I was educated in a Catholic monastery, I understand only too well how these images determine prostitution as a symbolical limit. When we transgress this limit, we enter a danger zone where familiar norms are no longer valid. The images symbolically charge ways of life that are both feared and detested. As Laura María Agustín cogently wrote, some think that sexuality constitutes our identity, the Western idea of the self, which could be damaged by improper use.[12] In interviews she has talked about sex workers who make no distinction between paid-for sex and other work like paid-for household work or babysitting.[13] With statements like these she has provoked reactions ranging from irritation to massive protests.

Another salient attraction of images of victims is that their closeness to physical pain creates a semblance of authenticity resulting from the unreflecting crudeness of the representation. By taking the effects out of context and isolating them, the motif of the image is perceived as unreal. The representation of pain in images of victims does not tell a personal story, it rather generates attention by means of its event character. It suggests evidences that are not meant to inform, but to create the impression that similar events have taken place since times immemorial. By means of their irrational perspective and the persistent repetition of their motifs, they achieve a narcotic effect. From this perspective, they could be compared to spiritual imagery and its language of ritual.

Mostly, representations of suffering—as a kind of *visual humanism*—are deployed as a means to propagate proper ethical values. In scenarios generated by PR agencies, they become mere clichés of an aesthetics of pity geared to sell *issues*. The overstimulation of this emotional approach to ethics numbs the viewer until he becomes used to shocks.

The shock effect is another salient feature of images of victims. *Body genres*, such as porn, horror movies, but also the representation of suffering in general, attack the viewer with an almost physical intensity before he can use his intellect. The emphatic perception of characters in painful situations with its almost tactile effect can cause a shock. If this shock is produced within a clearly delineated victim-perpetrator scheme, these negative feelings are translated into an anger against the perpetrator who is seen as the cause of our own negative feelings. Empirical research on affective intelligence[14] offer surprising descriptions of the effects of fear and anger, which may be caused by media representations, in situations

12 | Agustín 1988.
13 | Agustín 2009.
14 | Huddy/Feldmann/Cassese 2007; Steenbergen/Ellis 2006.

that seem threatening and could cause a shock effect. Fear arises when it is not possible to determine a perpetrator or a cause. A feeling of helplessness and loss of control becomes predominant. Its consequences are a heightened awareness, the search for new information, and an openness for political alternatives. But if it is possible to determine a clear cause, the search for information is less elaborate. In other words, anxiety leads to thought, but not much action. The perceived hostility of the perpetrator reinforces stereotypes. Consequently, anger as motivating force of information gathering may lead to ignoring information that could provide a more complex perspective on women trafficking, for example.

Part 3: Conclusion

Images of victims can instill a wish to transcend our singularity and to assume responsibility for others. Particularly by means of their lack of reflection, their naturalizing effect, their physicality, their remembrance; by means of repetition, their dramatization of scenes; by means of stereotypes; by means of these particular forms of passivity, they insistently appeal to us and we cannot wholly resist their effects. Wherever images of victims may direct our emotions, their power lies in their capability of absorbing both desire and violence, in their silent insistence on ever the same message. W. J. T. Mitchell assumes that such images gain in force if we want to destroy them. Consequently, I believe that it makes sense to turn our attention to everyday imagery and its emotional structures and to the social practices attached to them.

But on the other hand there is my immediate experience with images of victims that they loose their impact due to their persistent repetition of stereotypes. My political problem with images of victims lies in the volatile range of emotions they engender. If used in a campaign against trafficking women, the stereotypes of suffering can develop a life of their own, as I have described above. The victims that are supposed to empathically move us can suddenly turn into toxic subjects from whom we have to protect ourselves.

Slavoj Žižek has pointed out in terms of the political role and position of victims that only a passive and helpless victim is a good victim. "The ideal subject-victim is a political subject without a clear agenda. [...] But a victim who decides to fight back, one who is no longer ready to play the role of a good victim, [...] it magically turns all of a sudden into a terrorist/fundamentalist/drug-trafficking Other."[15]

This statement could also be applied to the role of the victim in prostitution: only *environmental prostitutes* are good victims.[16] But if they begin to

15 | Žižek, Slavoj: Against the double blackmail. http://www.lacan.com/kosovo.htm (accessed August 2008).
16 | When the migration is considered to be forced and not a matter of choice, the term environmental refugee is also used.

question the environmental policies of the state, they suddenly loose their image as good victims.

We are familiar with the consequences of this victim-perpetrator perspective. The stigmatization of women as victims in turn leads to a focus on the protection of these victims. The paradoxical consequence of these framings is that it's suddenly the women who have a *problem* and thus need security precautions and legal protection. The image of the woman as victim creates the possibility of moral agency only for their helpers. This paradox was further emphasized by the *Euro 08* campaign appeal to tricks to alarm the police in case of a suspicion in order to *save* women from their dilemma.[17] The victim status of the women was not subject to discussion, on the contrary, they were treated as incapable of managing their own affairs, mere victims of their situation.

The camera movements in the video spot emphasize this paradoxical role of the victim: We become observers of a scene where women are apparently helpless victims of a violent situation. The camera provides us with a voyeur's gaze on the scene. We, the viewers, remain in a neutral und disinterested position, where we don't have to ask ourselves any questions, removed from the dramatic situation that is presented to us in a fast-paced editing style. However, if the board of the campaign claims to be committed to outlining the complexity of the issue, the viewer's *involvement* in the video should have been an issue. Since the camera does not merely record a situation, but decisively shapes our ideas and attitudes towards what we see, a visual strategy would have been required that breaks with the victim-perpetrator dichotomy. In the last shot, for example, the window display, the workplace of the prostitute, mirrors the potential customer on the street. A situation such as this offers a broad range of possibilities to destabilize the security of the viewer's position, in this case the soccer fan as potential client. The American artist Dan Graham has frequently shown in his work how such social orders and the role of media in maintaining them can be destabilized, particularly in regard to the viewer's position. In his famous 1976 installation *Public Space/Two Audiences* [constructed for the Venice Biennale], two audiences in a room with a mirrored-glass partition observe each other through the partition and their own reflection on the glass partition. "[...] As soon as there was more than one person, you would get a double reflection, beside the feeling of bewilderment caused by the continuous reversal between the observer and the person observed."[18] In this constant reversal of the situation—from observing to being observed— positions of power are being reversed. Moreover, his installation reflects the fictions that decisively shape the observer's position. "[...] His installations crystallized the fact that the position of the subject depends fundamentally upon a field given by another, by a field of fiction."[19]

17 | www.verantwortlicherfreier.ch (accessed October 2008).
18 | Di Bartolomeo Massimiliano 2003, p. 115.
19 | Pelzer 2001, p. 52.

Figure 1: Dan Graham—Public Space/Two Audiances 1976

Figure 2: Stop Trafficking—the spot: Agentur: walker

Certainly the interactive strategies in Graham's performances and installations with their visual transmissions are not immediately applicable to a video campaign. Their strategies, however, point out possibilities how the visibility of women trafficking with its intricate social and political entanglements could be reframed and could be turned into a site of personal and public reflection. Works of art such as these could be an inspiration for visual strategies that don't refuse to face complex contexts, but create nexuses where it is possible to interlace political and social contexts, or that show that victim narratives are indeed fictions and consequently can be experienced as such.

At the same time, various scientific approaches offer possibilities to break away from the victim-perpetrator paradigm. Particularly salient are new intellectual approaches and results of research to broaden our views on sexuality and sex work without playing down the use of physical violence. Marie-Luise Angerer, for example, describes a shift from the *sexual truth* to a *truth of the affective*.[20] She correlates emotions and effects to the way in which the West has turned sexuality into the crucial dispositif for personal development in the past 200 years. Certain ideas—for example that prostitution or rape can destroy our personality—are changing, hence we no longer have to confront these structures as passive victims.

LIST OF FIGURES

Figure 1: Dan Graham—Public Space/Two Audiances 1976—Private Collection http://humanscribbles.blogspot.com/search?q=dan+graham (accessed June 2009).

Figure 2: Stop Trafficking—the spot: Agentur: walker Werbeagentur, Zürich; Kreativteam: Pius Walker, Serge Pennings, Stephen Clark; Beratung: Patricia Meneghin; Regie: Jeff Thomas; Produktion: Sonny, London; Producer: Rhun Francis; Musik: Jonny Greenwood. www.walker.ag pictures http://www.stopp-frauenhandel.ch/spot/ still 3 (accessed June 2009).

BIBLIOGRAPHY

Agustín, Laura María. 1988. *Sex at the Margins. Migration, Labour Markets and the Rescue Industry.* London and New York: Zed Books.

Agustín, Laura María. 2009. *Border Thinking on Migration, Trafficking, and Commerical Sex,* http://www.nodo50.org/Laura_Agustin/ (accessed June 2009).

20 | Angerer 2007.

Andrijasevic, Rutvica. 2007. "Das zur Schau gestellte Elend. Gender, Migration und Repräsentation in Kampagnen gegen Menschenhandel." In *Turbulente Ränder. Neue Perspektiven auf Migration an den Grenzen Europas,* ed. Transit Migration Forschungsgruppe, p. 121-140. Bielefeld: transcript-Verlag.

Angerer, Marie-Luise. 2007. *Vom Begehren nach Affekt.* Zürich, Berlin: Diaphanes.

Di Bartolomeo, Massimiliano. 2003. "Dan Graham, ARTIST, Maybe ARCHITECT." In *Parkett* 68 – 2003: p. 114-117.

Huddy, Leonie/Feldmann, Stanley/Cassese Erin. 2007. "On the distinct political effects of anxiety and anger." In *The Affect Effect: Dynamics of Emotion in Political Thinking and Behavior,* ed. Crigler Ann et al., p. 202-230. Chicago, IL: University of Chicago Press.

Pelzer, Birgit. 2001: "Double Intersections: The Optics of Dan Graham." In *Dan Graham,* ed. Birgit Pelzer, Mark Francis and Beatrice Colomina, p. 36-79. New York: Phaidon Press.

Steenbergen, Marco R./Ellis, Christopher. 2006. "Fear and Loathing in American Elections: Context, Traits, and Negative Candidate Affect." In *Feeling Politics. Emotion In Political Information Processing,* ed. David P. Redlawsk, p. 109-135. New York: Palgrave MacMillan.

Žižek, Slavoj. *Against the double blackmail,* http://www.lacan.com/kosovo.htm (accessed July 03, 2010).

Invasion, Infection, Invisibility:
An Iconology of Illegalized Immigration

FRANCESCA FALK

What is perceived as familiar or unfamiliar, as being part of the community or not, is very often the result of mental and material images: Communities are imagined and thus constituted among others by certain kinds of visualizations.

Figure 1

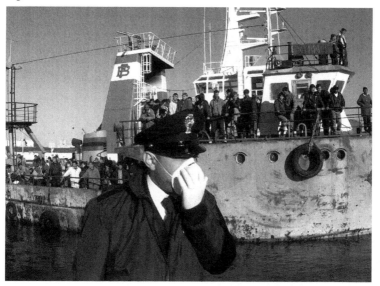

"A carabiniere with a mask, seen today in the harbour of Brindisi at the arrival of a fishing cutter filled with illegal immigrants from Albania"[1], says the caption of a photograph from *Associated Press*. With a white see-through glove, the elegant officer presses a mask to his mouth. He turns his back on the crowded ship where the illegalized immigrants are waiting. We see many men, some women and a few children, all standing and looking at us. In 1997 Albania was ravaged by riots and as a consequence many Albanian refugees[2] arrived in Italy. This was reminiscent of the situation in 1991, when Albania's former communist regime collapsed and mass emigration began.

Figure 2

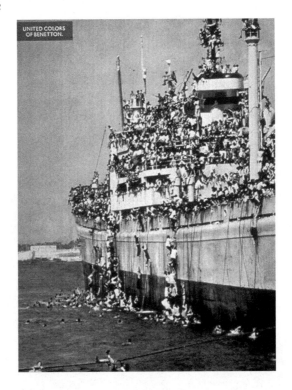

1 | Translation from the Italian by the author. A similar but shorter version of this article will be published in Drechsel, Benjamin/Leggewie, Claus, eds. 2010. *United in Visual Diversity. Images and Counter-Images of Europe*. Innsbruck: Studienverlag.
2 | In this article, the term "refugee" is used in a broader sense and not specifically to refer to persons whose asylum application have been accepted.

The year after, Oliviero Toscani chose a photograph of a cramped vessel for his provocative Benetton campaign.³ Interestingly, not only Benetton but also right-wing parties referred to the image of the cramped boat. In the 90s, the German right-wing party Die Republikaner used a poster of a Noah's Ark overcrowded with immigrants and in 2002, Lega Nord used a similar motif for an anti-migration campaign.⁴ Today, boat people clambering ashore at Europe's borders are a frequent cliché in the European media, while most of the numerous victims dying at sea during the crossing remain invisible. It is usually the survivors that are depicted in the media, and not the dead or dying or the actual sinking of a boat. On the other hand, "successful" and therefore unobserved passages also go "undocumented".

The image of the full boat can vary: Noah's Ark could in fact have a positive connotation in a Christian context and a ship full of Albanian refugees waving upon arrival in Italy may transport another message, as is the case in the example mentioned above.⁵ Such pictures are often polyvalent, their sense can change according to the context, as they contain a multiplicity of possible meanings; the viewer can feel either pity or fear—or both. Nevertheless, generally, packed ships have the potential to evoke a feeling of threat.

INVASION

However, the image of the "cramped boat" is not limited to the visual domain. During the Second World War, Eduard von Steiger, a member of the Swiss government, referred to Switzerland as a lifeboat in distress, with scarce supplies and restricted room.⁶ In claiming that there was a lack of space and resources, he wanted to legitimize a policy of highly restrictive admission of refugees to Switzerland. Many of the refugees who were refused entry later died in German extermination camps. Nevertheless, after the war, Switzerland imagined and presented itself as a humanitarian haven that had given protection to those who had needed it, as depicted in a huge two-part-poster made by Victor Surbek in 1946.

This poster, portraying Switzerland and especially the Swiss army in a very heroic way, was used for an exhibit that was displayed in several Swiss cities just after the war.

3 | This picture was taken in August 1991 in the Albanian town of Durrës; see Pagenstecher 2008, p. 610. Pamela C. Scorzin mentions the same picture in her article in this publication.
4 | Pagenstecher 2008, p. 610 and http://www.leganord.org/ilmovimento/manifesti2002.asp (accessed March 05, 2010).
5 | http://www.corbisimages.com/Enlargement/Enlargement.aspx?id=TL017003&caller=search (accessed March 05, 2010).
6 | Häsler 1989, p. 180.

Figure 3

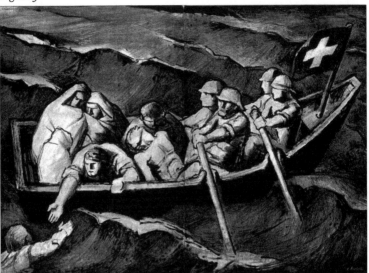

The aim of this poster was to collect money for the war-damaged countries of Europe. Even though Switzerland is shown here as an almost full lifeboat, there is still room for one more person, and therefore a strong man unhesitatingly reaches out to rescue a drowning man. In actual fact, during the war, Switzerland had for a long time granted asylum only to refugees who were under personal threat owing to their political activities, but not to those who were in danger because of their religion or ethnicity. More than twenty years later, in 1967, Alfred Häsler initiated a critical discussion about Swiss refugee politics during the Second World War with his book "*The Boat Is Full*". Twelve years later, in 1979, the same author wrote an article about the refugees coming from Indochina.

Häsler urged Switzerland to accept more fugitives; the title of his article was: "*Our Boat Is Not Full.*" It was in these days that the term *boat people* came into common use with the mass departure of Vietnamese refugees.

Today, cramped boats have become an icon of threatened borders. But the term icon as it is used here doesn't designate a particular photograph. In fact, similar pictures circulate widely. These images constitute a visual place of memory. However, that doesn't mean that these pictures are only effective on a visual level. In Byzantine times, icons were already characterized by an interrelation between the picture and the inscription. Furthermore, the boundary between words and images has fluctuated in the course of history.[7] Moreover, icons do not possess a stable status: an icon is not for everyone and for all time an icon, and its meaning can change according to the context.[8]

7 | Foucault 1997.
8 | Perlmutter 1998, p. 10.

INVASION, INFECTION, INVISIBILITY: AN ICONOLOGY OF ILLEGALIZED IMMIGRATION 87

Figure 4 and 5

INFECTION

Strikingly, on photos of boat people arriving in Europe, the refugees are often received by persons wearing a mask. In these pictures, migration meets medicine—and the military. This is the case in a photograph by the European Pressphoto agency. The caption reads: "In the early hours of Monday 20 October 2003 Carabinieri assist a severely dehydrated and starving immigrant Somali man as he is brought to Lampedusa island harbour—an island midway between Tunisia and Sicily. Coastguards counted 13 dead bodies on the wooden vessel when it was spotted last night off the island."

The situation shown and described here clearly differs from the image of the cramped boat. We see a fragile individual, who arrived, as the caption says, in a wooden vessel and not in a big fishing cutter. Some of his fellow passengers have died on the way. The flabby arm and the drooping hand reveal the weakness of the Somali—a weakness that contrasts with the strong body of the man supporting him who is also wearing a white glove and mask. This composition recalls countless representations of the Pietà, for example the painting by Giovanni Bellini in the Basilica of St John and St Paul in Venice.[9] On a polyptych of St Vincent Ferrer, a Spanish Dominican, Jesus is supported in a very similar way as the Somali refugee in the picture taken at the harbour of Lampedusa. An angel holds the bent arm of Jesus, so that the stigmata of Christ become visible. We can find the same posture, though as a reversed image, in the photograph of the Somali refugee.

Iconology always requires a certain amount of shared knowledge. I have no way of telling whether the photographer or someone at the European Pressphoto agency consciously had the image of the Pietà in mind when selecting this particular picture from a number of possible other ones. However, a visual tradition can cause a déjà vu effect[10] and thereby influence the way a photo is perceived even unconsciously.[11] The immigrant from Somalia thus appears here in visual imitation of the Pietà: as an innocent victim. Images of refugees in the tradition of Christian iconography are in fact widespread. For instance, you can find a motif recalling the Madonna with her child on the cover of Seyla Benhabib's book "The Right of Others"[12] where the author argues for an ideal of porous borders.[13] Or in the poster by Surbek, see especially how the upper part of one refugee's body is depicted in reference to Michelangelo's famous Pietà.

9 | This piece of art was created in 1460, but the attribution is contested. However, for the point I am making here the question of authorship is immaterial.
10 | Leggewie 2000, p. 156.
11 | Assmann 1998, p. 30.
12 | Benhabib 2004.
13 | The photo recalling a Madonna was taken by Sebastian Bolesch in Afghanistan in 2002.

Photos are always taken from a specific perspective, and representations showing immigrants as victims are one-sided insofar as migrants are active agents, not merely passive victims without agency.[14] They act in order to change their situation, even if the price is very high. There is however an important difference between the two pictures, the polyptych of St Vincent Ferrer and the Somali refugee, as the latter is alive, staring at us, thus breaking out of his role as a merely passive victim. At the same time, the picture of the Somali can provoke not only pity, but also fear, as the mask hints at the possibility of infection. This fear is born of the discursive and iconic connection between infection and immigration.

Medical discourses have long been important for the creation and legitimation of borders and for attempts to control the movement of people. Passports, for example, were to some extent a product of measures against the plague. My point here is not to downplay the medical risks that can result from the movement of people. But after taking a closer look at such pictures—for example, by analyzing the TV newscast—it becomes clear that very often only some of the persons present wear a mask, while others, performing the same tasks and standing just as close to the immigrants, do not. People's motives for wearing a mask are thus not at all evident.[15] Furthermore, "can we really be certain that immigrants have so many more infectious diseases as to justify our fear of them, whereas business travelers, sex tourists, students, all the other millions who cross international borders every day are somehow less affected by them? SARS has taught us differently"[16], as Philipp Sarasin has pointed out. This is why he emphasizes "how quickly fact and fiction melt in this area"[17].

The mask has an iconic character, but its connotation can vary. For example, the mask became more common in Europe with the bird- and the swine-flu. The mask was for some time a very "popular" motif for the mass media: In July 2009, on the cover of the Swiss tabloid L'illustré for example, Roger Federer and two other celebrities were shown in a photomontage wearing a mask.[18] In China, during the time of SARS, the wearing of a mask was an expression of solidarity. "The mask symbolized a rule of conduct—namely an obligation to protect the wider community—and an expectation regarding how one was to be treated by others [...]. More simply, the mask was the emblematic means by which people communicated their responsibilities to the social group of which they were members."[19] Howev-

14 | See here Fassin 2001, p. 5 or Bleiker 2007, p. 149.
15 | I made this observation regarding the Spanish *Telediario* TVE in 2008, specifically on August 26 (15:23), September 2 (15:20), September 4 (15:10), September 14 (15:15), September 22 (15:22).
16 | Sarasin 2006, p. 220.
17 | Sarasin 2006, p. 217.
18 | http://www.illustre.ch/edition/2009-30/index.htm (accessed 03 March, 2010).
19 | Baehr 2008, p. 150.

er, the significance of the mask is different in the analyzed pictures, which were obtained from European stock photo agencies. Here, territorial borders are superimposed on the boundaries of the body; migration appears at the same time as an assault upon the integrity of one's own body and that of Europe. Even though, in the constellations examined here, the image of the full boat and of the immigrant as a victim are connoted very differently, both pictures share a common feature: the fear of infection. Such images become part of our collective and cultural memory and thereby shape the perception of immigration as a threatening danger. However, it is remarkable that in Lampedusa tourists who are physically close to the site of conflict are usually shielded from its sight. Furthermore, the majority of the illegalized immigrants in Europe do not arrive as boat people; they come by land or by air. And in Europe, most of the so-called illegal immigrants have never crossed a border illegally, but rather had their residence permit withdrawn.[20] Despite this fact, the European icon for "illegal immigration" seems to be condensed to cramped boats full of male Africans.

COLONIAL CONNECTIONS

A poster made by *Lega Nord* shows a face of a Native American with a big feather headdress. The caption reads: "They were subject to immigration, now they live in reservations."[21] Under the logo of the *Lega Nord* showing the Lombard hero Alberto da Giussano with his sword, is written in red „Pensaci", "Think about it". Here, today's immigration is depicted as a colonial invasion. Following this logic, if immigration is seen as a colonial invasion, this needs to be answered by military means. But this suggested analogy between today's immigration and the colonial invasions is misleading, as there is no state with colonial ambitions behind today's immigrants to Italy who want to participate in the established economic system and not replace it by another. Quite the contrary, the European illegalization of immigration very often hurts people coming from former colonial regions, which becomes visible in the two photos discussed in this article: During Fascism, Albania was occupied by Italy and Somalia was an Italian colony, where the carabinieri were involved in atrocities. But *these* historical connections linking the past with the present are very often invisible in today's discussion about immigration. Even Switzerland, that was never a formal colonial power, participated in and profited by European Colonialism. In Swiss posters as well, migration is depicted as occupation and a kind of colonization.

20 | Schwenken 2006, p. 13.
21 | Translation from the Italian by the author: "LORO HANNO SUBITO L'IMMIGRAZIONE. ORA VIVONO NELLE RISERVE!" http://www.leganord.org/ilmovimento/manifesti2008.asp (accessed February 10, 2009).

Figure 6 and 7

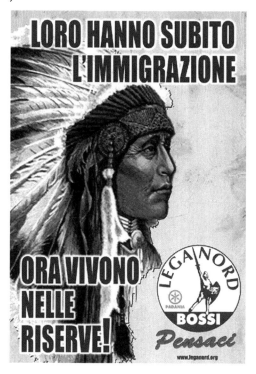

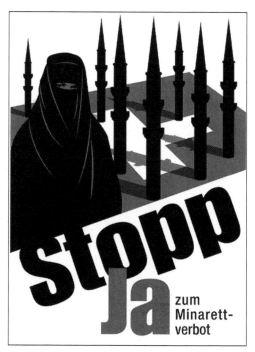

This is for example the case in a poster that was used for the initiative to ban the construction of new minarets. Here, the symbol of a certain group of migrants was illegalized (at the time of the vote, there were only four minarets in Switzerland). In the poster, we see a Swiss flag shaped like a map of the country and occupied by black minarets shooting out of it like missiles or big penises. In the foreground, a woman in black shrouded from head to foot appears in a paradoxical way as *both* a threatening and potential terrorist danger *and* as a victim that has to be saved. The topos of intervening for the sake of women was and is, as Gayatri Spivak's work has shown, often used to legitimize colonialism.[22] The poster was backed by the Swiss People's Party, which in 2009 had the largest number of seats in the Swiss parliaments. Some cities like Basel, Lausanne and Fribourg banned the billboards, based on regulations forbidding campaigns with racist discriminatory contents. The Federal Commission against Racism denounced the posters, saying they "defame Switzerland's peaceful Muslim population, feed prejudice and portray the Muslim community as wanting to dominate Switzerland, oppress women and trample on fundamental rights"[23]. Supporters of the ban claimed that the minarets were a political symbol of domination. It is a characteristic of discriminatory discourse, that the "Other" is described as both profoundly backward as well as extremely powerful, as a small minority that poses a grave threat to the vast majority.

In/Visibility

As an economic actor, Switzerland was part of the colonial constellation. But colonial violence was less visible here than in those states that explicitly understood themselves as colonial powers. It is not only this colonial past which is very often invisible (not only in Switzerland), it is also the illegalized immigrants themselves.

Also not very visible are the detainees in the deportation camps. These places are usually located in the periphery, and pictures showing these institutions circulate very seldom in the Swiss media. In Basel, for example, this prison-like building is located at the very edge of the city and near the border to Germany. In Zurich, it is in the area of the airport and therefore not easily accessible either. It is remarkable that fishing cutters packed with immigrants are a popular motif in European news media, whereas deportation camps receive only marginal coverage; they do not get a lot of public attention, at least in Switzerland. But there is not only a strategy of invisibility at work here, but a complicated dialectic of visibility and invisibility: For the spectacle of deterrence, the camps have to be visible

22 | Spivak 1988.
23 | http://edition.cnn.com/2009/WORLD/europe/11/29/switzerland.minaret.referendum/index.html (last accessed May 07, 2010).

for the *sans-papiers* themselves.[24] Furthermore, the camps can signalize that something is done against "illegal immigration". For journalists, it is very difficult to meet the detainees, and the NGOs working in these places shouldn't be too visible in the media in order to be able to carry out their work. The detainees themselves can be perceived, in Gayatri Spivak's terms, as subalterns who do not have the position and possibility to have their voices heard in public.[25] Sometimes, their "answer" to this situation is to set fire to their cells, as it happened several times here in Basel in 2007. The success in silencing illegalized immigrants here quite literally fanned the flames. Nevertheless, there are attempts to counteract this invisibility.

Figure 8

24 | I also investigate these problems in my dissertation *Eine gestische Geschichte der Grenze. Wie der Liberalismus an der Grenze an seine Grenzen kommt*, to be published in 2010.
25 | Spivak 1988.

On a white wall we see the black, sketchy silhouette of a falling person. The part of the body that breaks through a boundary is painted dashed; the fingers look like a skeletal hand. „I Am Not Exotic—I Am Exhausted", says the title of this graffiti-like project which was displayed in a public space in Basel in 2007. It visualised the invisibility of illegalized immigrants. The artist creates a transitory and at the same time ongoing project, which manifests itself anew on each wall. His tools are cheap felt-tip pens. As this (for once not illegal) graffiti will be erased after a certain time, Dan Perjovschi eludes the usual criteria of the traditional art market, where a particular product generates a profit. Illegalized immigrants are also often accused of violating the standard rules of the market.[26]

Some months before, the Romanian artist Dan Perjovschi had used a similar figure for an exhibition in the Museum of Modern Art in New York. The situation Perjovschi wants to depict is similar in all these places, as the artist himself has stated.[27] In Geneva in 2008, a bronze statue by Senegalese sculptor Ousmane Sow was unveiled. It stands near the train station. The monument shows an oversized seated man dressed for winter, in a heavy overcoat and a cap with earflaps. The figure is reading a newspaper. The inscription of the monument reads: "In order to make their silence speak."[28]

Incidentally, two years before, in 2006, another Ousmane Sow, a refugee from Guinea, died of thirst in a Swiss prison as a result of his hunger strike in protest against a court decision.[29] A study in 2005 estimated there were 90,000 unauthorized people living in Switzerland, other sources speak of 300,000 persons.[30] Women mostly work in private households, while men are employed on construction sites and in agriculture. Geneva is estimated to have a *sans-papier* population of at least 10,000.[31] It may not be a coincidence though, that such a statue was first created in the French speaking part of Switzerland. It is this region that often takes a stand against the growing repression that illegalized immigrants today have to face, for example the city of Lausanne, which backed the right of children of illegal residents to pursue apprenticeship programs. Generally, policies are getting more and more restrictive in Switzerland for illegalized immigrants—as in other countries in Europe. But in a surprise vote, in March 2010, one house of the Swiss parliament supported the decision taken in Lausanne to give the right to pursue apprenticeships to children

26 | I discuss this (misleading) argument in my dissertation Falk 2010.
27 | Perjovschi 2008, p. 74.
28 | Translation from the French by the author.
29 | http://www.augenauf.ch/bulli/art/b048a07.php (accessed February 28, 2010).
30 | http://www.sans-papiers.ch/site/uploads/media/AA-Traber_Andrea-FS_08.pdf (accessed March 01, 2010).
31 | http://www.geneva-city.ch/culture/coin_presse/dossier_presse/dpOusmaneSow.pdf (accessed March 01, 2010).

of undocumented immigrants.[32] Some right-wing politicians reacted very harshly to this intention and labeled it as illegal.[33]

The statue in Geneva does not want to honour a famous person as in the artist's series *"Merci"*, where, among others, statues of Gandhi, Rosa Park, or Mandela are being created,[34] but commemorates the *sans-papiers*. The artist himself is an immigrant who moved to France while in his twenties. Ousmane Sow said his only directive from mayor Patrice Mugny, a member of the *Green Party*, was to create a figure of "dignity" paying tribute to immigrants without the required residence permit. The mayor wrote in the press release that the sculptor would inscribe the solidarity with victims of social injustice and minorities in the public space and thereby remember Geneva's vocation to be an open city.[35] A group supporting illegalized immigrants welcomed the statue *"L'immigré"*. But at the inauguration ceremony it hoisted banners saying: "A statue is fine, a statute (protecting *sans-papiers*) is better."[36]

Also in France, the topic of the *sans-papiers* is highly contested. In the small city of Billère, the mayor Jean-Yves Lalanne, a member of the *Socialist Party*, inaugurated in 2009 a wall remembering deported illegalized immigrants who lived in this region before they were expelled from the country. In big letters words such as freedom, equality and solidarity, but also arbitrariness, deportation or shame are written on the wall of a public building. It recalls the "Communards' Wall" in Paris that commemorates the 147 communards that where shot here in 1871. Two folded hands as in prayer (again a reference to Christian iconography), an airplane or the hexagon of France surrounded with arrows likes spines, are some of the depicted symbols. The name, age and profession of fifteen deportees are written in white on a black plaque. During the inauguration, the ceremony was disrupted by a dozen members of a party of rightist extremists.[37] The *préfet* of the department, who represents the government and who exercises a control over local politics, also wants the wall to disappear. In January 2010, the administrative court ruled that the fresco has to be erased. The mayor refuses to accept the illegalization of these mural images: He wants to bring the case before the European Court of Justice. And if, in the

32 | http://www.swisster.ch/news/society/swiss-parliament-sends-mixed-immigration-messages.html (accessed March 07, 2010).
33 | http://www.nzz.ch/nachrichten/schweiz/lausanne_probt_den_aufstand_im_asylwesen_1.5056925.html (accessed March 07, 2010).
34 | http://www.ousmanesow.com/mac/fr/index.htm?mid=0&sid=0 (accessed March 01, 2010).
35 | http://www.geneva-city.ch/culture/coin_presse/dossier_presse/dp OusmaneSow.pdf (accessed March 01, 2010).
36 | https://www.swisster.ch (accessed August 01, 2009).
37 | http://ceciestunexercice.wordpress.com/2009/11/06/un-mur-a-la-memoire-des-expulses/ (accessed March 07, 2010).

end, there is no choice and the mural has to be erased, the mayor wants to paint the wall white.[38]

Conclusion

In my paper, I contrasted two types of pictures showing boat people in the European media. Either immigration is depicted here as an invasion, where refugees appear as an anonymous and threatening mass—or an individual refugee is portrayed as a victim, following the tradition of Christian iconography. Even though the analyzed image of the cramped boat and the image showing a victim are connoted differently, both pictures share a common feature: The fear of infection. Such images can evoke both pity and fear; they recall the concept of catharsis, where the catastrophe seems to be inevitable. This makes it easier for the beholder to refuse responsibility, all the more as it is not easy to determine who is to blame *directly* for this deadly drama which takes place in the Mediterranean.

Boat people are a frequent cliché in European media, even though in 2009, such pictures were less often present, as the media space was occupied by the economic crisis and the swine-flu. Furthermore, due to treaties for example between Libya and Italy, boats have recently been more often forcibly prevented from leaving, with less media coverage as a result, since only the ones that make it to the European borders receive any attention. The global problem of an unjust economic system manifests itself at the border and becomes visible here, for example at the beaches of Lampedusa or in Ceuta, but it is not actually produced there.

The European illegalization of immigration very often hurts people coming from former colonial regions. These historical connections linking the past with the present are very often invisible in today's discussion about immigration. Slogans such as: "We are here because you were there"[39], used in demonstrations of (illegalized) immigrants, try to counteract this. Also monuments are raised in order to make illegalized immigrants and the violence produced by their deportation visible in public. Such monuments not only want to remind, but also to warn and challenge; they are directed to the past as well as to the present and the future. It is precisely the metaphor of a *fortress of Europe*, which evokes the image of a clear-cut boundary between in- and outside, that makes the existence of illegal immigrants inside Europe invisible. Besides, the metaphor of the fortress has some implications: There is a religious connotation to

38 | http://www.ldh-toulon.net/spip.php?article3700 (accessed March 07, 2010).
39 | http://www.newamerica.net/publications/articles/2005/were_here_because_you_were_there (accessed March 07, 2010).

it.⁴⁰ Furthermore, in war no one is allowed to leave a fortress, which is not the case for the Europeans themselves. In fact, there are different laws applying to the movement of people. But even though Europe may evoke, under a certain perspective, a fortress, it is a fortress with an entrance for servants.⁴¹ Europe's borders thus become filters that weaken the position of the illegalized immigrants, as it is very difficult for *sans-papiers* to stand up for their rights.⁴²

The illegalization of migration is produced by a contingent legal system, but in the media it is often naturalized and migratory movements are shown as a natural disaster, where the mass of African immigrants appears as a tsunami that floods the dam erected by the European Union. What global and local conditions make people leave, is more often than *not* shown in the mainstream media. Furthermore, the boundary which separates legal residents from illegalized immigrants is most often not seen by people who are not directly affected by it. Borders which are not perceivable are all too often the most powerful ones and the most impenetrable. Moreover, media consumers seldom come across the nationally approved compulsory measures for which they are clearly politically accountable—such as in Switzerland detaining illegalized immigrants in prison-like deportation camps for up to two years. States are clearly accountable for the deportation camps on their national territory; here, there is doubtless some possibility for action. However, the "home-made" violence produced by illegalizing immigration does not become visible in the media. Apparently, the visibility of deportation camps is (still) embarrassing for the "general public", as closed borders are in contradiction with a "freedom of movement", which would be in fact a classical liberal notion.⁴³

LIST OF FIGURES

Figure 1: Luca Bruno, Carabiniere with Mask, March 18, 1997. Photograph: AP/Keystone.
Figure 2: Oliviero Toscani, Benetton Group Campaign 1992.
Figure 3: Victor Surbek, lithograph, 1946, 127/182 cm.
Figure 4: Franco Lannino, Carabinieri assist a severely dehydrated and starving immigrant Somali man, October 20, 2003. Photograph: EPA/Keystone.
Figure 5: Giovanni Bellini, Polyptych of St Vincent Ferrer, 72/67 cm, Basilica of St John and St Paul in Venice, 1465-68. Source: Olivari, Mariolina. 1990. *Giovanni Bellini*. Antella: Scala, p.28.

40 | As embodied by Luther's famous hymn *Ein feste Burg ist unser Gott*.
41 | Marischka 2006, p. 152.
42 | Schilliger 2008, p. 166.
43 | This is one topic of my thesis Falk 2010.

Figure 6: A poster made by *Lega Nord* from 2008/2009: http://www.leganord.org/ilmovimento/manifesti2008.asp (accessed March 07, 2010).
Figure 7: Poster used for the initiative to ban the construction of new minarets in Switzerland: http://www.minarette.ch/pdf/F4_Plakat.pdf (accessed March 07, 2010).
Figure 8: Dan Perjovschi, "I Am Not Exotic—I Am Exhausted", Basel 2007, photo taken by the author.

Bibliography

Assmann, Aleida. 1998. "Frauenbilder im Männergedächtnis bei Pater, Proust und Joyce." In *Bildergedächtnis, Gedächtnisbilder*, ed. Marion Strunk, p. 24-65. Zürich: Edition Howeg.
Baehr, Peter. 2008. "City under Siege: Authoritarian Toleration, Mask Culture, and the SARS Crisis in Hong Kong." In *Networked Disease. Emerging Infections in the Global City*, ed. Harris Ali and Roger Keil, p. 138-151. Oxford: Blackwell Publishing Ltd.
Benhabib, Seyla. 2004. *The Rights of Others. Aliens, Residents, and Citizens.* Cambridge: University Press.
Bleiker, Roland/Kay, Amy. 2007. "Representing HIV/AIDS in Africa: Pluralist Photography and Local Empowerment." *International Migration Review* 51: p. 139-163.
Falk, Francesca. "Eine gestische Geschichte der Grenze. Wie der Liberalismus an der Grenze an seine Grenzen kommt." To be published.
Fassin, Didier. 2001. "The biopolitics of otherness." *Anthropology Today* 17: p. 3-7.
Foucault, Michel. 1997. *Dies ist keine Pfeife.* München: Carl Hanser.
Häsler, Alfred Adolf/Dürrenmatt, Friedrich. 1989. *Das Boot ist voll: Die Schweiz und die Flüchtlinge 1933-1945.* Zürich: Diogenes.
Leggewie, Claus. 2000. *Amerikas Welt: Die USA in unseren Köpfen.* Hamburg: Hoffmann und Campe.
Marischka, Christoph/Pflüger, Tobias. 2006. "Das militarisierte Grenzregime der EU." *Widerspruch* 26: p. 143-154.
Pagenstecher, Cord: "'Das Boot ist voll'. Schreckensvision des vereinten Deutschland." In *Das Jahrhundert der Bilder. 1949 bis heute*, ed. Gerhard Paul, p. 606-613. Göttingen: Vandenhoeck & Ruprecht.
Perlmutter, David D. 1998. *Photojournalism and Foreign Policy: Icons of Outrage in International Crises.* Westport, Connecticut: Praeger.
Sarasin, Philipp. 2006. *Anthrax. Bioterror as Fact and Fantasy.* Cambridge, Mass.: University Press.
Schilliger, Sarah. 2008. "Migration im Kontext der Globalisierung des Kapitals." In *Zukunft der Demokratie. Das postkapitalistische Projekt*, ed. Beat Ringger and Willi Eberle, p. 155-187. Zürich: Rotpunktverlag.

Schwenken, Helen. 2006. *Rechtlos, aber nicht ohne Stimme. Politische Mobilisierungen um irreguläre Migration in die Europäische Union.* Bielefeld: transcript.

Spivak, Gayatri. 1988. "Can the Subaltern speak?" In *Marxism and the Interpretation of Culture*, ed. Lawrence Grossberg and Cary Nelson, p. 271-316. Chicago: University of Illinois Press.

Voice-Over Image

PAMELA C. SCORZIN

"Das Boot ist voll!"—the boat is overcrowded, but is it really? The slogan has been all too frequently used in so many recent political debates and disputes, but the critical discussion of the visual power and the impact of stereotypical images that deal with undocumented migration and illegalized immigration in our European context has, if anything, been neglected in our contemporary visual culture studies—especially when they are linked to such a strong, but problematic metaphor like "Das Boot ist voll!" (the boat is full). Coined during World War II in Switzerland to repel Jewish refugees[1], it actually means: Our country is overrun by too many foreigners. With this most quoted, often misused and politically instrumentalized example of a strong metaphor I would like to reflect on the relations of visual and verbal representations in the context of social and political issues. I will, therefore, first of all be looking at the following questions: How do slogans and stereotypical images like the "boat is overcrowded" actually shape the way we perceive migration, or rather illegalized immigration? Who creates and distributes these images? Why, and under which conditions? Where do the stereotypical as well as metaphorical images originate?[2] Where and why do they seem to circulate endlessly in our culture? And are there alternatives to these strong clichés—and in how far? Might the human voice and its individual identity in the end have the power to break the regime of the visual in imagery and rhetoric, and can we conclude that sound portrays the individual situation in a less stereotyped way? The aim of my article is to deal more critically with the visual evidence of illegalized immigration by first demonstrating and outlining the origin of metaphorical images and stereotype clichés with some

1 | Häsler 1979, passim. See also Pagenstecher 2008, p. 606-613.
2 | Thoughts and questions provoked by the organizers in the CFP of the Basel conference Images of *Illegalized Immigration*, posted on www.arthist.net (December 19, 2008). My cordial thanks go to the organizers of this international conference, Christine Bischoff, Francesca Falk, Sylvia Kafehsy, to American media artist Cindy Gates and, of course, to W. J. T. Mitchell for our conversations.

particularly prominent and significant examples, and then showing that some contemporary mixed-media works of art actually do have the potential, the visual aesthetics as well as the multimodal rhetoric to operate as helpful counter-representations in this field.

So let me begin by giving an outline of the stereotype cliché involved in the imagology of illegalized immigration. Presumably most of our readers are already familiar with the media coverage of the so-called *Lampedusa protests* recent years. These violent protests against displaced persons and undocumented migrants in the Mediterranean countries showed us again and again small, frail boats and old vessels overcrowded with wretched refugees from Southeastern Europe and North Africa, becoming illegal immigrants and clandestine workers (*clandestini*) when they happen to cross the Mediterranean Sea (Figure 1), the *mare nostrum*, with their improvised maritime vehicles, officially referred to as "suspected illegal entry vessels".

Figure 1

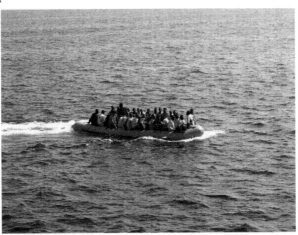

These iconic images of boat people are not only taken and used to report and to document, but above all to emotionalize, and this in a disconcerting way, insofar as they produce and demonstrate an extreme paradox in the visual documentary. Why? Because they present in a most questionable way people crossing borders unlawfully—like a coin with its two sides: On one side they are made highly visible in the sense and form of actually being stamped and stereotyped, as strange and exotic foreigners, into certain widespread and long-standing clichés, such as the well-known image of waves and floods of poor, hungry, strange and unskilled dangerous aliens; and, at the same, on the other side, they are virtually made invisible as individuals and human beings, each with their own dreams and wishes, their hopes and desires. So the stereotypical, even iconic cliché, itself travelling long-distance across our global mediascape, in the blink of an eye shapes the way we perceive and experience the real such as this overwhelming, seemingly endless stream of people, currently sweeping into Europe via

the wide expanse of the Mediterranean Sea. Hereby echoing the maritime image of a flood that follows in the wake of a global crisis and worldwide migration phenomena. An immigration that is triggered off by seemingly never-ending repetitions of war, terror, socioeconomic inequalities, social and political conflicts, famine, overpopulation, global warming and the many more catastrophes of our times. Sources that constantly nurture the bulk of various push and pull factors for global migration processes.

To sum up here, the most common stereotype cliché Europeans can encounter at present, receiving wide currency again under the *Lampedusa protests* since the beginning of the new century, is once more that of lost or shipwrecked boat people. The term came into common use during the late seventies in connection with the mass escape from Communist-controlled countries in Asia following the Vietnam war. And although it referred to illegal immigrants and undocumented asylum seekers it was used to raise sympathy with the refugees before the end of the Cold War. While, during the seventies and eighties, the Vietnamese refugees had been represented in the public media with the iconic symbol of a floating ship, which in our Western culture traditionally stands for the idea of a closed, homogeneous society and of mankind's rescue solidarity, after 1989 the iconic image of boat people seems to have taken on a rather reversed, xenophobic sense: picturing masses of strange dark people, crowded in crudely made vessels that carry the connotations of arrows and missiles from newly hostile foreign cultures. So what is the possible origin of re-using and relaunching this iconic image? Why has it been converted from a positive one to such negative one? Why has the archaic symbol of Noah's Ark become synonymous for the state of being overcrowded and too heterogeneous instead of its former, rather optimistic and hopeful meaning as that of a blessed, surviving community—with the option for a new and better start in life, perhaps in a new promised land—a second paradise? Now the suspicion prevails that there are too many different species, mantled in the fear of overpopulation and the *angst* of loosing living space. Yet where is the actual evidence that the boat really is already too overcrowded—since these boats are only the temporary vehicles for a transition? All the same, (documentary) images are still best believed to show the truth and reality—and even more so when they are connected to a strong verbal metaphor.

So the theme "das Boot ist voll!" (the boat is full) was even picked up by Italian photographer Oliviero Toscani, well-known worldwide for designing controversial advertising campaigns for the Italian brand *Benetton* from 1982 to 2000.[3] Most of these advertising campaigns were actually mere commercials for the brand, always composed of rather controversial photography, usually without any further comment or slogan with only the company logo *United Colors of Benetton* as caption. But Toscani dealt with the discussed visual metaphor in a more ambivalent and sarcastic

3 | Francesca Falk mentions the same picture in her article in this publication.

way (Figure 2). In 1992 he used an anonymous press photograph by the *Albanian Telegraphic Agency* which showed an Albanian refugee ship at the city Dürres, near the Albanian coast. The commercial work recalls the embarkation of Albanians at Bari, Italy on August 18th, 1991. We see a huge ship besieged by hundreds of wretched people who are obviously chasing a chimera of freedom and economic dignity, oppressed in their own country and refused legal entry elsewhere. So this documentary (outer) image from the third Balkan war coincides with and reloads not only an ancient iconic (inner) image like Noah's Ark, but also the already negatively communicated traditional ones like Charon's ferry carrying the souls of the dead or the sinister ghost ship, and more recently again even the real ones such as the authentic, non-fictitious pirate ships roaming today's oceans, again stirring up fear and loathing across the worldwide seas. Yet, Toscani's poster also quotes and refers explicitly to contemporary political media campaigns of the extreme right, since, like the book cover by Michael Schwelien[4], it evokes the resounding populist slogan "Das Boot ist voll!" The metaphorical visual is characterized as the highly emotional and affective that beats the rational and objective argument such as facts and statistics, which clearly show in numbers that the actual total population within Europe as a whole is gradually and dramatically decreasing at present. One need only think of our current pension debates.

Figure 2

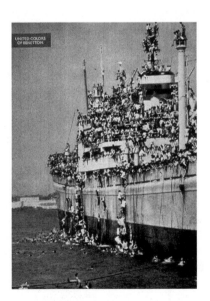

4 | Schwelien 2004.

So I have to ask again, is the ship really already too overcrowded? At least, the visual evidence of what we usually get to see in the media is profiling stereotypes and more and more clichés: The threat and danger of a mute, growing crowd of strange and exotic foreigners, pictured as an anonymous, menacing dark mass of hungry aliens, illegal invaders and suspected criminals and dangerous violators. Racial others who all look alike. Invasive aliens, anonymously portrayed in pictures taken by press people and officials, not by the migrants and displaced peoples themselves, of course. They themselves are, of course, usually left out in this crucial visual role-taking and role-making process. So here we have already a fundamental hierarchy in the relationship with them, the others, and us: On the one side subjects who have the power and tools to create and control images, and on the other, those powerless and passive objects of that fatal image-taking process.

Another dialectic dualism which has to be considered is the tricky interaction of the mental and the real, the inner image and the outer picture. For some years now, these refugees have been trying to cross Europe's outer borders via the Mediterranean Sea in thousands, breaking European immigration laws in doing so (in 2008 for example a number of approximately 33,000 people from North Africa reached the small European out-post island and Italian holiday resort Lampedusa[5]), but many died during their passage and risky travel. There are countless and nameless graves at the bottom of the Mediterranean, as, for example, the artistic research group *Multiplicity* has shown us in its multimodal project *Solid Sea: Ghost Ship*, a multimedia installation prominently staged at the Kassel *documenta 11* (2002). Or, if the refugees were more fortunate, they were arrested by border police officials, only to be transferred to detention and deportation camps in which their future continues to be threatened. But then the real picture is enhanced and fuelled by another one, which is optically invisible. This image comes form a distant past and incorporates cultural history. It is not only an archaic as well as an historical one from our own past, the European cultural history, but a rather uncanny one, too, because the ship is also the most prominent vehicle and vessel of European imperial conquest as well as European migration to the New World such as the United States or Australia. And not to forget, transport of and trade in slaves also took place by boat during the 18th and 19th centuries. The blacks were sold in Africa and then used to row themselves over to other shores, such as North America. Now it seems the coloured are tragically delivering themselves once more into similar uncertain situations—especially when they have to pay enormous amounts of money to so-called people smugglers for their escapes and flights.

So the ship or boat might be regarded as the crucial instrument and main vehicle of European conquest, colonialism, imperialism, emigration, and nowadays even globalization and therefore it is, as a strident image,

5 | See also Kermani 2008.

part of European collective consciousness. But it now seems as if those forceful ships of discovery, endeavour and enterprise, of colonial conquest, territorial invasion and global discovery are, in fact, returning home again. However, they are now loaded with the bitter fruits and harvests of long-time European imperial politics, cultural hybris and economic greed. It is like projecting an image of yourself and reversing the valence of that image. We can experience a strange duplication of imagery with a sense of inversion. Interpreted as such, it appears we see boats full of our frightening specters, ghosts we ourselves actually provoked and summoned and are now unable to rid ourselves of. It is a return of the unconscious and the repressed in a double sense. Or it is the repetition of what so far the (former) European imperial countries have never been able to understand and accept in their cultural-historical past and present; something which is not only a current socio-political challenge, but a psychological one as well: a strange haunting. Manifested in the sensation of the spectral, such as in the vision of ghost ships cruising endlessly across the Seven Seas, bound homeward to their mythic haven in the Mediterranean—without number, mostly in the dead of night, clandestinely and silent, like shadows and ghosts without names and voices—image phantoms floating through space and time, now occupying the realm of our media space. By contrast, European emigration and expatriation still seem to be featured again in a reversed, positive way in European media. It stands for the pursuit of greater socioeconomic opportunities and better quality of life in the countries of destination. The enterprising emigrant, the travelling businessman and the modern tourist are iconic figures of modern society in the West. "Off into the world!"—a slogan used by the German Emigration Center, a newly founded museum of European emigration in Bremerhaven[6]—really does not sound like a threatening martial slogan here.

So here we have to intervene in the diffuse gap between the conscious and the unconscious, and the task will be to distract the real from the mental images and to consider and find new images for the social and political problems of illegalized immigration. It will, of course, not solve the problem as a whole, but should now give us a better awareness of the interconnectedness and the intertwined actions of the mental and the real in representations in general. A metaphorical image like "das Boot ist voll!" can be considered a visual metaphor acting as a powerful agent in political debates. It has a subtle power and hidden impact in political realities and theoretical discourses insofar as it stirs up strong emotions. And therefore we might become blind to capturing the actual real.

We all know by now that pictures have the power and ability to generate a reality of their own. So, if we still have to stick to the ships as our most prominent historic vehicles of mobility and migration, let us at least build more and better, larger and newer ships, if the old ones

6 | See www.dah-bremerhaven.de.

are supposed to be already too overcrowded—as artists for example create new visual vehicles in juxtaposition and contradiction to the stereotyping media industry... Because we finally have to consider the ethical implications of the aesthetics of iconic or metaphorical images. And we should explore the iconographical power that permeates these images as they endlessly circulate through our culture via media channels. A number of multimedia artists see it as their task to make significant interventions into the constant image flow in our visual culture industry today. Actually, multimedia works of art do have the potential to operate as helpful counter-representations in this field.[7] This is however not only a question of creative imagery, but also rather an indication of the rise of a "sonic turn" in the contemporary arts.

As seen with the issue of illegal immigration, we mostly perceive and experience iconic images floating through our global media scape—and the people in these pictures are more often than not mere mute specters, and remaining so, since even the press rarely gives them a voice. But at least there are now some international media artists like the *Multiplicity* group from Milan or Sarajevo-born media artist Danica Dakic who have recently represented them with sound samples in their gripping mixed media installations: There we can experience what I choose to call "voice-over images". It is a subtle strategy to break the regime of traditional imagology and the hegemony of the dominating visual in our media culture by remarkable sound elements, combining journalistic research, documentary, poetics and artistic design as well as acoustic components to a multi-faceted portrait that draws a new perspective on the issue and essentially lives from its integral sound parts in which the voice of the human and its individual and unmistakable identity play an important part. It is then more than a mere text-image-issue. The image and the voice/the sound together form a new, multimodal complex meaning for the viewers, or the users, such as the players of the computer game "Frontiers—You've reached fortress Europe"[8], produced by *gold extra* artists from Salzburg (Austria). It enables its players to experience in a 3D world with authentic sound elements life on both sides of the military border at the Maroccan-Spanish fenceline in Ceuta. The gamers using avatars, play either a refugee or the border patrol in challenging stations of several, illegalized routes to Europe. The sound parts enhances the effects of immersing oneself into a virtual 3D frontier incident and getting affected by this situation which actually simulates daily routines on the outer European borders.

In Danica Dakic's *documenta 12* entry *El Dorado* (2006-2007) we merely encounter young illegal immigrants to Europe via the classical genre of single video portraits: Those young foreigners tell the audience before

7 | Cf. Dierck Schmidts picture series SIEV-X – Zu einem Fall von verschärfter Flüchtlingspolitik, (2001/2003).
8 | See www.frontiers-game.com; www.goldextra.com.

a "background" of exotic panoramic wallpapers and lush paradise tapestries of the 18th and 19th century, imageries from the heyday of European imperialism and colonialism, their own individual stories, their pressing hopes, private dreams, ideals and wishes for the future. The spaces of the Tapetenmuseum Kassel became the scenery and action space for the young people's dreams and desires, their needs and fears.

Now Europe is imagined in many undeveloped countries of a postcolonial, yet globalized world as the new paradises. Ten young protagonists, former unparented, underage refugees that had been taken in by the Hephata, a Protestant charitable organization in Kassel, Germany, pose and perform before the artist's camera, they sing and dance, they run and fight, and relate their experiences and visions to their audiences. They were free to represent themselves in whichever way they wanted and tell about their paradises. By turning representation into self-representation, Danica Dakic's mixed-media installation allowed those young immigrants without papers to express themselves with their whole bodies as a signifier of identity in whichever way they desired, as the artist explained: "Für die Klanginstallation im Tapetenmuseum habe ich 200 Jugendliche befragt, was El Dorado für sie bedeutet—Lebenserfahrungen, Glück, Durchhalten. Dann habe ich das Audiomaterial zusammen mit dem Komponisten Bojan Vuletic in 25 Tracks verarbeitet, die jeweils mit einem klassischen Schlaginstrument unterlegt sind."[9] Sound parts and moreover voice speech in general play a central part in Dakic's multimedia art since she considers it a crucial element for becoming aware of the body and its personal as well as its cultural identity. The single voice can be seen, at the same time, as an expression of the self and as an acknowledgment of the body. And the body, the naked life in the sense of Agamben's *homo sacer*[10], is the only thing refugees worldwide bring along with them and what still constitutes their identity. You can manipulate their image, but you won't be able to change their voices. That is something they remain in control of. And in the end, speech might be able to break the domain of the hegemonic visual up into a multi-perspective and multi-dimensional portrait.

9 | Danica Dakic on her *documenta piece in* "documenta 12: Traum und Trauma, 28.06.2007 | 16:39 | Interview: Johanna Hofleitner (Die Presse – Schaufenster)". See also Dakic 2009/2010, p. 80-95; www.danicadakic.com.
10 | Agamben 2002.

Figure 3 and 4

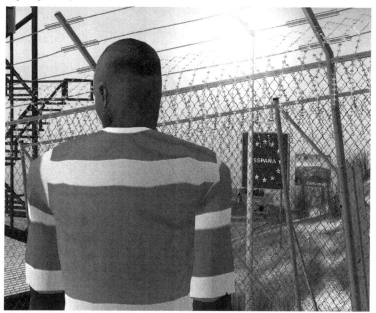

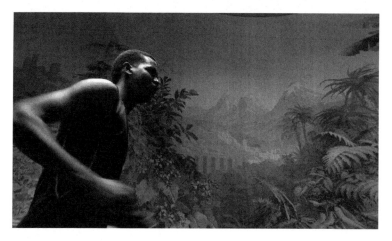

In giving discriminated, marginalized and illegalized immigrants not only a face, but also, in a double sense, a "voice", Dakic's mixed-media installation makes us aware in the end that the refugees portrayed here have not only an individual identity but are individuals and human beings just like the rest of us, the audience, if we just allow those images to have an identity, an individual identity generated by a voice-over—even though they still might fit into a certain repertoire of our hackneyed clichés picturing illegal immigration. However, the regime and evidence of these will be forever discredited and the critical discussion opens them up instead for new meta-discourses in the fields of critical cultural studies.

List of Figures

Figure 1: Anonymous, *Boat people before the coast of Lampedusa*, 2004.
Figure 2: Oliviero Toscani, *Boat*. Benetton Group Campaign 1992.
Figure 3: Gold extra, Screenshot of *"Frontiers—You've reached Fortress Europe"*, Computer game. 2008f. Courtesy: the artists gold extra, Salzburg (Austria).
Figure 4: Danica Dakic, Screenshot of *"El Dorado"*. Video Installation. 2006/07 (VG BILD).

Bibliography

Agamben, Giorgio. 2002. *Homo sacer. Die souveräne Macht und das nackte Leben*. Frankfurt/Main: Edition Suhrkamp.
Häsler, Alfred A.1979. *Das Boot ist voll... Die Schweiz und die Flüchtlinge 1933—1945*. Zürich: Diogenes, 2nd. Edition.
Kermani, Navid. 2008. "An Bord sind Maria und Josef. Auf der italienischen Insel Lampedusa kommen die Bootsflüchtlinge aus Afrika an. Dann verliert Europa sie aus den Augen." *DIE ZEIT* 52, December 17.
Pagenstecher, Cord. 2008. "'Das Boot ist voll.' Schreckensvision des vereinten Deutschland." In *Das Jahrhundert der Bilder. 1949 bis heute*, ed. Gerhard Paul. Göttingen: Vandenhoeck & Ruprecht.
Schwelien, Michael. 2004. *Das Boot ist voll. Europa zwischen Nächstenliebe und Selbstschutz*. Hamburg: Mare Buchverlag.

Masking, Blurring, Replacing:
Can the Undocumented Migrant Have a Face in Film?

Olaf Berg and Helen Schwenken

The question whether undocumented migrants can have a face in film points first of all to the ethical responsibility that is implicit in every documentary film, because the filmmakers have to consider the possible harmful effects their film can have for those being represented in it. "Ethics becomes a measure of the ways in which negotiations about the nature of the relationship between filmmakers and subject has consequences for subjects and viewers alike", states film scholar Bill Nichols.[1] This general consideration gains special importance when the film's subjects are as vulnerable as undocumented migrants. Their legal status generates more often than not a need to be "invisible" to the police and therefore to control their visible exposure. Showing the migrant's face, flat or work place can help government authorities to trace them and lead to their detention and expulsion.

Thus the visual appearance of undocumented migrants becomes a critical point for every documentary on the issue of irregular migration. On the one hand the visual presence of a person is vital for the viewer's positive relation to the subject. On the other hand it exposes the undocumented migrant to a considerable danger. Caught between those two conflicting interests, many filmmakers opt for techniques of showing and hiding a migrant's face at the same time by masking or blurring the face, filming the migrant from behind, back-lighted, or as a shadow in the dark. The problematic side of these strategies is the fact that these techniques are culturally associated not only with witnesses of crimes that need to be protected, but also with the representation of criminals and persons who shamefully hide themselves. It is a representational strategy that concedes the undocumented migrants' visibility only for the price of waiving their

1 | Nichols 2001, p. 9.

recognizability as normal individuals. Thus, even though not necessarily intended, these remedies to protect the migrants at the same time produce an ambivalent aesthetics. Such ambivalent representations also have ambivalent political impacts. While minorities tend to equal more media presence with more political power, Johanna Schaffer argues that this is not necessarily the case as it can also result in tighter surveillance and discipline. Therefore the modes of visibility are key issues.[2]

In this space of aesthetical and ethical forces, politics of representation take place. The migrant's face becomes a contested space of conflicting representations. The very intention to represent undocumented migrants forces the filmmaker to participate in the construction of what an undocumented illegal migrant might be. One should not forget that to be or not to be "illegal" is not part of a human's nature but a social attribution that state authorities ascribe to certain persons. Hence every documentary film on undocumented migration has to face the fact that "[a]n illegal alien looks exactly like a legal alien or, for that matter, a citizen"[3], as Mireille Rosello states. Therefore it is impossible to visualize an undocumented immigrant as such through exclusively visual means. In her analysis of French television coverage of migration issues, Rosello noticed that all strategies which filmmakers use to represent undocumented migration "have one feature in common: each time, illegal immigration is not defined, but it is *associated* with other concepts or elements, for example clandestinity *and* invisibility, clandestinity *and* papers, or clandestinity *and* the police, and clandestinity *and* race"[4].

Therefore documentaries about migration can be considered a constitutive part of the migration and border regime as Brigitta Kuster states.[5] No filmmaker can escape from being part of these politics. Within these politics there is no simple answer to the question how undocumented migrants might best be portrayed. And, wondering "about the cultural consequences of the association between illegal immigration and invisibility," Rosello states that "the paradigm cannot be appropriated as positive or negative. Therefore, this is not a type of representation that dispenses the viewer from a reflection about what should be done"[6].

In the following we identify different strategies of visual representation of undocumented migrants in (independent) documentary films that go beyond the black-barred face that makes them appear as criminals. We consider these alternative aesthetic strategies an important contribution to antiracist and pro-immigrant struggles. Nevertheless, even in these documentaries, as Brigitta Kuster puts it, the visibility of migrants is always in danger of being quite close to the "visual economy of its criminalization,

2 | Schaffer 2008.
3 | Rosello 1998, p. 139.
4 | Rosello 1998, p. 139, emphasis in original.
5 | Kuster 2006, p. 187.
6 | Rossello 1998, p. 146.

regulation and control" and to "reproduce the depictions of the police, of ruling law, of accepted truths"[7]. The line between policing and criminalizing modes of representation and more empowering and appreciating ways can be a thin one.

THE AMBIGUITY OF SHOWING AND VEILING

One answer to the problem involved in filming undocumented migrants who do not want to show their face to the camera is simply to avoid filming them and looking out for other migrants who do accept being filmed. One example for this strategy is the documentary *Próxima Estación (Next Station)* by Estela Ilárraz. The filmmaker tells the story of Ecuadorian women and couples and their challenges of transnational family-lives. The women work in Madrid as domestic workers, often taking care of other children, while their own children are left in Ecuador under the supervision of mostly female family members. The faces of the protagonists are shown like the ones of any other person. The viewer learns their names and the places where they live are displayed openly. In one case the film even visits an undocumented migrant at his easy identifiable working place, a radio station where he has his own radio show for migrants. There is no visual sign that labels the migrants as "undocumented" and the viewer learns about the migrants' status only when they talk about specific experiences such as being caught without papers by the police. The filmmaker's decision to work with undocumented migrants who show their face without fear to the camera normalizes the visual representation of undocumented migration and allows for focusing on the complex transnational family relations.

The film's conception is based on the specific Spanish situation that differs significantly from the one in countries such as Austria or Germany. In Spain, undocumented migration from Latin America is in many aspects less stigmatized and criminalized in every-day practices. Undocumented migrants can even register as inhabitants with the local administration. Therefore, undocumented migrants can move more freely in Spain as compared to other countries—this does, however, not mean that the life is an easy one, as is also shown in the film when for example one couple gets caught by the police, but manage to talk their way out of it.

The decision to film only persons that show their face works fine as long as there is always an alternative person to portray. To generalize this decision in the case of undocumented migrants carries the risk of excluding by default a group of persons that are systematically deprived from the possibility to show their face and identity without an essential risk. In fact, the films we know that show undocumented migrants' faces mainly cover three groups of migrants: Firstly, migrants on the move, that do not

7 | Kuster 2006, p. 188, translation ob/hs.

care much about the traces they leave behind, secondly, migrants in countries where the risk to be detected through the film's images is less acute and finally migrants that already got caught by the police or immigration authorities. As a consequence, the generalized decision to only film those undocumented migrants who agree to being shown would inhibit access to life realities of undocumented migrants beyond these groups for documentary film. So, this strategy could lead to the result of banning most groups of undocumented migrants from documentary film.

The German TV Production *Schattenmenschen—illegal in Deutschland (Shadow People—illegal in Germany)* aims at throwing light on the living condition of people without legal documents. TV has the possibility to reach a general public, at the same time it compels the filmmakers to make concessions to mainstream viewing patterns. The advantage of potentially reaching many people is paired with the amplified risk for the migrants of being apprehended by state officials. By portraying persons who need to protect themselves from being recognized, the film challenges, within the constraints of a TV-production, the aforementioned ambiguity of representing undocumented migrants.

The film follows three lives of undocumented migrants: Nikolai comes from Ukraine and entered the European Union by foot. He travels like a rover from one place to another in search of work—and no border regime will stop him. Valérie came as a young child with her parents from Africa and grew up in Germany. Although she graduated from high school with excellent grades, she cannot register at university to study medicine because she still lives without any legal status. She represents the young generation of migrants that grew up and are culturally rooted in Germany but still have no right to obtain a residence permit let alone citizenship. Elisa came from South America 13 years ago and has been working since then as a domestic worker. She remits as much money as she can afford in order to pay for her daughter's education. Now she is in trouble because she needs a medical treatment and, as undocumented migrant has no insurance. She paradigmatically embodies those hard working migrants who are excluded from social security and lack access to basic services.

Right at the beginning of the film Nikolai's border crossing into Germany is dramatically restaged. A man in the dark runs through the bushes, crossing a river by swimming and warming himself on the other side at a campfire. The camera shows the man's feet, follows him from behind, dives with him into the water, shows his hands lighting a cigarette while the face is a shadow-profile in the flicker of the campfire. The dramatic string music grows louder and louder in this opening scene until the film's title appears flickering like the fire in the background of the image. The undocumented migrant appears as somebody between intruder and Marlboro man. The images function within the parameters of genre knowledge: As in a thriller which at the beginning often shows the criminal at work while the viewer is still left in the dark about his or her identity,

it is in this case Nikolai's identity which is kept undercover. The cigarette smoking man at the campfire foreshadows the coming adventures of a tough guy.

Figure 1: Schattenmenschen, Germany, 2007[8]

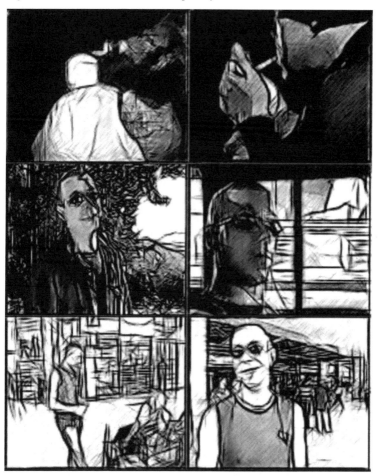

After this opening scene the film switches to Valérie. To gain more dynamism the film switches between the three stories of Nikolai, Valérie and Elisa which are developing in parallel. When the film returns to Nikolai we can see him in a light-flooded forest answering questions of the film team. The potentially dangerous intruder from the first scene transforms into a smart guy looking for some adventure and work to make a living. Like a modern rover he wanders through Europe and the film team follows him on his way from the Polish-German border to Italy where a friend

8 | Unfortunately the filmmaker refused permission to publish photo-stills of the film. To avoid legal trouble we only publish sketches of the film shots.

promised to help him getting a job. In contrast to his first border crossing through the river, the camera films him sitting in the back of a car and smiling into the camera while passing a control post. The commentary, "Nikolai is at the destination of his desires, in Italy" (translation ob/hs), suggests it is the border control station into Italy. A close look at the image shows it more likely to be a toll-station on the motorway. As there are no regular passport controls anymore between the countries of the Schengen zone, the control post, as the place where the decision whether you can enter a country or not takes place, dissolves into a border zone of controls upon suspicion. Thus the border becomes less visible while maintaining its function as a barrier for people's free circulation. In public imaginaries the control post still represents the border and thus the toll station functions as a symbol for entering Italy.

Obviously in the case of Nikolai there was no need to hide the face in the first scene. It was an aesthetic decision to dramatize his border crossing. One reason was most definitely to catch the viewer's attention before he/she switches to another TV channel. It also marks Nikolai as an irregular border crosser.[9] At the same time he appears as someone engaged in a criminal activity, if not a threat to the viewer. It can be argued that the filmmakers counter this concession to the TV format in the remaining parts of the documentary. They contrast the first image of a potentially criminal undocumented migrant with the image of smiling Nikolai as an ordinary adventure seeking young guy in the subsequent scenes. Nikolai is the embodiment of what critical migration studies call the "autonomy of migration"[10]. The subject of autonomy of migration is clearly a male one. This is true for most critical migration studies[11] as well as in this film. While the two women are much more portrayed as victims of migration policies and societal circumstances, the only male protagonist embodies the independent rover. This difference is underscored in the film by the fact that the migrant women's faces are blurred while Nikolai's is shown openly.

The film's visual strategy illustrates the ambivalent potential effects of the decision to show undocumented migrants while avoiding to film their faces. As Nikolai in the opening scene, undocumented migrants find themselves in such images most of the time placed somewhere in the dark and bound to stereotypes known from genre cinema. The power of images attaches this position to the migrants as a kind of ontological feature, not as a temporary and involuntary situation. This effect has rightly led to the criticism that such representations willingly or unwillingly contribute to the criminalization of undocumented migrants. Public discourses on

9 | Cf. the paradigmatic figure of the border crosser Horn/Kaufmann/Bröckling 2002.
10 | Cf. Moulier Boutang 1993; Karakayali/Tsianos 2005.
11 | Cf. Benz/Schwenken 2005.

migration are in many contexts characterized by "threat narratives"[12]. Threats are socially re-/produced, and visual media are one important way how that is achieved. This danger of the potential negative effect of hiding faces is countered in the film by the open appearance of Nikolai later in the film. By deconstructing the threatening intruder image of the opening scene, the film invites the viewer to critically reflect upon the viewer's own pre-perception of undocumented migrants with which the dramatic opening scene operates.

Views from the Back

A common strategy to make undocumented migrants visible while at the same time ensuring their anonymity is to film them from the back or from a perspective where their face is not recognizable. This strategy is a less obvious intervention to the image than blurring and therefore intercepts less the viewers' perception of the image. While blurring is symbolically charged and reminds the viewer of the potential manipulation that can happen to every image, filming from the back works more subtle. The following examples show, however, how different the effect of this strategy can be.

In the already mentioned film *Schattenmenschen*, the first appearance of Valérie is like the one with Nikolai characterized by images that build on the viewers' genre knowledge. 19-year-old Valérie is going up a stairway in short jeans and with red flip-flops. The camera shows her legs from below following her going upstairs. She walks along a corridor with a range of doors on each side, still being followed by the camera, playing with a key in her hand. The subjective camera positions the viewer in a voyeuristic perspective that sexualizes the image and alludes to a sex-worker going up to her room followed by the gaze of her client. However, Valérie is not working as a sex worker. Nonetheless, she appears like an object of the camera's voyeurism, which is enhanced by the voice-of-god commentary that talks about her. The view of the camera invokes a common and highly gendered visual repertoire of the undocumented migrant woman as a sex worker, or even a victim of trafficking.

The sequence ends with the back-profile of Valérie looking out of the window. An empty metal coat-hanger is swinging in the foreground, like a loop hanging from a gallows. It may be read as a symbol for the threat of being captured and deported. Unlike the presentation of Nikolai, the first stereotyped portrait of Valérie is not countered by an image of her face. To protect her from being recognized, her face is blurred out throughout the film. The filmmakers told us that they were aware of the problematics of blurring. In the first version they felt that the migrants appeared unsympathetic or like "monsters". They experimented with different types of blurring until they found a less distorting type of blurring.

12 | Chavez 2008, p. 3.

Figure 2: Schattenmenschen, Germany, 2007

The stereotype reproduced in Valérie's entry scene is challenged by her later appearance in the film. The camera follows her while cooking, doing her laundry or shopping and the spoken words alternate between commentaries and her own voice. Valerie is shown as an active person who leaves her parents' home to live with her boy-friend and finds a way to study psychology in spite of all difficulties. When trying to counter the image of the migrant woman as a victim, the filmmakers told us, they were confronted with Valerie's self-staging, actively using victim narratives as well as playing with her sexuality. In the tension between the motives offered by Valerie and the images taken by the camera in the editing process, the filmmakers tried to construct an image that caters to both, Valerie's personality and the paradigmatic figure she stands for in the film.

The film *Haus-Halt-Hilfe (Domestic Helper)* portrays a range of women—migrants and non-migrants—who work in private households in Germany. In addition to the extended 92 minutes version, different shorter versions exist for educational use; an important distribution channel of the film are trade unions, educational institutions and social movement groups. The central intention of the film is to show the dignity and strength of women who work in other people's households and to promote the recognition of their work as regular work that should be honored and paid as such. Having such an intention, it is important to refrain from the possible impression that domestic workers shamefully hide from the camera. Yet a significant part of workers in this sector is undocumented, therefore it is important to include a woman with this background among the portrayed. Thus the filmmaker had to face the fact that while the women with a legal

status show their faces to the camera, Maria G. from the Philippines needs to protect herself from being identified.

Like in the introduction of Valérie in *Schattenmenschen*, the camera follows Maria, but this time while she is working in a household cleaning a room. Instead of the commentary voice from a speaker, it is her own voice that comments on her daily-life and working conditions. She appears as an active person. The subjective camera positions the viewer as a person that accompanies the migrant, listens to her and steps back to not disturb her while performing her work duties. Even though in other interview sequences Maria is filmed against back-light, so that her face is not recognizable, the images taken at her workplace prevent her from appearing out of line in comparison to the other women who do show their faces in the same documentary. Embedded in the stories of these women that demonstrate proud and dignity for their work, Maria G.'s own dignity and power is transmitted, even without openly seeing her face.

Figure 3: Haus-Halt-Hilfe, Germany, 2006

Otrás Vias (Other ways) by FrauenLesben-FilmCollectiv and the Latina group MuCoLaDe is a documentary about Latin American women sex workers and transsexual migrant sex workers in Hamburg. They talk about their lives, their motivations to come to Germany, the problems they have with the police and clients, their dreams etc. Some of the protagonists are shown openly, they either have a secured legal status through marriage or were in a women's prison at that time. Others objected to being identified. Together with the protagonists, the filmmakers developed different ways of showing them in the documentary: The whole film's concept is charac-

terized by the intention to position the migrants as being an active part in the process of producing the film. Like the documentary *Haus-Halt-Hilfe* the film works mostly with the original voice of the protagonists, there is almost no voice-of-god commentary.

Instead of interviews with the individual migrants the film draws on many occasions on conversations between migrants and a group of feminist supporters. These scenes are recorded at a kitchen table, in a cozy atmosphere with coffee and cookies or at a picknick in a park. For filming these conversations, the camera is positioned in relation to the migrants who do not want to show their face in a way that they are shown from the back. In these group situations with people sitting in a circle it appears most likely that not everybody's face can be seen, although it still irritates when the face of the person speaking is not shown. Instead, the camera shows the persons who listen to the migrant. This allows the viewer on the one hand to identify with the role of the listener and on the other hand it shows the migrants being integrated into the group and interacting quite naturally with the others. Thus mediated through the group, the undocumented migrants appear in an ordinary, non discriminating manner.

Figure 4: Otrás vias, Germany, 2003

In another scene, one of the migrant sex workers is shown in front of a mirror while dressing up as a transvestite. It appears probable—as in the case of the domestic worker who cleans the flat in *Haus-Halt-Hilfe*—that the viewer is standing behind the person who is dressing hirself up. The camera position has definitely something voyeuristic, but the migrant, while shown from the back, clearly communicates through hir movements towards the

camera and thus plays an active part, self-confident of hir control over the voyeuristic constellation. The backstage situation of the professional dressing and masking procedure reminds of as well the staging and masking as the voyeurism inherent in general to producing and viewing a film.

These examples from *Schattenmenschen, Haus-Halt-Hilfe* and *Otrás vias* indicate to which extend the formally identical strategy—to show undocumented migrants from their back—can have very different effects in the overall context of the film.

MASKING, SUBSTITUTING OR EVACUATING THE MIGRANT BODY FROM THE IMAGE

Passagères clandestines. Mothers crossing by Lodet Desmet and Nawzad Tofec is a documentary film about the people smuggler "Djouma the Arab" and the Iranian mother Sima with her two daughters clandestinely crossing the land border between Turkey and Greece. This documentary represents the "passage" genre, in which film-makers follow migrants' journeys across borders. A characteristic of this genre is the "embeddedness" of the filmmakers.[13] In this case authenticity is given by the fact that the filmmakers provided the smugglers with (infrared) cameras and had them film the dangerous smuggling themselves.[14] Mireille Rosello coins this kind of representational strategy "clandestine filming of clandestinity" in which "[o]ften the quality of the images is (artificially?) poor as if to confirm that the filming itself was contaminated by stealth and danger.[15]

While the previous films that we discussed avoid showing the protagonists' faces, this film uses a different strategy: In the first sequence of the film the camera shows a make-up artist working on the smuggler's face applying a false beard and altering his nose. Throughout the film the smuggler appears as a normal person directly looking and talking into the camera. In a self-reflexive manner masking is here put into the context of the everyday business of make-up in the film-industry. It reminds us of the fact that every film alters reality and the simple act of installing a camera changes people's behavior. The documentary film too inevitably creates its own filmic reality that only relates in a mediated way to the reality outside of the film.

13 | Kuster 2006, p. 191.
14 | Transit Migration 2010.
15 | Rosello 1998, p. 145.

Figure 5: Passagères clandestines, Belgium/France, 2004

The documentary *Mit einem Lächeln auf den Lippen (With a smile on her lips)* by *Anne Frisius, in cooperation with Nadja Damm and Mónica Orjeda* tells the story of the Latin American undocumented migrant domestic worker Ana S. in Hamburg who successfully claimed compensation for her withheld wages. The filmmakers accompany the domestic worker through the long process from the moment on where she contacted a street worker for undocumented women up to the court case two years later. During the production of the film it was uncertain how the court case would end. The documentary reproduces this tension by revealing step by step the development of the domestic worker's struggle to the audience. *Mit einem Lächeln auf den Lippen* circulates among activists and trade unionists to give an example of how to attain the difficult to achieve compensation for unpaid wages of an undocumented worker.

In the introductory scene of the film, a female dancer expresses in a pantomimic way and with a white, long shawl in her hands Ana's daily work such as caring for a baby or cleaning. During the dance the film's commentary adumbrates the working and living conditions of the film's main protagonist. After several years she has finally decided to claim her right for a decent payment which has been withheld from her by her employers. The dance not simply substitutes what cannot be shown, because Ana's former employers would have hardly allowed her or the film-team to shoot for the documentary film in their house. It is a representation that is conscious about the difference and the power relationship between the representation and the represented. The dancer transforms the typical movements domestic workers constantly repeat in the private zone of

their bosses' household into an aesthetic form exposed to the public view. At the same time the expression through body language keeps the represented work bound to the intimate realm of the body. Thus, even though Ana is physically evacuated from the images, her bodily experiences of performing physical and emotional labors are still perceptible.

Figure 6: Mit einem Lächeln auf ihren Lippen, Germany, 2008

The emphasis the film puts in its beginning on the expressiveness of body language is relevant for the following scenes with Ana: She explicitly tells her story as a story of gaining confidence, losing fear and becoming less nervous about claiming her rights. Her body language shows a woman who went through a very difficult time, but who is learning to know what her rights are and that she has to fight for them. However, in an irritating contrast to her statements, Ana's face appears blurred throughout the film. The missing face clearly obstructs the relation the viewer can build to the protagonist. One of the filmmakers explained to us that when the film project started Ana originally planned to return to Latin America and agreed to be shown without blurring. Only briefly before finishing the film, she decided to extend her stay in Germany. Therefore the filmmakers had no alternative but to ex-post manipulate the already recorded pictures in order to hide her identity or to completely do without the scenes with Ana. The filmmakers took a twofold decision. They reduced the use of footage showing Ana's face and tried to find substitute images like the dance that do not objectify or criminalize the main protagonist.

Maybe the most radical answer to the question of visual representation of

the invisible undocumented migrant is exhibited by Anja Salomonowitz in *Kurz davor ist es passiert (It happened just before)* by visualizing the invisibility instead of the invisible persons. While the migrants are completely absent from the images shown, the film documents the daily lives of those who play important roles in the migrants' lives: a border-police official, a barkeeper, a diplomat, etc. Those persons had to memorize excerpts from interview protocols with trafficked women and they interrupt their own activities in a Brecht'ian manner in order to recite the excerpts for the camera. An eccentric female Cameroonian consul of Austrian decent, for example, recites the story of an abused domestic worker working for a diplomat's household. The worker has to work long-hours, is not allowed to wear her hair as she wishes, has to cater for large parties and in the end faints from exhaustion and loses her job which makes her liable to deportation. While the consul is reciting the fate of the worker, she herself lives a daily-life which would qualify her as the employer of the domestic worker whose story she is telling. She gives orders to her domestic worker and professionally negotiates the status of diplomatic housekeeping personnel with other diplomats. These interwoven, yet clearly separated stories correspond in an uncomfortable manner.

Figure 7: Kurz davor ist es passiert, Austria, 2006

Every event that documentary film pretends to represent always happened "just before" we can see its image on a screen. Instead of the illusion of sharing the migrant's perspective for a moment in film, Salomonowitz disturbs the spectator and forces her or him to double-read the film. The images represent their protagonists' daily life and they sharpen the viewer's sense for what is invisible in this representation and in all our ordinary daily life as well. Film becomes no longer a medium of recognition but of cognition. The evacuation of the migrants' bodies from the images is the price Salomonowitz has to pay for showing the invisibility. However, it is not only a price to pay, but opens up new perspectives beyond the understanding of documentary as pure replication of reality.

The three films discussed in this section have in common that they build on the fact that film inevitably creates its own reality. Mediated through the film's own reality they facilitate a different perception and knowledge of the world we and the undocumented migrants live in, without pretending to offer a plain view through the window into someone else's life.

Conclusion

The question whether the undocumented migrant can have a face in film is at first glance *not* a question of aesthetics. It is their social and legal condition, not aesthetics, which prevent undocumented migrants from showing their face. But the question becomes more complex if we take into account, that films are a part of the migration regime. It works like a vicious circle: The migration regime forces undocumented migrants to conceal their face. But the image of a face not only helps to identify and trace a specific person, it also helps the spectator to identify with the person's needs and feelings, to recognize a person's condition as a human being. Therefore to protect the migrant's identity at the same time can easily produce a de-humanizing discriminatory effect on the migrant that strengthens the hostile perception of and policies against undocumented migrants. From this point of view, the aesthetic question *how* a film shows or does not show the faces of undocumented migrants is a highly political issue and the filmmakers' ethical responsibility.

Nonetheless, it is possible to counter the discriminatory effects of concealing the migrants' faces. It does matter how a face is disguised and in what context it is put. It is possible to shoot and integrate images from the back of a migrant in a nearly natural and unspectacular way while another camera position reinforces sexualized and/or criminalizing pre-perceptions of the audience. It is possible to localize the disguised faces in a genre of playful masking and travesty in order to allow for a positive relation between viewer and undocumented migrants. It is possible to find visual expressions to fill the gap left by an unseen face. It is possible to turn the missing image of a face into a reflection on the invisibility as a socially produced condition.

It seems to make also a difference whether the documentaries are made in close cooperation with the undocumented migrants themselves or whether they are passive objects of documentation. The latter one is what Nichols identifies as the most classic interaction between the filmmakers, the subjects or social actors and the audience: "*I* speak about *them* to *you.*"[16] *This has been the case in some of the analyzed documentaries in which for example the voice-of-god commentary dominates. Whereas the documentaries Otrás vias and Mit einem Lächeln auf den Lippen were both produced together with the migrants portrayed in the film.* The spectator can

16 | Nichols 2001, p. 13.

see them develop over time, gaining confidence, fighting for justice and their rights and consciously using the medium of the film. Participating in the documentary may be a means of individual empowerment as well as a means of political mobilization and collective empowerment, including questioning the political and economic conditions leading to their undocumented status—all three dimensions are central for a change-oriented notion of empowerment.[17]

For the migrants, appropriating visual presence on the screen, however, has no legal power to also regain a legal status. Nevertheless, at least on a symbolic level it counters the legal status of being 'undocumented' by documenting one's status as a human being. If the film also manages to critically bring up the negative effects of the migration regimes and border regimes, it has even more the capacity to contribute to a critical discourse on migration. In fact, Rosello demonstrates that gaining visibility and challenging the representation of undocumented migrants by proposing new visual narratives was an important factor for the political impact of the *sans papiers* movement.[18] Visual techniques allowing for this kind of presence of undocumented migrants and their conditions thus contribute to the legitimate presence of migrant subjectivities that usually are portrayed as deviant and criminal.

LIST OF FIGURES

Figure 1: Schattenmenschen, Germany, 2007.
Figure 2: Schattenmenschen, Germany, 2007.
Figure 3: Haus-Halt-Hilfe, Germany, 2006.
Figure 4: Otrás vias, Germany, 2003.
Figure 5: Passagères clandestines. Mothers crossing, Belgium/France, 2004.
Figure 6: Mit einem Lächeln auf ihren Lippen, Germany, 2008.
Figure 7: Kurz davor ist es passiert, Austria, 2006.

BIBLIOGRAPHY

Benz, Martina/Schwenken, Helen. 2005. "Jenseits von Autonomie und Kontrolle: Migration als eigensinnige Praxis." *PROKLA. Zeitschrift für kritische Sozialwissenschaft* 140 35/3: p. 363-377.
Chavez, Leon R. 2008. The Latino Threat. Constructing Immigrants, Citizens, and the Nation. Stanford: Stanford UP.
Horn, Eva/Kaufmann, Stefan/Bröckling, Ulrich, eds. 2002. Grenzverletzer. Von Schmugglern, Spionen und anderen subversiven Gestalten. Berlin: Kulturverlag Kadmos.

17 | Parpart/Rai/Staudt 2002.
18 | Rosello 1998, p. 148 et sq.

"Interview mit Yann Moulier-Boutang." 1993. (first publ. in "razza operaia", Padova edizioni, May 1992). Materialien für einen neuen Antiimperialismus 5: p. 29-55.
Karakayali, Serhat/Tsianos, Vassilis. 2005. "Mapping the Order of New Migration. Undokumentierte Arbeit und die Autonomie der Migration." Peripherie. Zeitschrift für Politik und Ökonomie in der Dritten Welt 97/98: p. 35-64.
Kuster, Brigitta. 2006. "Die Grenze filmen." In Turbulente Ränder. Neue Perspektiven auf Migration an den Grenzen Europas, ed. Forschungsgruppe Transit Migration, p. 187-201. Bielefeld: transcript.
Nichols, Bill. 2001. Introduction to Documentary. Bloomington, Indianapolis: Indiana University Press.
Parpart, Jane L./Rai, Shirin/Staudt, Kathleen. 2002. "Rethinking em(power)ment, gender and development. An introduction." In Rethinking Empowerment. Gender and development in a global/local world, ed. Jane L. Parpart, Shirin M. Rai and Kathleen Staudt, p. 3-21. London: Routledge.
Rosello, Mireille. 1998. "Representing illegal immigrants in France: from clandestins to l'affaire des sans-papiers de Saint-Bernard." Journal of European Studies 28: p. 137-151.
Schaffer, Johanna. 2008. "Ambivalenzen der Sichtbarkeit: Zum Verhältnis von Sichtbarkeit und politischer Handlungsfähigkeit." In Medien – Politik – Geschlecht, ed. Johanna Dorer, Brigitte Geiger and Regina Köpl, p. 233-248. Wiesbaden: VS.
Transit Migration. 2010. "Passagères clandestines.", http://www.transit-migration.org/db_transit/ausgabe.php?inhaltID=109 (accessed May 31, 2010).

Filmography

"Haus-Halt-Hilfe. Arbeiten im fremden Alltag." (Germany 2006, 92min), by Petra Valentin.
"Kurz davor ist es passiert." (Austria 2006, 73 min), by Anja Salomonowitz.
"Mit einem Lächeln auf den Lippen." (Germany 2008, 57 min), by *Anne Frisius, in cooperation with Nadja Damm and Mónica Orjeda*.
"Otras Vias." (Germany 2002, 56 min), by FrauenLesben-FilmCollectiv in cooperation with MuCoLaDe.
"Passagères clandestines. Mother's crossing." (Belgium/France 2004, 61min), by Lodet Desmet in cooperation with Nawzad Tofec.
„Próxima Estación." (Spain 2007, 70 min), by Estella Ilárraz.
"Schattenmenschen. Illegal in Deutschland." (Germany 2005-2007, 45 min), by Julia Beerhold and Carsten Linder, broadcasted February 07, 2007 on WDR, Reihe Menschen hautnah.

Border: The Videographic Traces by Laura Waddington as a Cinematographic Memorial

Eva Kuhn

A shadowy figure huddles in front of a dark ground, surrounded by high, billowing grass. The sky is crimson and a light is glaring from the horizon. Now the figure stirs—a bright hooded sweatshirt can be made out. The camera is close; it kneels with the figure in the field and films as it stalks onward and ducks down again—now it can no longer be seen. Alone, the camera films wind and grass and the constant white light. The image becomes grainier and wavers. This place seems oddly dematerialized, disembodied, as in a dream or memory. A small black silhouette rises up, becomes visible against the light on the horizon, and again dissolves into the glimmering dots of the image noise. The camera, working hard with hardly any light, seems to reach its limit. A pan to the left makes the image into a painterly blur of crimson, gray, and brown tones.

Figure 1

The documentary video essay *Border* takes place in the years 2002-2004 and was realized by the filmmaker Laura Waddington, born in 1970 in London. In the first part of this essay, drawing from newspaper articles and individual studies, I will attempt to grasp more precisely and to reconstruct in its main features the referential reality—the setting and the history—in which *Border* takes place and to which, as a documentary film, *Border* refers, in order in the further course of the text, to assess how and to what extent the video itself tells of this reality in a specific way. At the center is the question of how the filmmaker approaches this complex reality, in which way and with which filmic forms she gives this reality expression.

At the beginning of the film, an inscription stating the following: "This is a film about Afghan and Iraqi refugees I met in the fields around the Sangatte Red Cross camp, in France. Unable to get to England legally, they tried to enter the channel tunnel, hidden in trucks and on freight trains."

Sangatte is a small town in northern France, right on the sea, a few kilometers south of Calais. It is 35 kilometers from here to England—in clear weather, the coast is visible. Near to Sangatte is the entrance to the fifty-kilometer railway tunnel that runs underneath the English Channel and connects the continent of Europe with Great Britain. Between the coasts pass shuttle trains—rail loops at the terminals enable them to turn around. The trains carry automobiles in double-story, closed cars, and trucks on beds secured with caging. Coming from Brussels on the A16, and from Paris/Dijon on the A26, the trucks can drive over a ramp directly into the terminal compound. In addition to freight trains, around thirty Eurostar high-speed passenger trains commute back and forth each day. The ferry port of Calais also does a brisk business, with more than sixty daily crossings to Dover.[1]

At the time of the war in Yugoslavia, many Albanians from Kosovo came as refugees to the region in order to attempt illegalized entry into Great Britain—since they were denied a permanent migration. They slept in the public spaces of Calais, and local and private aid organizations made provisions for the refugees and demonstrated to the authorities against their living conditions. At the end of September, 1999, the French Ministry of Social Services impounded an empty warehouse on the outskirts of Sangatte and commissioned the Red Cross to install and maintain an emergency shelter there. Originally intended as temporary accommodation for 650 people, the warehouse at Sangatte became the largest refugee camp in France. At the time of its closure in December, 2002, 1,600 people were camping there on a daily basis. Since its opening, more than 70,000 people had stayed there.[2]

1 | See Fezer et al. 2003, p. 9-12.
2 | See Fezer et al. 2003, p. 3-5; "Le centre d'hebergement de Sangatte." 2002; Dufour 2002.

The following arrivals were increasingly Afghans, Iraqis, and Iraqi Kurds, mostly young men between 16 and 28 years old. For a small portion of the refugees, England was the first destination of their journey; for the majority, it was the last hope. Before setting out on their migration, many had only a vague notion of Europe, and knew little or nothing about asylum procedures and residence permits in the different countries. England was generally made into an Eldorado while on the road—through constantly shifting the place where sights were set, and through communication with other refugees and government workers who said they should "try it over there". In fact, at that time, access to the asylum process was less bureaucratic in Great Britain, and social services were better there than in France or other European countries.[3] Often this image was also put forward and promoted by profit-oriented traffickers, who could earn large sums of money from the precarious traverse of the Channel. Especially in the camp, after all the disappointments along the way, the United Kingdom was made into an icon, and collective fantasies—such as that of British hospitality—were formed and cultivated.[4] Ultimately, the refugees had to keep at it—every night, they had to motivate themselves to make another attempt. And after every failure, the country of their dreams seemed again at "a distance, however close it may be"[5].

Each night the refugees attempted to cross the border to England unobserved. The camp served as a base, a service station for the fueling and repair of bodies, and a platform for information exchange. In the evening they would set out, mostly in small groups, heading toward the ferry port and the nearby highway rest areas. There, they would attempt to climb unobserved onto a truck bed, or else they would have a "blind date" with a driver, arranged by a smuggler in exchange for a lot of money. However, since the end of 2001, the Eurotunnel terminal was increasingly the objective, where the fugitives would attempt to get directly onto the trains. The main reason for this shift was the massive increase in stringency of truck inspections. Using infrared scanners, X-Ray machines, CO_2 monitoring stations, and heartbeat detectors, the clients' cargo was to be made more transparent.[6]

It was five kilometers from the refugee camp to the compound of the Eurotunnel terminal. In between lay the highway A16, which was to be crossed on foot. The compound, equipped with video surveillance and lit to be as bright as day at all hours, is surrounded by multiple wire or barbed-wire fences, up to four meters tall. Then as now, people searched for pre-existing holes in the fencing, cut their own, or attempted to get past the fences by climbing over them. Once the outer security systems had been dealt with, refugees attempted to climb aboard shuttle trains turn-

3 | See Dufour 2002.
4 | See Laacher 2002, p. 101-105.
5 | I am borrowing this phrasing from Benjamin 1968, p. 222.
6 | See Fezer et al. 2003, p. 10-14; "Der Kanaltunnel als Weg illegaler Migration" 2001.

ing around in the terminal. Occasionally, they jumped from overpasses onto the roofs of approaching trains. Since the high-speed trains produce a high wind pressure, it is not possible to walk through the tunnel on foot. Nevertheless, such attempts have repeatedly been made.[7]

Although security measures became more and more stringent, hurdles became higher and every attempt more dangerous, the refugees persevered. Stubbornly, tirelessly, evening after evening they set out under cover of darkness, and generally were apprehended on their route. With flashlights, they were taken from the fields and bushes, or were plucked from the trains and brought by the CRS back to the camp at Sangatte. After a failed attempt, many proceeded voluntarily to the buses—"police taxis," as the refugees called them. The attempt to escape became a nightly routine. It was a job—a mission. Giving up would mean making the entire way here into something futile, counting as lost all the hard-earned money invested in smugglers, burying one's own hopes and above all disappointing one's family.[8]

In fact, several people continued to make it somehow, to find their way through somewhere—hurrying with a fleeting shadow, keeping within the blind spot of a border guard, balancing in the off-zone of the surveillance cameras, making use of a technical malfunction or the blinking of the 300-eyed security force in the security command center. At the end of 2002, about ten people were successful each night. According to Red Cross estimates, in the three years between the opening and the closing of the camp, of the 60,000 camp residents, 85% succeeded in reaching England.[9]

In May 2002, Nicolas Sarkozy was named Interior Minister of France, and in solidarity with his British counterpart, the like-minded hardliner David Blunkett, a "new era of cooperation" began, an "energetic, joint course of action against illegal migration across the Channel"[10]. On November 5, ten days before the officially announced deadline, the camp was closed to new arrivals. Police officers in front of the building turned away unregistered refugees.[11] In December 2002, France and Great Britain came to an agreement on the terms of the camp's closing—by the end of the year it was to be entirely vacated. On December 30, the building was torn down, razed to the ground by bulldozers, and by mid-February, clean-up operations had been concluded. The problem was solved; Sarkozy's coup had been achieved.[12] Or so it seemed: "When I came back two days later, no trace remained. They left no memory, not even a sign or statue."[13]

7 | Hahn 2001; "Vierundvierzig Asylsuchende im Kanaltunnel festgenommen" 2001.
8 | See Zappi 2002; Pereira 2001.
9 | See "Fermeture du centre de Sangatte" 2002.
10 | See Ceaux 2002.
11 | See Mesureur 2002.
12 | See Fezer et al. 2003, p. 9-12.
13 | Waddington 2005.

But the spirits of Sangatte could not be driven away so easily. Winter 2006—three years later: "Des centaines de clandestins errant dans le froid, sans droits, sans protection. L'Etat ne peut continuer à ignorer cette détresse."[14] The image of the Eldorado England was still twinkling on the horizon, appearing as a fata morgana on the long way here, glittering in the dawn or shimmering in the evening mist, gleaming off the cold coast of France.

This is my attempt at a brief overview of the geographic and political reality in which the video *Border* was made, and to which Laura Waddington's documentary essay makes reference. Actually, the material has all the makings of a film—it has the components of a plot with suspense and emotion. It provides the context for various possible scenarios and individual dramas. Heroes and villains are given—the roles can be cast differently according to narrative point of view and intended message. The respective motivations, the drive to action, as well as the goals and obstacles are evident: some want to get to England in order to install themselves in a safe country, while others want to preserve their peace and possessions, and take measures accordingly—these elements would be established in the classic first act, the introduction.

An escalation of the conflict, the most important feature of the second act, takes place against the background of an increase in new arrivals, a heightening of security measures and more vigorous deterrence of border crossing, with increasing tension on the political level. There are scenes of action, such as police officers chasing refugees, with figures scaling high fences and leaping onto arriving trains, as well as suspenseful breaks in action—a refugee waits in the dark corner of a truck container while the unsuspecting driver returns from his picnic dinner, or brings his vehicle to the CO_2 monitoring station—energetic discussions between politicians and business leaders of the Eurotunnel Corporation, and so forth.

Finally, in the third act there must be a decision that puts an end to the turmoil. This could coincide with the closing of the camp: a happy ending for an Afghani family, who, after staying in the camp for six months, on December 5, 2002 are officially permitted to enter England.[15] Or, an unresolved ending for a Kurdish boy, who, one month previously, on November 5, after a year-long migration, is the first one to stand in front of the closed doors of the camp, and who finally, after a violent exchange with the police, constructs a hut in a park in Calais.

The material offers clichés such as good guys and bad guys, the impoverished victims and the ignorant rich people, the blasé, jaded politicians, who, at their meeting tables over a glass of Vittel, make decisions that determine countless fates.

14 | Jeanson/Laacher 2006.
15 | See Zappi 2002; "Grossbritannien nimmt 1000 Kurden auf" 2002.

Laura Waddington's video is something else entirely: plot, suspense, emotion are indeed elements, but it is necessary to define these terms specifically for our context.

In September, 2001, the filmmaker visited the region and the refugee camp for the first time, and decided not to film inside the camp. Instead, she went undercover with her digital camera, into the fields and streets between the camp and the Eurotunnel terminal, and took part in the nightly routes and routines of her protagonists. She hid from the police with them in the fields and accompanied their tireless attempts to become stowaways and smuggle themselves across the border.

Figure 2 and 3

Laura Waddington risked adverse conditions and brought her physical situation, her point of view and her mode of existence, close to that of her protagonists. She accompanied their nightly campaigns and attended their barely visible existence as a type of floating consciousness. She became

"interested" in the most literal sense—she was there, she became an intermediary and transformed the political event into a personal experience.

No establishing shot explains the site to us at the beginning, nor between the takes, establishes a context that would enable us to orient ourselves in the fields. No field commander surveys the situation. We are in the midst of the action with the filmmaker and the protagonists—at night, often in high grass. Together with her and her video camera, our seeing goes to the border. Most of the time, we see little or nothing. If there is light, it is from cars driving past, the spotlights of helicopters, or the flashlights of police searching for refugees in the fields. No omniscient narrator illuminates the situation, explains to us the politically complex constellation, or establishes the chronological sequence of events, as I attempted to do at the beginning of this essay. Waddington made no summary and constructed no overview. Instead, she left a blurry videographic trace—the trace of an encounter with a disturbing reality, the fragment of an action that she attempted in the fields and streets of Sangatte.

The voice-over does provide information about the object of the images—the filmmaker narrates fragments from the lives and destinies of those she encountered, and also names particular events and key dates. However, this information and these descriptions of the situation are just scattered sporadically, and are not illustrated and confirmed by the images, as is customary in classical expository documentary. Together with the other thoughts, in addition to the music, they form a second trace. And this trace is always the trace of an "I"—not a conventionalized and disembodied voice, like that of the sovereign classical commentator, whose statements are to be accepted simply as facts, but the voice of an affected and compassionate subject.

Figure 4

The film *Border* is shaped by the presence of the filmmaker herself. Laura Waddington does not "document" in the sense of an expository repre-

sentation of a profilmic situation, nor does she seek, like a journalistic reporter, to make us able to experience events from the protagonists' perspective. The images are very closely tied to the filmer's line of sight, and her movements and her voice cannot be separated from the filmmaker as a person. The camera's view is not anonymized or objectivized, nor is it identified with the protagonists' view: as much as the filmmaker seeks proximity to her protagonists, and also to an extent does find it, she remains permanently an Other, an outsider, and she reflects herself as such in her images.

Waddington takes part in a life that is not hers and that existentially and socially does not concern her. The boundary space of Sangatte, which functions for the refugees as a space of "enclosing exclusion"[16], serves the artist as a type of refuge, where she bides her time in playful existence and artistic production. A free spirit, she accompanies the unfree spirits of Sangatte, which, under the "sovereign ban"[17], as if in a loop, over and over again make another attempt. What for the fugitives and their pursuers is serious, for her is more like play—ultimately, it is aesthetic play in the sense of a game of hide and seek, in which, despite her physical engagement, she takes on the role of spectator. Because of their different modes of existence, her perspective never coincides with that of her protagonists, and *Border* deals with this experience of distance in a specific way. The images testify to the aestheticizing, distancing gaze of the filmmaker and her camera, both of which—in attempting to see, to recognize, and to understand—are deflected by the surface of the visible and cast back upon themselves.

But *Border* is not only the subjective document of a biographical action and experience; it is simultaneously a representative filmic image—a type of sensory allegory—for the disturbing condition in which these semi-transparent, nocturnal shadow beings at the margin of collective consciousness have found themselves. No papers means no identity, no face, underground and without any ground to stand on, restlessly wandering in place. With *Border*, Laura Waddington creates an image for this barely visible presence, a filmic equivalent for this paradoxical condition of sleepless stasis on the site of transit.

I have termed this filmic image a "memorial" *(Denkmal)*. I mean this in two respects: first, "memorial" in the sense of an appellative "think about this" *(Denk-Mal-Nach)*. Waddington refers to the presence and existence of this pro-filmic reality and wants to bring it to our minds. Second, I mean "memorial" in the performative sense, that the film itself keeps something in mind *(Gedenken)*: this is a film in which thinking, in the sense of reflection as a structure and process, is inherent. In the following, this thesis will be further elaborated.

16 | See Agamben 2002, p. 27.
17 | See Agamben 2002, p. 119.

Figure 5

Subjected to the precarious lighting conditions and the unevenness of the terrain, Laura Waddington's camera operates at its technical limits. At the site of the event, it produces artifacts, pictorial disruptions, which obstruct the view of the represented and estrange the concrete, pro-filmic reality. The camera's technical reactions become visible, on one hand in substantial image noise, and on the other hand, in the blurring and stalling of the flow of movement, which has to do with the prolonged exposure time of the individual images. These two effects mark the aesthetic of the video and place the motivic object at an aesthetic distance. The individual takes do not present themselves as objective depictions of a given situation, but rather refer to the endeavors of a technical apparatus, which, consigned to the conditions of the site, is impaired in its functioning and attempts in vain to grasp its object. The faces of the protagonists cannot be identified and their silhouettes remain hazy—they merge with the background into a smoldering noise.

Because of these media-specific disruptions, the referential reality is not seemingly made apparent, but is expressed in the images as a reality that has been transfigured through distortion, that has been apparatively and subjectively mediated. The quasi-subjective reactions of the camera at the site of the action refer to the technicity and opacity of the images, and simultaneously, they contribute to an abstraction of the concrete, to a dissolution of the particular into an approximate, which amounts to a type of un-realization of the real. For a documentary film, this is an astonishing turn.

The filmic image is a witness to its object, without showing this object. Or, showing is here always connected with concealing, and the filmmaker's testament implies the inaccessibility of the visible. For *Border* evades both our recognizing seeing and our conceptual grasp. We neither recognize concrete or conspicuous details, nor are we carried along by a stringent argumentation or coherent narration. Rather, we are confronted by

unwieldy and salvaged material—with much that is dark and unexplained, arranged in a fragmentary manner.

This approach testifies to a media-ethical stance: Laura Waddington's protagonists hide in the noise of the image. She protects them from discovery or from visual exposure by the "violent act of the camera"[18], and she keeps them from being assaulted by a voracious reception. Waddington shows her protagonists confidentially—as secrets.[19] This runs entirely counter to conventional TV journalism, or even to critically intended documentary films, in which faces often serve as the most important carriers of identification.

At the same time, this approach also testifies to an epistemo-critical stance. In interviews, Laura Waddington talks of being overwhelmed, of the feeling that what she saw in Sangatte could not be communicated, and the constant impression that everything is much more complicated and more complex than people, or than she, is able to understand: "I knew I could only leave a very small and incomplete trace."[20]

As fragmentary as Waddington's work is as a document, as a filmic tableau of a highly unsettling situation, *Border* comprises an entity, in which these ghostly existences wander restlessly in place. This tableau does not intend to reveal or explain the profilmic reality; rather, it visualizes this reality's presence and existence with genuinely filmic means, and functions as a memorial—a memorial *(Denkmal)* that aims to meet its own implicit challenge to "think about it" *(Denk-Mal-Nach)*. No utmost and no inmost truth is disclosed. A reality is shown as one that simultaneously conceals itself; a secret is portrayed without being divulged or done away with. *Border*'s drama does not aspire to any resolution—the film remains a tension without any cathartic effect, and in this way *Border* is a filmic image of the refugees' condition—an intrusive image in which the experience of Sangatte is reflected as defining and traumatic.

I propose reading the artifacts that the camera produces at the site of filming under critical lighting conditions as the traces of a consciousness—first, as the traces of a camera consciousness that accompanies the object being shown. By means of the visible restrictedness of the video gaze and the always concomitantly displayed materiality, the image-producing camera brings itself to mind and the displayed object cannot be separated from the displaying medium. Through the voice-over, which was written later, this camera consciousness receives a personal voice, that of the filmmaker. Through the acoustic memories of the experience in San-

18 | Barthes 1985, p. 102.
19 | In an interview, Laura Waddington says, "I am afraid of filming. For me to film someone is an enormous responsibility because I don't believe a camera just captures the surface but also something underneath. And that's very sensitive and intimate. I think a camera has the potential to be something very violent." Eltimich 2004.
20 | Waddington 2005.

gatte, the indexical images are brought into a temporal distance and styled as spiritual images that are remembered or recur in dreams. Subjected to the conditions of this location, filmic images are produced that, following Deleuze, can be considered metaphors for mental images.[21] The technical impairment then symbolizes the deforming processes of time—producing a type of weathered or mentally processed image. The pro-filmic reality is expressed as one that has been internalized and appropriated; or, the videographic expressions take on the quality of subjective impressions, of dream images, of the images of memory.

This effect is enhanced in that Waddington's filmic gestures at the site of the action hardly grasp what they attempt to see and to understand. This is demonstrated in how the camera movements are not subordinated to their object, in the sense of classic "following shots." Instead, the camera movements remain visible as gestures, as actions that are not capable of catching up with their motif. In combination with the almost abstract, dematerialized images, these searching movements become the movements of reflection; they take on the quality of movements of thought. If one considers the conservational aspect of filmic recording, one might conclude that, with the insistent actions of her camera on the site of the event, Waddington anticipates the traumatic memory of this site. She reflects the experience—her own and above all that of the protagonists—in the lastingness of its effect.

In the last third of the film, the descriptions in the course of their recollection in the voice-over revolve around the situation after Sangatte: "Often I thought of that little girl on the road and wondered what she'd remember, where she was now, what she would be." The refugees said to her that later, they would not tell anyone how it had been. "They wanted to forget." Now and then she hears from them; they write to her from Hastings, Margate, Manchester. "They don't like England very much, they thought it would be different." Finally, Waddington directly addresses a specific person. The commentary takes on the form of a letter: "Months later you write me. You told me sometimes walking down the street, it all comes back to you. And you walk all day. And you think maybe you're not strong enough. And the people who live among you they don't know anything."

The radical subjectivity that distinguishes the film *Border* in many respects is Laura Waddington's artistic answer to the encounter with an extremely complex reality, in which the difference between objective reality and subjective experience, as it is established in the theory of documentary film, becomes untenable. Sangatte is one particular occasion and site in which the harsh reality of facts and the fictive, invented, imaginary merge into one another. Many different stories with varying truth content are condensed at this site—the stories of media, of the refugees, of their smugglers. And the fiction has harsh consequences—ultimately, the pre-

21 | Deleuze 1989, p. 266.

sentation of a person's life story will determine their entirely real fate, at latest by the time of their application for asylum. The hopes and projections directed at the other side of the Channel, dreams of better lives and local fears are as much a part of the reality of Sangatte as the three daily meals and the Eurotunnel corporation's strengthening of security measures. Sangatte also has a retroactive effect—as a defining and lingering experience, which will leave, which has left impressions and traces.

In Sangatte, a heterogeneous, aggregate condition of reality prevails, and this is the object of Waddington's video reflection. She cuts her narrow trail in the thicket of stories and creates a poem, a filmic commemoration, which brings this repressed parallel world into view in an appropriate way. She treats Sangatte both as the site of muffled fear and delectable hope as well as the site of bitter memory. In retrospect, Sangatte is guarded as a secret, is attempted to be repressed and forgotten. But the experience is haunting. It returns in memories and dreams – this is how *Border* presents the situation to me.

Translation: Elizabeth Tucker

LIST OF FIGURES

Figures 1-5: filmstills from *Border*, directed by Laura Waddington, F/GB 2005, 27 min.

BIBLIOGRAPHY

Agamben, Giorgio. 2002. *Homo Sacer: Die souveräne Macht und das nackte Leben,* Frankfurt am Main: Suhrkamp.
Barthes, Roland. 1985. *Die helle Kammer.* Frankfurt am Main: Suhrkamp.
Benjamin, Walter. 1969. "The Work of Art in the Age of Mechanical Reproduction." In *Illuminations,* ed. Hannah Arendt, p. 217-252. New York: Schocken Books.
Ceaux, Pascal et al. 2002 "M. Sarkozy: 'Il faut porter le fer dans les zones de non-droit'." *Le Monde,* May 31.
Deleuze Gilles. 1989. *Das Bewegungs-Bild.* Frankfurt am Main: Suhrkamp.
Del Lucchese, Filippo. 2005. 'The Two Speeds 'Frontera'. Interview with Laura Waddington." *JGCinema,* http://www.jgcinema.com/single.php?sl=laura-waddington (accessed July 03, 2010).
"Der Kanaltunnel als Weg illegaler Migration: Britische Besorgnis über französisches Laisser-faire." 2001. *Neue Zürcher Zeitung,* September 03.
Dufour, Jean-Paul. 2002."A Sangatte, avec les derniers réfugiés du centre de la Croix-Rouge." *Le Monde,* December 14.
Dufour, Jean-Paul. 2002. "Le centre d'urgence de Sangatte, une petite ville de 1300 habitants qui rêve d'Angleterre." *Le Monde,* May 30.

Eltimich, Cedric. 2004. "Smash The Border. A look at Border. A film disconcerting in its sensitivity." *Web Reporters*, November 25, http://www.laurawaddington.com/article.php?article=12 (accessed august 20, 2006).

"Fermeture du centre de Sangatte." *Croix Rouge: Actualités 4e trimestre*, December 2002, http://www.croix-rouge.fr/goto/actualites/sangatte/point-fermeture-2002.asp (accessed september 25, 2006).

Fezer, Jeko et al., eds. 2003. "Grenzgeografie Sangatte." *An Architektur 03* (Juli).

"Grossbritannien nimmt 1000 Kurden auf: Rasche Schliessung des Lagers Sangatte bei Calais." 2002. *Neue Zürcher Zeitung*, December 03.

Hahn, Dorothea. 2001. "Zwischen allen Zäunen." *Taz*, November 01.

Jeanson, Françoise/Laacher, Smaïn. 2006. "La grande misère de l'après Sangatte." *Le Monde*, February 24.

Laacher, Smaïn. 2002. *Après Sangatte: Nouvelles immigrations, nouveaux enjeux*. Paris: La Dispute.

"Le centre d'hebergement de Sangatte au bord de l'explosion." 2002. *Le Monde*, January 6.

Mesureur, Claire. 2002. "Le centre de Sangatte n'accueille déja plus les nouveaux arrivants." *Le Monde*, November 07.

Möller, Olaf, 2005. "Interview with Laura Waddington." *The 51st Pesaro International Film Festival Catalogue*, http://www.laurawaddington.com/article.php?article=10, (accessed June 27, 2010).

Pereira, Acacio. 2001. "A Sangatte, des migrants prêts à tout essayer pour gagner l'Angleterre." *Le Monde*, December 29.

"Vierundvierzig Asylsuchende im Kanaltunnel festgenommen." 2001. *Neue Zürcher Zeitung*, August 31.

Zappi, Sylvia. 2002. "Comment Paris et Londres veulent en finir avec Sangatte." *Le Monde*, December 03.

Zappi, Silvia. 2002. "Une étude précise les parcours des étrangers de Sangatte." *Le Monde*, June 14.

Politics, Representation, Visibility: Bruno Serralongue at the Cité Nationale de l'Histoire de l'Immigration

Lambert Dousson

Figure 1

The following paper will focus on a work by the French artist Bruno Serralongue, born in 1969, which is on show at the permanent exhibition "Repères" ("Marks") at the Cité Nationale de l'Histoire de l'Immigration ("National City of Immigration History") in Paris. This work, *Manifestations du Collectif de sans-papiers de la Maison des Ensembles 2001-2003*, is a series of forty-five photographs, from which the image accompanying

this paper is taken.[1] The banner reads: "Autonomous collective of the undocumented immigrants / [the address:] Maison des Ensembles / 5 rue d'Aligre Paris 12 / Legalization of all undocumented immigrants / 10 years residency card / Closing of the Administrative Retention Centres."

The question I would like to try to answer here is the following: What allows us to assert that in this photograph there is politics at work? Asking this question implies that the political meaning or efficiency of this photograph is not directly evident, which means that we need to examine the conditions in which this image can be considered as pertaining to politics. The question also implies that the political dimension or efficiency of this image is not necessarily based on the fact that it represents a political act. For one thing, because the political nature of what this photograph shows, a demonstration of "undocumented immigrants", first needs to be established. For another, because it is in itself not unproblematic to assume that this image is political merely because it represents an activity that can be considered to be a political one.

The purpose of this paper, then, is to try to clarify the connections between politics and representation. My hypothesis is that these connections are questioned by the very existence of "undocumented immigrants" on French territory. It is therefore the expression "undocumented immigrants" (in French: "sans-papiers"—"without papers"), that we have to elucidate, and I would like to show in which usage this expression is a political act, and how making oneself visible as "undocumented immigrants" constitutes a political act. In other words, the question of politics is not based on matters of representation, but of visibility and expressibility. Politics consists in making visible and rendering expressible what, in a definite configuration—in this particular case, the French policy of combatting so-called "illegal" immigration—has no business being visible and expressible, but on the contrary must be invisible and kept silent. It is exactly because this visibility is established in opposition to the conventional concept of representation that it constitutes a political act. By making visible the invisible and, at the same time, breaking with representation, this image becomes political, as a closer look at the artistic devices Bruno Serralongue implements in his work will show. The question which arises at this point is the material and institutional inscription of this image in the permanent exhibition of the Cité Nationale de l'Histoire de l'Immigration, and I would like to show that the conditions the exhibition provides for this image challenge—even risk neutralizing—its political efficiency, because they re-inscribe it in a system of representation.

1 | The entire series can be seen at the URL http://www.airdeparis.com/bruno.htm.

1

How does what this image represents, i.e. a demonstration of "undocumented immigrants", asking in particular for the "legalization of all undocumented immigrants" and the "closing of the Administrative Retention Centres", have to do with politics? To show that, I will base my paper on the theories developed by Jacques Rancière on connections between aesthetics and politics. According to him, if there are artistic practices that pertain to politics, it is because politics is already aesthetics, in the sense that it establishes a certain configuration of sensible experience. This aesthetics, Rancière calls it "distribution of the sensible", pertains to the "police". "Police" here means "the set of procedures whereby the aggregation and consent of collectivities is achieved, the organization of powers, the distribution of places and roles, and the systems of legitimizing this distribution"[2]. As for the "distribution of the sensible", Rancière defines it as "the system of self-evident facts of sense perception that simultaneously discloses the existence of something in common and the delimitations that define the respective parts and positions within it [...]. This apportionment of parts and positions is based on a distribution of spaces, times, and forms of activity that determines the very manner in which something common lends itself to participation and in what way various individuals have a part in this distribution. [...] It is a delimitation of spaces and times, of the visible and the invisible, speech and noise, that simultaneously determines the places and the stakes of politics as a form of experience"[3]. Contrary to the "police", which concerns the French policy of combatting "illegal" immigration, "politics" corresponds to the activity of "whatever breaks with the tangible configuration, whereby parties and parts or lack of them are defined by a presupposition that, by definition, has no place in that configuration—that of the part of those who have no part [...]. Political activity is whatever shifts a body from the place assigned to it or changes a place's destination. It makes visible what had no business being seen, and makes audible a discourse where once there was only place for noise [...]. Political activity is always a mode of expression that undoes the perceptible divisions of the police order by implementing a basically heterogeneous assumption, that of a part of those who have no part, an assumption that, at the end of the day, itself demonstrates the sheer contingency of the order, the equality of any speaking being with any other speaking being."[4]

So, within the "police" order, the expression "undocumented immigrants" is a noise, and the class of individuals denoted by this expression does not exist: only the expressions "foreigners in irregular situation" or "clandestine workers" pertain to discourse, and it is under the modality of illegality that the class of individuals these expressions denote partici-

2 | Rancière 1999, p. 29.
3 | Rancière 2006, p. 12-13.
4 | Rancière 1999, p. 29.

pates in the common. As such, their inscription in the field of sensible experience pertains to invisibility, in the hidden private space of houses or sweatshops, or in the urban space, within which they develop strategies of invisibility to escape identity checks, because their visibility in the public space identifies them as delinquents to be potentially apprehended[5] and whose "vocation" is to be "taken back to the border". The policy of combatting "illegal" immigration also takes place invisibly, and results in making the "undocumented migrants" invisible, who are identified as and reduced to "illegal migrants". For example, detention is outsourced to outside the borders of Europe; annual reports on the conditions of detention in France, until then made public by the CIMADE[6], are no longer permitted according to the decree modifying the assistance to the immigrants in Administrative Retention Centres[7], with the detention itself constituting exceptional circumstances in the state under the rule of law, because the deprivation of freedom it implements is decided by administrative and not judicial procedures; in the prefectures, the processing of files of candidates applying for regularization is taking on an increasingly discretionary character, and the collective identity checks are more and more frequently conducted by plain-clothes policemen who operate from unmarked vehicles, while operations of intimidation against the individuals who actively support the "undocumented immigrants" have multiplied—the invisibility being perfected when the "removal process" is accomplished.

In this perspective, demonstrating and showing oneself in the public space as "undocumented immigrants", is, in fact, making visible and expressible what had no business being visible and expressible; it is refusing to have to be hidden and to participate in the common as "foreigners in irregular situations" or "clandestine workers" asking for "regularization"

5 | This invisibility of the so-called "illegal immigrants" poses another problem: it inscribes itself in France within the hyper-visibility of the "legal" immigrants or of the French of immigrant origin, which is due to the colour of their skin. From this perspective, they are not distinguishable from each other, so that both groups are affected by the identification with or the confusion between immigration and delinquency, especially when being submitted to systematic collective identity checks that are now regularly conducted in the public space. From now on, anybody in France whose skin colour is not white is liable—at least indirectly—to be the target of both the policy of the battle against the so-called "illegal" immigration and the policy of the battle against delinquency, the same colour of skin that makes anybody, structurally, a potential delinquent. Seen from this angle, this double security-obsessed device is tantamount to a functional—for lack of an intentional—racism.

6 | Comité inter-mouvements auprès des évacués, http://www.cimade.org/.

7 | Décret n° 2008-817 du 22 août 2008 modifiant le code de l'entrée et du séjour des étrangers et du droit d'asile en matière de rétention administrative. (Decree modifying the code of both entry and stay of foreigners and the right of asylum in administrative detention.).

in order to be spared "collective identity checks" and not to be "removed"; and it is constituting oneself as "those who have no part", by wanting to participate in the common as "undocumented immigrants" asking for "legalization" in order to be spared "raids" and not to be "deported". The expression "undocumented immigrants" is a speech act, a performative utterance that constitutes its speakers as such, and re-configures the field of experience defined by the "distribution of the sensible". Indeed, the term "document" (the French word "papiers") to mean residence permit, becomes a metonymy that, through the literary term of antiphrasis, expresses a paradox, a contradiction, because the "undocumented immigrants" do, in fact, possess documents: passport, proofs of residence, etc.[8] This expression highlights both the contingency and the arbitrariness of what the "police" tries very hard to make invisible and to naturalize, namely the process of illegalization of their very existence. For if they possess, as everyone, "documents", they consequently have to be considered as taking part in this universal equality—a consideration that contradicts the logic of the "police". In this light, demanding the "legalization of all undocumented immigrants" expresses a tautology, because claiming to be an "undocumented immigrant" is already asking the legalization of "all" undocumented immigrants and rejecting the individual logic of the "police". The performative utterance "undocumented immigrants" un-identifies the migrants from the "police" identification which reduces them to "foreigners in an irregular situation" or "clandestine workers", and this un-identification is a political process of emancipation, that Rancière calls "subjectivation"[9].

2

So how can an image release the political nature of this operation of "subjectivation" which undoes the "distribution of the sensible" defined by the "police"? If it has to break with representation, it is because representation pertains to a dimension of the visible determined by the political aesthetics of the rhetoric of the media image, in particular the one which spectacularly illustrates the "short news item", which neutralizes the political visibility of the "undocumented immigrants" by reducing it and them to the "drama" of "clandestine" or "illegal" or "irregular" immigration. Indeed, the "drama" or the "tragedy" the short news item narrates—for example

8 | The undocumented immigrants possess even too many documents. There is a symbolical meaning in the care they take in archiving their documents: filing, photocopies, etc. This care must be understood in relation to the practices of the administration dealing with the processing of their situation: while the prefectures systematically ask for "more" documents, the front desk agents and clerks will not tolerate "too many" documents.

9 | Rancière 1999, p. 35.

the shipwreck and death by drowning of immigrants in the Mediterranean —, presents the event as an exceptional spectacle and as the effect of fate and disconnects it from any political origin—in this particular case the French or European policy of fighting against "illegal" immigration. In other words, the short news item presents itself as total visibility, a spectacle outside the frame of which nothing exists, and contributes to naturalizing the event by making invisible the contradiction between "police" and "politics". This device is the device of representation. It therefore plays a part in the device of legitimization of the "police", since the policy of fighting against "illegal" immigration presents itself as a way to prevent the immigrants, who supposedly embody "all the misery in the world", from risking their own lives by attempting to reach the borders of Europe, as if it were a humanitarian operation, and makes it visible only as a spectacle made for the short news item—for example when the regularization of an illegal immigrant is exceptionally granted on humanitarian grounds by the minister in charge himself—, showing that the French policy of immigration is a permanent state of exception. In other words, the political rationality of the policy of fighting against the so-called "illegal" immigration is the one of a state of emergency, indissociable from the emotional charge the media broadcasting this state of emergency generates. The respect for the fundamental rights in French law pertains to this state of emergency and is not related anymore to the constitutional frame—which is the subject of permanent negotiation. Fundamental rights and humanitarianism to which they are reduced are the subject of a kind of management or business.

All of Bruno Serralongue's work is based on a questioning of the political rhetoric of the representation the spectacular journalistic image embodies.

Serralongue realized this work, *Manifestations du Collectif de sans-papiers de la Maison des Ensembles 2001-2003*, between September 2001 and January 2003. He photographed, at every gathering, the demonstrators of La Maison des Ensembles who have since 1999 assembled every Thursday and Saturday between 5 and 7 p.m. around the fountain of the place du Châtelet in the centre of Paris. The fact that this series began more than a year after the beginning of these demonstrations is relevant to Serralongue's artistic project. Indeed, his work finds its point of departure in press pictures, and particularly the short news item—it was a "news in brief" in the French daily paper *Libération* which started this work —, of which he tries to shift the "space of both inscription and exhibition"[10], to show its political dimension by cancelling out its spectacular one. Thus, instead of offering an aesthetic image—a beautiful image—of the event which would appear from an internal demand, in a so-called fusion and obviousness of both objective event and subjective vision, as any photojournalist would want to achieve, Serralongue attempts to produce images

10 | Beausse 2006, p. 38.

"out of screen", of "low intensity, taken from the reverse side of the events, not in the warm centre of the media focus, but right nearby"[11], and shows them not in newspapers, but in art exhibitions. Both neutrality and impersonality of the image disregard the exceptional and spectacular dimension which qualifies the short news item: It disconnects the event from the vision and shows the artificiality of the connection—it shows that this connection, which generates the representation, is a device, a construction, an assemblage. In an interview with Isabelle Renard, in charge of contemporary art at the Cité Nationale de l'Histoire de l'Immigration, he explains: "What interested me in this demonstration was that it had been already in progress for about a year and, because of its regularity (it took place twice a week), it had melted into the background [...]. It had become commonplace, it was no longer something like a scoop and therefore no longer an item of interest for journalists or press photographers. Seeing that, I said to myself that I, I could be there like them every week. My regular presence distinguished my contribution from that of the press photographer who would have come once and who would then have published his photo in a paper. The fact of returning every week was more in accordance with their demand."[12]

The effect of distancing he is looking for—as if he was making delayed photographs—is produced by the technical equipment he utilizes: the use of a camera on a tripod slows down the movements of the photographer, allows only one shot and requires a particularly long exposure. The effect of remoteness generated by this process aims at revealing duration and continuity—namely what the "police" and its "distribution of the sensible" refuses the immigrants—, which the repetition of forty-five similar but different prints brings to the power of two. These photographs thus aim at making a connection between the non-event of the demonstrations and the political device into whose scope it inserts itself, to short-circuit the discreet and spectacular logic of the short news item.

We thus understand that it is the artistic disconnection between the vision and the event that allows the political connection between the event and the "police": It deconstructs the event and makes it a non-event, and, by this way, deconstructs the logics of the spectacle, of the representation. Indeed, the confrontation with the press photo has another function: It shows that photography cannot claim to be an autonomous medium and that it does not show the flesh (in the phenomenological meaning) of the event—as its very truth—as the press pictures would have us believe. As Carles Guerra writes in the catalogue of the exhibition *Notre Histoire* ("*Our History*"), which took place in 2006 at the Palais de Tokyo in Paris and where some photographs of Serralongue were exhibited: "No technical or stylistic resource suffices to attain the effect of reality. It can only spring from an extraphotographic device [...]. It is no longer photographers who

11 | Domino 2007, my translation.
12 | Renard 2006, p. 138, my translation.

make the photograph but rather the photographic institution that makes the photographer. Serralongue's work as a photographer demonstrates this. He renounces so-called freedom, which a good number of photojournalists think they enjoy, the very professionals who risk their lives because of the attraction exercised by the very heart of the action. Unlike them, Serralongue doesn't shoot an image of the event but rather the image of the photographic rhetoric that is supposed to capture the event."[13] In other words, while representation presents what it represents as something given and self-evident, that is a spectacle, Serralongue's artistic device shows that it is the outcome of a political process, a construction, that is a contingent and arbitrary device: It shows that the immigrants are illegal because they are illegalized.

3

The question which arises at this point concerns the material and institutional inscription of this image in the permanent exhibition of the Cité Nationale de l'Histoire de l'Immigration. Since its opening in 2007, this museum has embodied a network of more or less accepted contradictions: Firstly, it is housed in a building built in 1931 for the International Colonial Exhibition in order to house the Museum of Colonies. Secondly, the majority of the members of its scientific committee, including in particular historians of immigration, resigned in reaction to the establishment, following the election of Nicolas Sarkozy as President of the Republic, of the "Ministry for Immigration, Integration, National Identity and Joint Development", declaring that the combined presence of the words "immigration" and "national identity" was part of "the framework of a discourse which stigmatizes immigration and is in the tradition of a nationalism based on suspicion and hostility towards foreign people in moments of crisis"[14]. Thirdly, its opening was almost a clandestine one, without an official inauguration, while the President of the Republic, the Prime Minister and the four ministers jointly in charge (Education, Research, Immigration, Culture) were absent. Hence, it constitutes a public state institution, partner of the Ministry of Immigration, but which presents in itself a subversive dimension, in conflict with the present political power. The absence of an official inauguration was considered by one of the resigning members of the scientific committee (the immigration historian Gérard Noiriel) as a victory for the Cité. By all appearances, history of immigration and policy of immigration could not be visible at the same time.

Yet it seems that this set of contradictions affects the political meaning of Bruno Serralongue's work. The very presence of this work could, first of all, constitute an acknowledgment of the existence of the "undocumented

13 | Guerra 2006, p. 191.
14 | Weil 2007, my translation.

immigrants" as such, and as a problem of politics. Nevertheless, this acknowledgment is questioned by its material, namely spatial exhibitionary conditions. Indeed, by exhibiting this series as a work of art possessing an autonomous status, and as such designed to generate merely an aesthetic experience—the experience of a beautiful representation, a beautiful image—, the museum institution neutralizes its political meaning and efficiency. It exhibits the photos facing (in a spatial and symbolical way) historic and testimonial documents, as if the photos were simple illustrations, or even decorations for the documents, and then it denies them the possible status of documents: Their aesthetic—that is their spectacular—nature cancels out their cognitive power. But Serralongue's project aims exactly at highlighting their political contents: by showing the heteronomy of any photograph of immigrants as pertaining to an extra-photographic rhetoric of representation—stemming from immigration policies, what Rancière calls "police"—, which hides behind the mask of aesthetic experience. In other words, the exhibition depoliticizes these photos: by denying them any documentary—that is cognitive—power, it cancels out the ambiguity they create between fine art and photojournalism. In other words again, the aesthetic device neutralizes the artistic device.

In this light, the commentary accompanying the photos is significant: "[...] What is at the core of these photos is the relationship between an individual and a given group. These pictures allow us to realize the duration of the demonstration, the obstinacy of the undocumented immigrants in their claims but also the difficulty in reaching a political solution in one and a half years". Written by the curator of the exhibition, this note includes expressions that appear in the interview Isabelle Renard, in charge of contemporary art in the Cité Nationale de l'Histoire de l'Immigration, conducted with Serralongue. Nevertheless, in the same interview he also said: "Yes, the forty five photos are necessary to highlight the fact that this policy of immigration cannot be resolved in a day or in a month and that *there are political forces that are powerful enough to prevent any resolution of it*. Showing that this demonstration took place over one and a half years also highlights the obstinacy of the illegal immigrants, but also *the political obstinacy* in not finding a humane solution [...]. However, here the spectator has to build for himself the meaning and the stakes of this series."[15]

Yet if it is the institutional inscription of the exhibition of this series that builds "the meaning and the stakes of this series", mentioning in the presentation the "obstinacy of the illegal immigrants", without stating the opposite side to this obstinacy, i.e. "the political obstinacy", that the claim "Closing of the Administrative Retention Centres" embodies on the banner in the photograph, leads to an imposition of their meaning: the dissymmetry of what is expressed implies a dissymmetry of what is visible. Indeed, if it is only a question of "a difficult political solution", then what is only visible is an example of the "drama" or the "tragedy" of the "clandes-

15 | Renard 2006, p. 140, my translation, my emphasis.

tine" or "illegal" or again "irregular" immigration, and not the contradiction nor the heterogeneity between the logic of the "police", based on the policy of fighting against "illegal" immigrants, and the logic of "politics", based on the struggle of the "undocumented" or "illegalized" immigrants for equality: abstracted from this heterogeneity, the adjective "humane", used by Serralongue in the interview, becomes depoliticized.

We therefore negatively understand why this photograph pertains to politics, because it shows the double visibility of both logics, embodied by both expressions "undocumented immigrants"—automatically implying the "legalizing of all"—and "closing of the Administrative Retention Centres". But, if asking for the "closing of the Administrative Retention Centres" is kept silent, then the "police"—and its "political obstinacy"— becomes invisible, and this invisibility pertains to the "distribution of the sensible" it establishes, because it makes it obvious, and consequently implies the invisibility of the undocumented immigrants as such, as illegalized immigrants, to make visible only "illegal immigrants" or "clandestine workers".

Consequently, the invisibility of passers-by or policemen on the photographs can only be interpreted in the sense of a sensible, sensitive and above all structural indifference, i.e. of the absence of a political polarization, an absence that relegates the migrants to the isolation of a problem that can never be political, but only "human"—in the de-politicized sense the "police" imposes on this word. This network of invisibility thus makes invisible the contradiction of the two logics (the one of the "police" and the one of the "politics"), and consequently it neutralizes the political and performative force of the expression "undocumented immigrants" which the curator of the exhibition, caught in the contradictions of the Cité Nationale de l'Histoire de l'Immigration, nevertheless uses in the presentation. In other words, in exhibitionary conditions such as these, despite the intention to make "undocumented immigrants" visible as such, this photo represents the spectacle of "illegal immigration", but does not make visible the politics of the "illegalized immigrants".

List of Figures

Figure 1: Bruno Serralongue, *Manifestations du collectif de sans papiers de la Maison des Ensembles, place du Châtelet, Paris, 2001-2003*. 18. Manifestation du collectif de sans papiers de la Maison des Ensembles, place du Châtelet, Paris, Samedi 19 Janvier 2002, 2002. Tirage Ilfochrome sur aluminium, 125 x 156 cm. Courtesy Air de Paris, Paris.

Bibliography

Beausse, Pascal. 2006. "Bruno Serralongue." *W-Art* 8 (Spring): p. 34-43.
Domino, Christophe. 2007. "On *Backdraft*, Monographic Exhibition devoted to Bruno Serralongue in Geneva Photography Centre." *Journal des arts* (April).
Guerra, Carles. 2006. *Notre Histoire*. Catalogue of the Exhibition. Paris: Palais de Tokyo.
Rancière, Jacques. 1999. *Disagreement: Politics and Philosophy*. Minneapolis: University of Minnesota Press.
Rancière, Jacques. 2006. *Politics of Aesthetics*. New York: Continuum International Publishing Group Ltd.
Renard, Isabelle. 2006. "Bruno Serralongue, Passeur d'Images." *Hommes & migrations*, 1263 (September-October): p. 133-142.
Weil Patrick. 2007. "Ministère de l'Immigration: Première Crise, Premières Démissions." AFP/*Libération*, May 18.

The Image versus the Map: the Ceuta Border

MARC SCHOONDERBEEK

> "Opting for difference only becomes tenable when one learns how to distinguish specificity and identity."[1]

Figure 1: The Ceuta Fence (Photo credit: Petra Pferdmenges)

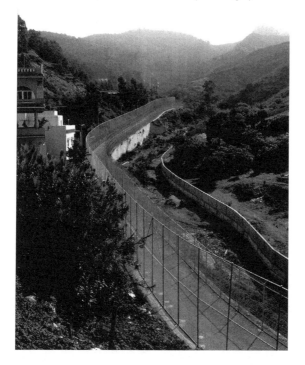

1 | Cache 1995, p. 15.

Introduction

The fence that separates the small Spanish exclave of Ceuta on the African continent from Morocco has received much attention the last few years, both in the press and in socio-political discussions. The attempts of illegal immigrants from Africa and Asia to get across the heavily fortified and controlled fence zone into Spain, and thus European space, have been the main focus point of this attention. Especially after the events of 29 September 2005, when hundreds of illegal immigrants simultaneously tried to get across the border fence, resulting in several deadly shooting incidents, the media reports have emphasized (and made into a rather cliché image) the poor, almost harmless immigrants being confronted with a fierce, merciless system of defence, not unlike the former Berlin Wall. Indeed, the Ceuta fence is constructed to prevent easy access to Europe for those seeking a better future, but a close investigation of the factual border conditions on site quite easily reveals the discrepancies and contradictions inherent in these media images of illegal border crossings and transgressions in comparison to the "found realities" on site.

This factual investigation into the physical presence of the Ceuta fence, and the spatial practices that unfold around it, shows that the border between Spain and Morocco is anything but clear. Rather, the mapping of the border discloses a sequence of complex, layered territories and entities, divided by a border that might appear to be a solid entity but on closer inspection proves to be a collection of sometimes blurry and in other instances straightforward zones with uncertain boundaries. By charting the physical and non-physical presences of the border and its surroundings, a de-mystification and counter-balancing is set to work, one that undermines the banalization and cliché character of the images "the media" has been producing.

Imagination and Imagery

Before starting to clarify the nature and content of mapping(s), a few remarks are necessary to properly frame the discussion of maps in relation to images. Firstly, for disciplinary reasons and in order to maintain a level of clarity, a critique within the architectural discourse on the use of imagery in the media should best be avoided. The dependence on the visual realm and the obsession with images[2] within the contemporary architectural discourse is mainly related to a confused understanding of the notion of vision and the visionary.[3] The specific disciplinary role of architecture is, therefore, a topic worth mentioning, but the architect can (or should) be

[2] | See, for instance: Colomina 1994, especially the chapter on "Publicity".
[3] | See: Virilio 1993, p. 96-105. Virilio quotes video filmmaker Gary Hill, while referring to the radically changed importance of vision: "Vision is no longer the possibility of seeing, but the impossibility of not seeing".

viewed as being a visionary, namely engaged in the disciplinary activity of producing a vision, an image of a possible future.[4] In other words, architecture is concerned with the workings of imagination in close relation to the production of imagery.

A second issue is the insights into the changed workings of images in contemporary thinking as well as the complex way we are nowadays engaged in the production, processing and consumption of images. In *Paris ville invisible*, Bruno Latour claims that these image processes are no longer static, but initiated via a movement of images: "Let's [...] say that the visible is never in an isolated image or in something outside of images, but in the montage of images, a transformation of images, a cross-cutting view, a progression, a formatting, a networking."[5] By introducing the oligopticon as a model for understanding the workings of contemporary imagery, Latour tries to get away from the superficiality of reading images and, perhaps equally important, reveal the inherent hidden ideologies of images. The oligopticon places us back in Plato's cave, though the analogy is now reversed: watching the projection is in fact the only place where we can see and the limitation of the cage actually allows us to see "reality". One dominates with a personal gaze, precisely by not looking outside, which would limit the view to one's own point of view, but by looking at traces (the projected shadows), thus allowing one to start to really see. Latour describes this process as becoming outside by becoming completely inside.[6]

The result is that the single image no longer conveys any significant meaning or message. Instead a sequence of images is required, one that simultaneously implies that the act of reading and understanding transforms into the act of sequential reading, not unlike the traversing of a map. Latour's argument can lead to the understanding that multiplicity cannot be seen from a single glance organized in a top-down manner. In reference to the bird-eye's view or satellite image, this is claimed to be literally the view from nowhere, to nowhere. This argument changes the critical understanding of the operative effects of images and thus reassesses the understanding that Western democracies are turning into "mediacracies", where the media is replacing the critical role of intellectuals. As a result, the technique of mapping is becoming more and more the proper instrument for addressing the more complex workings of images. On this increased importance of contemporary mappings within the spatial discourses, a similar argument was made by Denis Cosgrove: "indeed, the map may be the only medium through which contemporary urbanism can achieve visual coherence."[7] It is Guy Debord who has, with great lucidity, been able to connect the practices of image pro-

4 | Visionary Architecture refers to "unbuilt architecture" as well as to utopian plans. See, for instance: Macel/van Schaik 2005 or Spiller 2008.
5 | Latour/Hermant 1998, p. 58-59.
6 | Ibid, p. 22-25.
7 | Cosgrove 2006, p. 148-157.

duction with urbanism.[8] According to Debord, urbanism is aimed at creating separation, as much as image culture is aimed at creating separation. The separation Debord talks about is the individualization, the compartementalization if one will, of a capitalist, mass culture and consumer society.

MAPPING AS A MEASUREMENT

When architecture is defined as the discourse on space and spatial conditions (and not problem-solving functionality), the significant contribution it can make, next to the imagining of the future of societies mentioned previously, is by developing critical investigations into the spatial practices within current societies caused by societal, cultural, legislative and political processes. The techniques applied by architects can operate on this, more investigative, level, namely by testing, verifying and shading the current spatial conditions and their underlying forces, rules, laws and cultural practices. The act of mapping extends a mere description of space into an ordering of the investigated territory, which, consequently, introduces an ordering of the specific knowledge regarding that territory as well. Within the process of naming and drawing the content of the map, a limited and selected amount of information is made visible and tangible, even if these "spatial facts" might be non-apparent or irretraceable. As a result, a new territory is created, a new interpretation of "reality" that constitutes new, or other, readings and understandings of space. This is not to claim that mapping is an objectifying or neutral act, on the contrary. The conclusions and insights of an investigation via the fabrication of a map does not resolve the important characteristic of maps having an inherent ideological intent, which may or may not be very explicit.

Mapping is a means of representation that "measures" space: it measures the position of the human body within a cosmic constellation in reference to the ground and the sky. The technique of measurement via drawing, as it historically has been an intricate part of the architectural discipline, always entailed an element of positioning man in his surroundings, which were of divine origin. In more recent decades, this "measuring of the earth" has developed "simply" into the description of the earth's surface. The analysis of Alberto Pérez-Gómez and Louise Pelletier regarding the developments of representational techniques in the history of architecture, contain a fundamental critique that can be projected onto this argument. For them, representation has become "the deplorable outcome of the implementation of the technological will to power, of efficiency and rational control as the only unquestionable values for any practice," but they are "lacking a real 'theory', that is, lacking a philosophy and its concomitant historical grounding that may lead to ethical, critical, and subversive tactics"[9].

8 | Debord 2003, chapter 7.
9 | Pérez-Gómez/Pelletier 1997, p. 383.

Of course, contemporary mapping cannot "restore" this cosmic order to the realm of representation, but mapping can critically construct an interpretation of daily spatial processes and incorporate the random and dynamic events and behaviours that constitute urban space. When describing the cartographic practices of several European, socially engaged, collectives, Maribel Casas-Cortes and Sebastian Cobarrubias quote the *Car-Tac* collective to explain the larger contextual framework implied in maps: "Even though the map is not the territory, to make maps is to organize oneself, to generate new connections and to be able to transform the material and immaterial conditions in which we find ourselves immersed. It isn't the territory but it definitely produces territory."[10] Maps are tools to capture the incomprehensible, unconscious, or structurally "invisible" qualities of space.[11] The fact that maps are ideologically and culturally determined is a direct result of both their underlying instrumentality and mentality. In other words, the content of any map depends on both the physical instruments applied as well as the cultural background of the map producer(s). Mappings are indices of possibilities, or actualizations of virtualities[12], that introduce multiple perspectives and multiple dimensions on spatial issues. In a way, when referring to the original understanding of maps, namely as descriptions of the surface of the earth, nowadays a more non-hierarchical, less top-down, or even "lateral"[13] way of conceiving space is part of maps and the practice of mapping.

REPRESENTATION, BODILY EXPERIENCE AND SMALL-SCALE-READINGS

The traversing of the contemporary "landscape", during the act of mapping, takes on aspects of observation, interpretation and registering a field of investigation which also implies a strategy that treats matter "as found". Perception and reflection is a complex mechanism, as Merleau-Ponty has convincingly argued. The "reading" of the world is a bodily experience that pre-supposes a certain knowledge a-priori. Mapping, to be more precise, is perhaps not so much a mechanism that allows a completely new and open reading of contemporary urban conditions or landscapes, rather, it asks for a postponement of judgment in the sense of a direct "reality-check". One needs to start with questioning the assumptions and speculations regarding contemporary spatial processes and the way these are studied.

10 | Casas-Cortes/Cobarrubias 2008, p. 63-64.
11 | See: An Architektur 2008.
12 | Gilles Deleuze's insistence on the virtual, rather than the possible, in Deleuze 1997.
13 | Lateral thinking is described by Stefano Boeri as "moving at once toward physical space and mental space" when discussing the four gazes developed in Boeri 1998/1999, p. 102-113.

The observed processes, events, happenings, encounters, border conditions, etc., ask for a process in which the observations are "given" a "meaning" through the act of developing notational systems.

Mapping spaces allows the connection of bodily experience with conceptual reasoning. It is crucial to understand that mapping is but a filtering of "reality". Mapping is always the translation of sensory input through the filter of the body, both in terms of sensory experience and as mental processes of cognition, into a notation system or methodology. It has been argued that sensorial experience itself is but a filtering, a deformation if one will, of the "world". Maurice Merleau-Ponty has meditated on this complex relationship between experience and knowledge: "The world is what we see and [...] nonetheless, we must learn to see it—first in the sense that we must match this vision with knowledge, take possession of it, say what we and what seeing are, act therefore as if we knew nothing about it, as if we still had everything to learn."[14]

As the map is "not the territory", (the map can only fully describe the territory if there is a 1:1 relationship), the map is always, by its very nature, a limited reading of the territory. If mapping unfolds potential, as James Corner[15] has stated, it does so on the basis of its openness, its invitation to interpretation. A mapping entails a small-scale reading that turns a measuring into an exploration. Investigating, exploring and describing the basic principles of spatial organization and spatial practices on a micro level inform the small-scale readings developed in mappings. It is important to understand that a mapping is the construction of a "language of imagination" and this language is constructed out of a modus operandi that has an inner logic and no apparent history. By positioning mappings as a device for critically investigating contemporary spatial practices, as in the Ceuta map presented here, a similar effect is intended as the "strategies of annoyance" of Jacques Derrida, in attempting to escape their institutionalization at the moment of practical execution. Several descriptions have been offered to define the specific content and intent of this type of mapping: termed a "cartography of war"[16], "tactical cartography"[17] or "radical cartography"[18], these mappings all present subversive tactics intended to

14 | Merleau-Ponty 1968, p. 4.

15 | Corner 1999, p. 213.

16 | Where the mapping "does not merely document war but which actively opposes it or uncovers its horrors", in Dorling/Fairbairn 1997, p. 150-154.

17 | According to the Institute for Applied Autonomy, tactical cartography produces "spatial representations that confront power, promote social justice and are intended to have operational value. [...] In taking up the term 'tactical', we link cartography with tactical media, an approach to art production that privileges critical social engagement".

18 | "We define 'radical cartography' as the practice of mapmaking that subverts conventional notions in order to actively promote social change", introductory statement by Lize Mogel and Alexis Bhagat in Mogel/Bhagat 2008, p. 7.

undermine the common understandings of spatial practices. In all these cases, the mappings simply make explicit political points. However, as they present artificial geographies, as reflections of the survey of existing conditions, they simultaneously confirm Dalibor Vesely's argument that representation is fragmentary by nature since there are experiences within spatial conditions that escape any re-presentation.[19]

The Ceuta map

In the Ceuta map, the subtle and sometimes temporal lines of division within the area are collected and their spatial workings have been investigated. The map of the Ceuta border conditions offers an insight in the several border zones present across the territory. The access to Ceuta from mainland Spain is organised via the water, meaning one enters the exclave by boat and through the port that is designated as a new, free economic zone. Towards the western side of the city, the historical border, that used to enclose Ceuta (until the Spanish-Moroccan War of 1859-1860), can still be distinguished in the current city fabric as it remains spatially present as a green, not clearly evident corridor. Alongside this border, a peripheral zone can be found where annexed Moroccan houses are situated as well as a sizeable population of Moroccan origin. The official, legal border crossing points from or to Morocco are located at the outer ends of the official border zone, all in close proximity to the water. Here, a double-fenced, razor-wired border is erected, inclusive of a surveillance area, along the outskirts of the Spanish territory on the African continent. Yet, inside this territory, an entire array of specific border conditions has emerged because of the illegal incursions and transgressions and the related administrative procedures for the illegal immigrants. For instance, the area between the old city and the refugee camp (CETI) has become a promenade used by commuters, workers and leisure-seeking inhabitants.

The borders within the Ceuta territory have at least a couple of "temporary states of exception" that create a permeability of the observed borders. These temporary states of exception emerge as a result of economic, military and political processes, and cause changes in orientation within the border zones. The Moroccan workers entering Ceuta every morning and returning in the evening, or simply the border patrol along the Spanish-Moroccan border are examples of this phenomenon.[20]

19 | Vesely 2004, p. 317-354.
20 | The Ceuta Map is part of a larger map that includes Gibraltar. This 'BC_Gibraltar/Ceuta' map has been developed by Oscar Rommens, Marc Schoonderbeek and Sebas Veldhuisen in the context of the 'Border Conditions' (BC) research programme at the Faculty of Architecture, Delft University of Technology. Map drawn by Adi Fajar Utama.

162 MARC SCHOONDERBEEK

Figure 2: The BC_Ceuta map

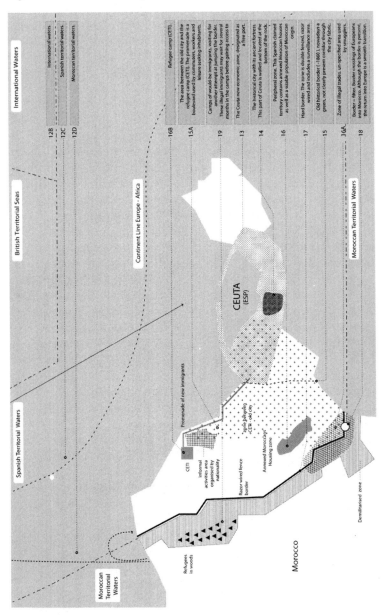

All the borders mentioned in the map are physical manifestations of conflict as well as profound spaces of encounter. The Ceuta map investigation discloses a sequence of complex, layered territories and entities, zones that are circumscribed by unclear divisional lines. The Ceuta map shows a sequence of divisions that are unstable both in space and time and whose influence stretch far beyond their localities, a feature that is common to borders in general: "closed off in most cases, borders are sufficiently permeable to enable the trafficking of people and goods. And sufficiently sealed that social and family ties cannot be rewoven"[21]. While the hope that the specific spatial representation developed in the Ceuta Map might confront power should be considered a too naïve position, it does constitute a critical position and engagement which, at least, aims or intends to nuance the image of the border and the spatial practices unfolding in its close proximity.

Figure 3: Temporary refugee camps in Morocco
(Photo credit: Petra Pferdmenges)

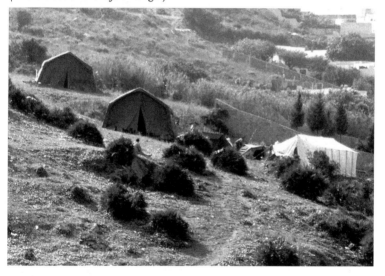

21 | Glasson Deschaumes/Iveković 2003, p. viii.

Figure 4: Satellite image of Ceuta (Source: Google Earth)

Figure 5: Satellite image, zoom-in to the most Southern border crossing (Source: Google Earth)

Figure 6: Location of the former border within contemporary Ceuta (Photo credit: Anne Katrin Menke)

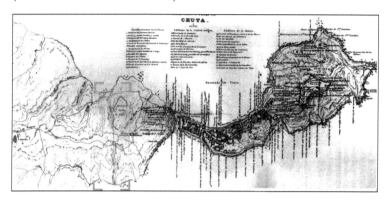

ADDITIONAL SOURCES FOR CEUTA MAPPINGS

http://mcs.hackitectura.net/show_image.php?id=593
http://www.noborder.org
http://www.countercartographies.org
http://bureaudetudes.free.fr
Border Conditions research group:
www.borderconditions.org

LIST OF FIGURES

Figure 1: The Ceuta Fence (Photo credit: Petra Pferdmenges).
Figure 2: The BC_Ceuta map.
Figure 3: Temporary refugee camps in Morocco (Photo credit: Petra Pferdmenges).
Figure 4: Satellite image of Ceuta. (Source: Google Earth).
Figure 5: Satellite image, zoom-in to the most Southern border crossing. (Source: Google Earth).
Figure 6: Location of the former border within contemporary Ceuta. (Photo credit: Anne Katrin Menke).

BIBLIOGRAPHY

An Architektur. 2008. "Map #4." In *An Atlas of Radical Cartography*, ed. Lize Mogel and Alexis Bhagat. Los Angeles: The Journal of Aesthetics & Protest Press.
Boeri, Stefano. 1998/1999. "Eclectic Atlases; Four possible ways of seeing the city" *Daidalos* 69/70: p. 102-113.

Cache, Bernard. 1995. *Earth Moves; The Furnishing of Territories.* Cambridge: The MIT Press.

Casas-Cortes, Maribel/Cobarrubias, Sebastian. 2008. "Drawing Escape Tunnels through Borders; Cartographic Research Experiments by European Social Movements." In *An Atlas of Radical Cartography*, ed. Lize Mogel and Alexis Bhagat, p. 63-64. Los Angeles: The Journal of Aesthetics & Protest Press.

Colomina, Beatriz. 1994. *Privacy and Publicity; Modern Architecture as Mass Media.* Cambridge/London: The MIT Press.

Corner, James. 1999. "The Agency of Mapping." In *Mappings*, ed. Denis Cosgrove. London: Reaktion Books.

Cosgrove, Denis. 2006. "Cartocity." In *Else/Where: Mapping. New Cartographies of Networks and Territories*, ed. Janet Abrams and Peter Hall, p. 148-157. Minneapolis: University of Minnesota Press.

Debord, Guy. 2003. *Society of the Spectacle.* London: Rebel Press.

Deleuze, Gilles. 1997. *Difference and Repetition.* London: The Athlone Press.

Dorling, Daniel/Fairbairn, David. 1997. *Mapping; Ways of Representing the World.* Essex: Pearson Education Limited.

Glasson Deschaumes, Ghislaine/Iveković, Rada, eds. 2003. *Divided Countries, Separated Cities; The Modern Legacy of Partition.* Oxford/New York: Oxford University Press.

Latour, Bruno/Hermant, Emilie. 1998. *Paris ville invisible.* Paris: La Découverte-Les Empêcheurs de penser en rond.

Macel, Otokar/van Schaik, Martin, eds. 2005. *Exit Utopia; Architectural Provocations 1956-1976.* Munich: Prestel.

Merleau-Ponty, Maurice. 1968. *The Visible and the Invisible.* Evanston: Northwestern University Press.

Mogel, Lize/Bhagat, Alexis. 2008. *An Atlas of Radical Cartography.* Los Angeles: The Journal of Aesthetics & Protest Press.

Pérez-Gómez, Alberto/Pelletier, Louise. 1997. *Architectural Representation and the Perspective Hinge.* Cambridge: The MIT Press.

Spiller, Neil. ed. 2008. *Visionary Architecture; Blueprints of the Modern Imagination.* London: Thames and Hudson.

Vesely, Dalibor. 2004. *Architecture in the Age of Divided Representation; The Question of Creativity in the Shadow of Production.* Cambridge/London: The MIT Press.

Virilio, Paul. 1993. "Speed and Vision; The incomporable Eye." *Daidalos* 47: p. 96-105.

Who is a Refugee—Strategies of Visibilization in the Neighbourhood of a Refugee Reception Camp and a Detention Centre

ALMUT REMBGES

INTRODUCTION

The illegalization of refugees[1] often finds its visual expression in invisibilization[2]: Detention centres and refugee camps are usually situated somewhere well out of sight from the public eye. And there are numerous examples of artistic or documentary works about undocumented migration where camouflaging the body seems to be the only possibility of portraying people for whom hiding their identity and location is a fundamental part of their survival strategy.

This paper discusses two projects which have been trying to find ways of creating a visual presence for refugees in Switzerland, in which they are neither invisibilized nor stereotyped by others. While one of the projects has already been completed, the other is still in progress at the time of writing. Both of them were initiated at the border of Basel (Switzerland), right at the so-called "Otterbachgrenze", just outside the city, where we find a detention centre as well as a refugee camp.

I write this text as the curator of an artspace called *bblackboxx* (www.bblackboxx.ch), based 500 meters from that camp. Since 2007, various

1 | According to the definition of the UNHCR "refugee" refers only those people who are persecuted by others. My own use of the term would also include those who have left their home for other reasons, for example poverty. In this context, I would also prefer the term refugee to the term asylum seeker, because it also encompasses the numerous undocumented migrants who do not apply for asylum. For the definition of the term "refugee" by the UNHCR see: http://www.unhcr.org/pages/49c3646c137.html, (accessed May 27, 2010).

2 | Numerous examples have been discussed during the conference, such as the work of Laura Waddington about Sangatte, presented by Eva Kuhn in this volume.

projects about the border have been realized here by changing teams of artists and theoreticians. The recurring theme in all these projects has been the development of communicative and interactive scenarios with the people who spend their time in the area and who like to visit us in our space. Most of these people are refugees who have to leave the camp during the day. The others are citizens from Basel and across the border, spending their leisure time here.

The first project is called "picture service", which was a collaboration with the art historian Barbara van der Meulen-Kunz.[3] She developed the idea that we could use our space as a kiosk with a free picture service, where people could borrow cameras and afterwards receive the pictures they had taken themselves while wandering around in the area. It was never planned to exhibit these pictures in an art context, but sometimes we printed out a photo or two, so that the people could see their own pictures on the walls.

The second project has the title "AuQuarellclub sans frontières"[4] and it is a collaboration with Passe-Partout, a group of politically committed academics and artists, who met in the beginning of the year 2010 in order to discuss counter- strategies against the so called "Ausschaffungsinitiative", the upcoming initiative of the Schweizerische Volkspartei (SVP), which is a right-wing party with gaining popularity in Switzerland. A fundamental motive in their campaigns is once again the establishment of the image of the "dangerous foreigner"[5], as Francesca Falk points out in a recent essay about the initiative.

Before going into more detail, I would like to give a better idea of the context we have been working in and to explain why strategies of visualization have been of particular interest here.

THE CONTEXT: LANDSCAPE OF WAITING

The so called "Otterbachgrenze" (Otterbach-Border) is situated in a extra-urban zone of Basel City, a no man's land, a typical borderland. Here, we find a nature protection area, very popular among the city dwellers, for picknicking, sports, walking with dogs and the like. Occasionally, the border police make an appearance, either looking for people or going on rounds with their German Shepherds, and sometimes they just seem to be walking the dogs. And there is the detention centre and the camp where around 300 people live in 15 rooms, while they undergo an interview pro-

3 | Barbara van der Meulen-Kunz is currently working on her Ph.D. thesis about the photographical work of Dan Graham (University of Basel).
4 | AuQuarellclub is a play of words with the term "Aquarellclub", meaning "water-color-club" while the *Au-* refers to the first syllable in *"Ausschaffung"*, the Swiss German term for detention.
5 | Falk 2010, p. 275-276.

cess and their fingerprints and photographs are taken and scanned with the EURODAC database.[6]

The daily schedule of the camp has also some impact on the rhythm of the movements in the area. The refugees leave the camp between 9-12 am and 1-5 pm. Within these periods, they walk to the city, or, alternatively, stay in the area near the camp. Therefore, the area must also be seen as an overdimensional waiting zone for refugees, a landscape of waiting. This is a fundamental element in the refugee context, because, as Tom Holert and Marc Terkessidis have pointed out, the state of waiting is a characteristic condition in the asylum system. So, while staying in the reception camp, the asylum seekers find themselves in a temporal vacuum, frozen in a situation where they can neither move forwards nor backwards, just waiting.[7] And obviously, it is a kind of waiting which is also perceived as a form of degradation.

The project space *bblackboxx*, an artistic research and action centre, is located only around 500 meters from the camp. Since 2007 we have been experimenting how we could fill this vacuum of time and resources with public interactions. So in all of the projects, communication and visibilization have been the main motivation to work here.

It was discussed at the conference how the numerous artistic or documentary projects about illegalized migration have to work with the contradiction that visual representation of faces should be avoided for obvious reasons. The only alternative seems to be in portraying the "shadow existence" of people living under illegalized conditions. And even if the faces are not hidden, in the recurring narrative of the media and photography, the refugee is universalized and stereotyped as a "special type of human being"[8], as the controlled, dependant individual. It is the picture of the nobody.

The *picture service* and the *AuQuarellclub sans frontières* can be seen as two alternative ways of visualization in the refugee context.

Picture Service: getting the picture of a somebody

The project *picture service* was never intended to be an art project in the sense that we had never planned to exhibit the pictures. We were more interested in the interactive part of it, how the photographical process might influence the communication with the people who were using the service. We liked to think of the project as a form of service or activism and we also wanted to offer something to the people that was useful from their own point of view. Considering that it is not uncommon for refugees to circulate around Europe for years while their journey generally remains

6 | http://ec.europa.eu/justice_home/key_issues/eurodac/eurodac_20_09_04_de.pdf
7 | Holert/Terkessidis 2006, p. 78.
8 | Ibid, p. 78.

undocumented, not only in the sense that they have no papers, but also in that they have nothing but their memories left from all these years, pictures seem to have an even more important value than the usual memory pictures.

Every day, from July until December 2008, people could borrow our digital cameras. The borrowing was completely confidential and we did not ask for any deposits, names or the like. When refugees had made their pictures, they could receive the images by mail or on CD. It was all for free. So the *bblackboxx* space turned into a gathering place, a kind of studio, with people of all ages and backgrounds coming and going, where we were constantly transferring the pictures into the computer, printing them, burning CDs, sending mails with the snapshots to the families and friends at home.

Meanwhile, an archive of about 8000 pictures has grown on our computer and we find ourselves in the contradictory situation that the special value of the pictures lies in the fact that the people are not invisibilized and still, it is problematic to publish them without veiling the identities. So again, the faces are pixled.[9]

In this paper, I can only provide a very fragmented insight into this archive. It is not at all representative. Even though these pictures are basically private ones, we have decided to show them sometimes in certain contexts, such as schools, conferences or in this publication, as we are convinced that they are a chance to give the refugee community a face and to deconstruct stereotypes. They don't show refugees. They show people like you and me. This might be banal, but it is being ignored often enough. And we should not forget that there are enough other examples where photographers or journalists publish pictures of refugees, without ever asking them if they agree to be represented like that in the media.

Figure 1

This statue of the melancholic Helvetia, an allegory of Switzerland near the Rhine seemed to have been a popular motive among the picture ser-

9 | The photographer Christian Knörr (Basel) helped us to find a balance, so that the expression is vaguely recognizable.

vice users. Ironically enough, this protagonist, like many others, was not really aware with whom he is associating here.

Figure 2

One man went with the camera to a public park called *Neue Welt* (Engl. The New World). In this environment he created an impressive series of 51 pictures that all show an utterly utopic scenario: The protagonist presents himself wandering in an almost surreal and picturesque landscape of green hills, a sea of flowers, fountains, and other decorative elements. On some of the pictures, he strikes the pose of a melancholic thinker, in others as a Kung Fu fighter; sometimes he is talking on the mobile phone, drinking from decorative fountains, or posing among the numerous flower beds in the park. And, of course, together with some public art exhibits, such as this real-size dinosaur.

It is striking that every single snapshot is in complete contrast to the real, precarious situation of the protagonist. With a strange kind of insistance, he stages himself in the setting of this absolutely ideal world. Obviously, this is not the standard image we expect when we think of pictures of refugees. He is placing himself into the nice side of life. And this seems to be a common interest of all of the picture service users:

Figure 3

To kill time, this young woman went to one of the numerous stores in Klein-Basel[10] where people buy dresses for oriental weddings. She took a couple of pictures in different dresses, even though she could in no way afford them and, anyway, there was no wedding planned. Again, it is the staging of a narrative, which is maybe not particularly exceptional, but which is in harsh contrast to that person's actual situation, considering the fact that a steady relationship or marriage is almost unthinkable under the conditions she was living in.

Figure 4

As already mentioned, the surroundings of the *bblackboxx* space are a popular area for dog owners. In this picture, there is one hint that this man is *not* the real owner of the dog: He is wearing flip-flops, but Swiss dog owners would usually wear sneakers or other good shoes that allow them to walk around here for hours. The picture must have been taken either by a friend or the dog owner, which might be the reason why he is not in the picture himself. When other refugees saw this picture, some of them also started to take similar pictures with other dogs they could find. In this way, self-portraits of refugees as dog owners became part of the iconography of the archive.

Other people did not only borrow dogs, but even the children of local families. So the archive also contains quite a number of pictures with "refugee-local citizen patchwork families".

10 | Klein-Basel is the part of the city near the border, well-known as the area with the highest percentage of immigrants and with many small stores and takeaways opened by them.

Figure 5

By the end of the year, as every year before Christmas, the road to the border was suddenly full with posters of an underwear campaign. As a result, for quite a while, we used to receive pictures of dressed men with less dressed angelic women. Others just posed with the poster of a cheese-maker couple near the camp. In this example, it is clear that the frame is set so carefully that the heads are more or less the same size and, perhaps more importantly, that the husband is no longer in the picture. The ironic touch needs no explanation, but it is even more interesting, as the sham marriage discourse (Scheinehe) has become very popular in recent years, when it comes to relationships between refugees and local citizens.

It is difficult to generalize the archive, and it is not useful for interpretations about cultural backgrounds or the like. To sum up, I should say however, that the archive transmits an image of refugees which is very much unlike other widespread visual representations. Ironically enough, we have to face the fact that in this case, they are not meant for the public and we don't hold the copyright. The pictures belong exclusively to the people who made them. On the other hand, such pictures express an impressive counterreality which is powerful in its banality. The refugees show themselves how they want to see themselves. As people with a normal life: with culture, with cars, with families, with relationships, with mobile phones, with a life, relaxed.

The Swiss filmmaker Fernand Melgar said about his film *La Forteresse* that it is not a film about asylum, but a film about family.[11] In a similar sense, I should say that the images of this project are neither about asylum nor about illegalization. The only aboutness seems to be how the persons want to see themselves. And this does not seem to differ at all from the non-refugees. It has nothing to do with so-called "utopic expectations" about Europe. It is just the standard way of life that we are all familiar with. And yet, there is something enigmatic in those pictures. The way in which the desire for a normal life is expressed is so over-affirmative, that it seems to be almost unreal. Therefore, these pictures resemble a strange mirror of the reality in which the refugees have ended up.

AuQuarellclub sans frontières: Occupation painting

In the year 2007, the right-wing populist party SVP launched the so called "Ausschaffungsinitiative" (Detention Initiative), a new draft bill for the migration law containing criteria which make it easier and more arbitrary to deport delinquents without a Swiss passport. About one year later, the same party successfully launched the so-called "Minarett-Initiative", with the result that the prohibition of minarets was accepted by public vote in a referendum in November 2009. The next step is the discussion about the burqa ban, and like the minaret ban it has no other effect than inciting xenophobic attitudes among the population.

As a reaction to these political developments, a handful of historians and cultural theorists formed the group *Passe-Partout*, in order to discuss plans how to react to the increasing influence of populist politics in the country. In our first meetings we discussed ideas how we could manifest public presence and find a language which deconstructs the dominant populist discourse. It seemed to be almost impossible to initiate public discussions which do not permanently circulate around the stereotype of the "dangerous muslim". It seemed even more difficult to make clear that the restrictive law attempts to normalize an unequal legal situation in society and also to reinforce the image of the criminal foreigner[12] in people's minds.

So we started from a different angle, relying on the power of our own physical and enduring presence in front of the very building where detentions take place in Basel, the so-called Ausschaffungsgefängnis Bässlergut. We founded the AuQuarellclub, a kind painting circle, which gathers on a regular basis (every first and second Friday at 6 p.m.) on the pavement in front of the detention centre. There we sit down and just start painting pictures of the building. The meetings are announced entirely

11 | I am referring to an oral statement in the discussion after the screening of the film, during the conference.
12 | Falk 2010, p. 275-276.

publicly on facebook.[13] Needless to say, any other creative practices are always welcome.

This activity is called *AuQuarellclub sans frontières* and it is basically a regular gathering on the pavement. The concept of the gatherings has to be something that does not infringe the law and therefore could not be disrupted by the police. In addition, it should be something where anyone can participate, anyone who wants to join up with others and talk about the complex topic from his or her own point of view. In this way, a forum is opened up for those who feel they want to associate and share their questions and knowledge with others about the topic separately from the media discourse. Ideally, the whole project will also inspire other groups to organize similar flash mobs in front of other detention centres. In the end, we plan to launch various exhibitions all over the country of the works created. With the AuQuarellclub, people can make themselves visible in public with their critical attitude, visible also to the detainees. And the exhibition is also a form of visibilization of traces of the people who have been gathering throughout the years.

A lot of things happen when a group of people just sits in front of a prison, totally occupied with something that is not obviously destructive, but still disturbing from the point of view of the security personnel.

Sometimes they come out to talk to us. Or call the police. They ask questions about art. About escape plans. About the art institution that we represent. Checking bags and names or phone numbers. And saying things like "no it's not prohibited to sit here and paint, but we have to make sure that everything is okay". And it's all recorded by the surveillance cameras.

Figure 6

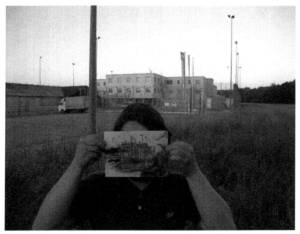

13 | See Facebook: http://de-de.facebook.com/pages/AuQuarellclub-sans-frontieres/120353831314550?v=info, (accessed May 27, 2010).

List of Figures

Figure 1: picture service, With Helvetia, 2008. Photograph: anonymous.
Figure 2: picture service, With Dinosaur, 2008. Photograph: anonymous.
Figure 3: picture service, With Weddingdress, 2008. Photograph: anonymous.
Figure 4: picture service, With Dog, 2008. Photograph: anonymous.
Figure 5: picture service, With Lady, 2008. Photograph: anonymous.
Figure 6: AuQuarellcub sans frontières, Prison and Wall, 2010. Photograph: Almut Rembges.

Bibliography

Falk, Francesca. 2010. "Diskursive Kapitulation." In *Von der Provokation zum Irrtum – Menschenrechte und Demokratie nach dem Minarett-Bauverbot*, ed. Gross, Andreas et al. St.Ursanne: Edition le Doubs.
Holert, Tom/Terkessidis, Marc. 2006. *Fliehkraft. Gesellschaft in Bewegung – von Migranten und Touristen*. Köln: Kiepenheuer & Witsch.

Editors and Authors

Editors

Christine Bischoff teaches cultural studies at the Seminar für Kulturwissenschaft und Europäische Ethnologie at the University of Basel. Her research focus is on visual anthropology, migration, transnationalism and sociocultural mechanisms of inclusion and exclusion.

Francesca Falk teaches at the University of Basel and is a Research Associate at the Institute for Critical Theory at the Zurich University of the Arts. She is currently working on a visual history of demonstration and protest marches. Her areas of special interest are illegalized immigration, postcolonialism, image and history, political theory and border studies.

Sylvia Kafehsy is an art historian and a curator of contemporary art. Her fields of specialization include the visual culture of illegalization, international urban development, pornography/prostitution and censorship.

Authors

Michael Andreas, Ruhr-Uni Bochum, Institut für Medienwissenschaft, Universitätsstr. 150, 44780 Bochum

Olaf Berg, Medienpädagogik Zentrum e.V., Susannenstr. 14d, 20357 Hamburg

Lambert Dousson, Centre de Recherches sur l'art/ethetique-philosophie (créart-Phi), Université Paris Quest Nanterre

Jan-Henrik Friedrichs, History Department, University of British Columbia, Rm. 1297-1873 East Mall, Vancouver, B.C., V6T 1Z1

Eva Kuhn, Kunsthistorisches Seminar der Universität Basel, Im Laurenz-Bau St. Alban-Graben 8, 4010 Basel

W. J. T. Mitchell, University of Chicago, Wieboldt Hall 202, 1050 E. 59th Street, Chicago, IL 60637

Almut Rembges, www.bblackboxx.ch, Postbox: Kraftstrasse 20, CH-4056 Basel

Marc Schoonderbeek, Faculty of Architecture Department of Architectural Design: Public, Building, Delft University of Technology P.O.Box 5043, 2600GA Delft Berlagewegi 2628CR Delft

Helen Schwenken, Universität Kassel FB, 05/Globalisierung & Politik, Nora-Platiel-Str. 1, 34127 Kassel

Pamela C. Scorzin, FH Dortmund, University of Applied Sciences and Arts, Max Ophüls Platz 2, 44137 Dortmund